The Golden Retriever

Kennel Club Books®

A Division of BowTie, Inc.

Andrew DePrisco, *Editorial Director*
Amy Deputato, *Senior Editor*
Jennifer Calvert, *Associate Editor*
Brian Bengelsdorf, *Art Director*
Karen Julian, *Publishing Coordinator*
Jessica Jaensch, *Production Coordinator*
Tracy Burns, *Production Coordinator*

Photographs by John Ashbey, Miguel Betancourt/In Focus by Miguel, Booth photo by Jaeger, Martin Booth, Steve Bull/Sirius Photography, Chris Butler, Alison Desmarais, Isabelle Francais, Henric Fryckstrand, GSK, Chris Halvorson, Nancy Kelly, R. Kohler, Ken B. Matthews, Connie Gerstner Miller, MR Photography, Nakamura, Tom and Linda Nutting, Pam and Jerry Oxenberg, Alice Pantfoeder, Photos by Elaine, Photos by Phoebe, Purebred Photos, Joe Rinehart, Alex Smith, Sombach Photos, Anne Strathern, Tonya Struble, Karen Taylor, JoAnn Tuan, Berna Hart Welch, Xuansu Photo Studio, and Ulrika Zetterfeldt.

Front cover art: *Haulstone Dipper* by Henry Crowther, courtesy of the William Secord Gallery, New York, New York. **Charts and illustrations** by Rachel Page Elliott, Tom Kimball, Christine Miele, and Marcia Schlehr.

Copyright © 2010

KENNEL CLUB CLASSICS

DIVISION OF BOWTIE INC.,
40 Broad Street, Freehold, NJ 07728 USA

Library of Congress Cataloging-in-Publication Data

Pepper, Jeffrey.
 The golden retriever / by Jeffrey G. Pepper.
 p. cm. -- (Kennel Club classic)
 Includes bibliographical references and index.
 ISBN 978-1-59378-686-1
 1. Golden retriever. I. Title.
 SF429.G63P47 2010
 636.752'7--dc22

 2009040323

Printed and bound in China
14 13 12 11 10 1 2 3 4 5 6 7 8 9 10

The Golden Retriever

An Authoritative Look at the Breed's Past, Present, and Future

By Jeffrey G. Pepper

ACKNOWLEDGMENTS

Golden Retrievers have been part of my life since 1969, when I acquired my first Golden with the help of longtime Golden breeder and veterinarian Dr. Irene Kraft of the Nerrissida prefix. Because of her assistance, my first Golden was a very good one. Purchased as a pet for $150, "Ricky" eventually became a Group-placing champion and earned his CD title, and thus began my journey with Goldens that continues today. I have met people all over the world who share my passion for the Golden Retriever and have had the opportunity to judge the breed in many different countries. It's an ongoing voyage.

No book of this scope is possible without the help of friends, and I have had plenty of help. For this book, I have enlisted the aid of several longtime friends who share my passion for the Golden Retriever. They have supplied some insight into areas in which they have particular expertise. Among them are three other Golden Retriever Club of America life members, two former GRCA presidents, and several former GRCA vice-presidents. Four of us are Golden breeder-judges, and all are breeders of titled Goldens. On a whim, I added up the number of years that each of us has spent actively involved with this breed, and I stopped counting when I hit a cumulative 225 years!

Marcia Schlehr has written a fabulous chapter about the first 100 years of Golden history, some of it appearing here for the first time in print, for which I am very grateful. In addition to being a longtime Golden breeder and a tireless historian for the breed, Marcia judges the breed and has judged the Golden Retriever Club of America's national specialty sev-eral times. Her extensive experience in the breed dates to the early 1950s. Marcia is one of the GRCA life members I mentioned.

Ann Strathern is another GRCA life member who contributed to this book. A breeder of multipurpose Goldens, she has provided some special insight into the world of the Golden Retriever field-trial dog. Her very special chapter on the original purpose of the Golden as a hunting dog provides a first-person look at the breed from the perspective of the field-oriented enthusiast. Ann is also a former president of the GRCA.

Sharon Bolton, a breeder of champion Goldens with multiple titles in other areas of the dog sport, has done a masterful job of explaining the many facets of obedience work and why a dog needs to have proper conformation to work to the best of his abilities. Her special medical understanding of the potential problems that can be caused by faulty structure provides a useful viewpoint. Sharon is also a GRCA life member.

Chris Miele, also a former GRCA president, gives us a concise report on one of the fastest-growing canine sports, agility. Her experience as both a breeder-judge in the conformation ring and a respected agility judge provides special insight into the need for correct conformation in a winning agility competitor. Chris is a breeder of dogs with champion, agility, and obedience titles.

Pluis Davern, a multifaceted judge and professional trainer, is approved to judge all Sporting breeds and a number of Hound breeds, as well as field trials. For many years, she has also hunted,

using Goldens, Labradors, German Shorthaired Pointers, and Sussex Spaniels. Truly a well-rounded person, she has been a very successful breeder of both field dogs and show dogs. Pluis worked for some time as a successful professional handler and continues to work as an obedience trainer. In addition, she is currently the lead trainer and a board member of the Search Dog Foundation. Her unique experience in so many aspects of working with dogs is very clear as she explains the qualities needed in a FEMA-qualified search and rescue dog.

Thanks also to Debbie Berry of the GRCA for an informative chapter on the breed's parent club in the United States.

I must mention William Secord of the William Secord Gallery in New York City. His unmatched expertise on the subject of the dog in art and his willingness to share his collection of artwork featuring the Golden have resulted in a chapter of both historical and aesthetic interest.

Some of the superb photographs of Goldens found in this book are the work of Christopher Butler, photographer extraordinaire. I also must thank Alison Desmarais, Nancy Kelly, Ken Matthews, Pam and Jerry Oxenberg, Tonya Struble, Berna Hart Welsh, Linda Willard, and my Swedish connection, Henric Fryckstrand, for allowing me to use photos of their wonderful dogs. Some of the other photos were taken by me during my travels to judge the breed around the world.

I must also thank Dorothy Macdonald for her invaluable input and suggestions as I wrote this book.

Special thanks to Rachel "Pagey" Elliott, who was an inspiration and mentor for many years. Her deep knowledge of and passion for the Golden Retriever, combined with her priceless contributions to all breeds through her writings and lectures on correct structure and movement, have made Pagey a legend. She was the first recipient of the American Kennel Club's Lifetime Achievement Award, a richly deserved honor. Pagey graciously allowed me to use some of the drawings from her latest version of *Dogsteps: A New Look* to illustrate this book's discussion on gait. We discussed "Golden gait" at great length, and Pagey made several wonderful suggestions, which were incorporated into the text of this book. Sadly, Pagey passed away on March 20, 2009. There is no doubt that she will remain an icon in the Golden Retriever world and in mine. I've lost a longtime friend, a valued mentor, and an honest critic. I shall not forget her.

As you read this book, I hope that you will find lasting value in our combined efforts and that you will work toward the improvement and protection (while adhering to the requirements of the breed standard) of one of the world's favorite breeds, the Golden Retriever.

Contents

67

167

206

INTRODUCTION

Hail the Golden Retriever! Few breeds have the Golden's global appeal. One of the most popular breeds of dog today, the Golden Retriever has devotees the world over. Golden lovers can be found just as easily in continental Europe, North or South America, Asia, and Australia as in the United Kingdom, the Golden's native land, where the breed's popularity is legendary.

The Golden Retriever originated in 1865 in Scotland, the result of the careful breeding program of Lord Tweedmouth. He documented his breedings in his writing with pedigrees, which was an unusual course of action for the times. Lord Tweedmouth's records were rediscovered in the middle of the twentieth century, and they provide us with detailed information about the development and history of the breed. You will learn more about the breed's fascinating beginnings in a chapter contributed by noted breed historian and expert Marcia Schlehr.

In my years of involvement with the breed, the Golden has gone from being one of the lesser-known breeds in the Sporting Group to one of the most popular, consistently ranking among the top five of all breeds registered with the American Kennel Club since the mid-1980s. This upsurge in popularity has led to much greater interest in the breed all over the world. This book is dedicated to advancing people's knowledge of the history and original purpose of the Golden Retriever and its resulting form and function.

One of today's most beloved breeds, the Golden has widespread appeal as a companion dog. People around the world have deep affection for their pet Goldens. Highly adaptable, the Golden Retriever is equally at home in a city apartment, a suburban home, or a sprawling farm. He is a willing hunting partner, able to work a full day in the field and then return home with his master to share the comforts of the house. He is a devoted companion, eager to share his unconditional love with all. It matters not to the Golden whether his owners are rich or poor, as long as they make him a part of the family and take good care of him with a suitable diet and regular exercise.

While the Golden is first and foremost an amiable companion, he is also quite happy to show off his beauty and skills. At conformation shows in the United States, Goldens consistently make up large entries, often among the largest in the shows. In the breed's homeland, the United Kingdom, the largest individual breed entry is often that of the Golden Retriever. The breed is equally well represented throughout Europe, and large Golden entries can be found at championship-level shows in Asian and South American countries. Indeed, the breed can be found winning Bests in Show all over the world.

The aforementioned adaptability of the Golden, along with his intelligence and his legendary desire to please his human companions, has led to the breed's sizable presence in the obedience and agility arenas. Easily trained and athletic, the Golden excels in such competition and is often found winning trials of both types. The breed is considered one of the most desirable by those who compete in these sports regularly.

Originally bred to retrieve both upland game and waterfowl, the Golden can be a great hunting companion, and the breed holds its own at formal field trials. Indeed, it is his innate hunting ability and strong desire to please his master that help make him valuable in many other kinds of work as well.

That same need to please and the good-natured temperament of the Golden make him an excellent companion for child and adult alike, as well as a dedicated helper for those with physical or mental handicaps. In fact, the Golden's temperament and versatility is so great that the breed's potential for new tasks is constantly being recognized. For many years, Golden Retrievers have been trained to act as guides for the blind, and they're now also used as assistance dogs for the hearing impaired and for people requiring other types of specialized help with everyday tasks.

In addition, the breed's great sensitivity to the unspoken feelings of humans makes the Golden a legendary therapy dog. Indeed, he is so tuned in to "his" people that he sometimes develops a truly extraordinary ability to sense medical issues in humans. A few Goldens are known to have such a close relationship with their people that they have developed the ability to foresee oncoming seizures in time to warn their humans to prepare for them. Some Goldens have been taught to differentiate smells to the point that they are able to discover some kinds of cancer in patients before conventional diagnosis is possible. The powers and skills of our Goldens are amazing.

With seemingly limitless potential to serve mankind, Goldens have been trained to act as bomb-detection dogs in places as famous as the Statue of Liberty. They can be taught to detect smells such as those of various drugs and fire accelerants. Following the September 11, 2001, terrorist attacks, several Golden Retrievers were among the first search and rescue dogs called into action at Ground Zero in New York City. The strong instinct to seek and retrieve, using his sensitive nose and intellectual drive, along with his agility and trainability are what make the Golden an outstanding search and rescue dog, and there are first-class FEMA-certified Golden Retriever search and rescue dogs. In this book, you will find a chapter on the training of search and rescue dogs written by Pluis Davern, the special lady who trained one-third of all of the dogs who worked at Ground Zero, the site of the collapsed World Trade Center in Manhattan.

The outstanding traits of the Golden Retriever are not the result of happenstance. Adaptability and trainability were among the qualities sought by the founders of the breed in 1865. The Golden Retriever was always intended to be both a field dog and a companion at home. Unlike some of the other retriever breeds, he was never intended to be a dog used to retrieve birds to be sold at market. Rather, he was intended as a gentleman's hunting companion, able to retrieve the birds shot by his aristocratic owners on land and in water and then return home to his family to lie quietly by the fireplace after a day's work.

The multifaceted nature of the Golden's job has evolved over time, making the Golden a true all-purpose breed of dog, treasured in the field and in the family. As a result of the breed's widespread appeal and popularity, many want to learn more about the Golden Retriever. This book is dedicated to teaching about the many aspects that go into making an outstanding Golden Retriever.

The overall theme of the book is to help you gain a good understanding of that oft-quoted phrase, "form follows function." And no matter his function, the Golden is always a joy to be with. His sunny disposition and his ability to carry out so many different jobs are based in large measure on his conformity to the requirements of the Golden Retriever breed standard. In each of the chapters of this book, the aim is to advance your knowledge of this wonderfully versatile breed by providing a better understanding of, and greater respect for, the essence of the Golden Retriever and what makes the breed so appealing.

PART I

The
Golden

Age

Chapter One

The First Hundred Years

BY MARCIA R. SCHLEHR, GRCA HISTORIAN

hile the Golden Retriever as a recognized breed is a product of the late nineteenth century, retrieverlike dogs of similar function, structure, and even coloring have been around far longer. The *Bradford Table Carpet*, a British tapestry made around 1600–1615, shows yellow or golden dogs retrieving birds for hunters who carried early versions

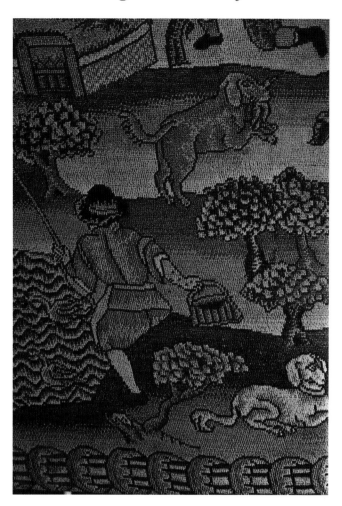

The *Bradford Table Carpet* shows retrieverlike working dogs performing as game-finders and retrievers more than 400 years ago.

of the shotgun. In another work of art, the painter Van Dyck portrayed a midsize retrieverlike red dog with the children of Charles I. These were not Golden Retrievers, nor were they dogs of any *breed* as we now define breeds, but they were of a defined *type*—that of an early setter or large spaniel—and not all that much different from the retriever types that were developed later. Such portrayals show that dogs with many of the physical and behavioral traits of modern breeds were known centuries ago.

Early setters in Britain were seen in various colorations, ranging from solid black to liver brown to shades of red to particolored, just as the spaniels were. An engraving by Reinagle shows a cream- or sandy-colored setter that has been identified as being of a strain from the border country between Scotland and England. George Garrard painted *Yellow Retriever on a Riverbank* in 1820, depicting the title dog with a game bird in his mouth. It has been written by canine historians that setters were only enlarged and "improved" spaniels; indeed, it is sometimes impossible to differentiate clearly between them, as they were often interbred and both were at times used for retrieving.

Early on, spaniels were roughly classified into "land" and "water" spaniels. The then-common English Water Spaniel bequeathed his genes for courage and skill in water retrieving, as well as his curly coat, to several modern breeds. Although the English Water Spaniel is now extinct, there is a very similar breed in western Europe, the Wetterhoun. The "land" spaniels of course developed into the modern British spaniels—Springer, Cocker, Field,

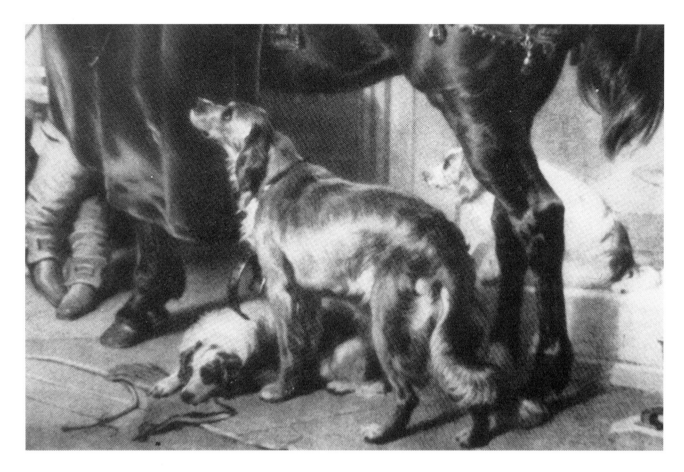

The Return from Hawking. **This engraving by Landseer depicts a retrieverlike dog, although his ears are more like a setter.**

and so on—as well as into European breeds such as the Munsterlander and Wachtel.

Other now-extinct water spaniels were the northern variety of Irish Water Spaniel (with a different coat type than the modern Irish Water Spaniel, which was known as the southern variety in the early nineteenth century) and the Tweed Water Spaniel. Water spaniels could be of varying sizes, coats, and colors; the "liver-colored" were said to excel in swimming. "Liver" could include everything from a light sandy color to the darkest brown. The Tweed Water Spaniel was known on the borders of Scotland and along the eastern coast by Berwick, and in Ireland as well; we shall see how very important he was to our own Goldens.

Edwin Landseer, later appointed the official animal painter to Queen Victoria, depicted a retrieverlike dog and several spaniels in the engraving *The*

Return from Hawking, circa 1839. A copy of this once hung at Guisachan House in the Highlands of Scotland, a place that some years later would become known as the birthplace of the Golden Retriever.

The British setters and spaniels are only an introduction to part of our story. From the New World—in this case, the cold, inhospitable shores of Newfoundland and Labrador—came to Great Britain dogs that have always been a headache to historians. They were of various sorts but similar in many respects. They were *not* the dogs we know as the Newfoundland or Labrador Retriever of today, which must admit to significant modifications after arriving in Great Britain. The dogs that arrived on fishing

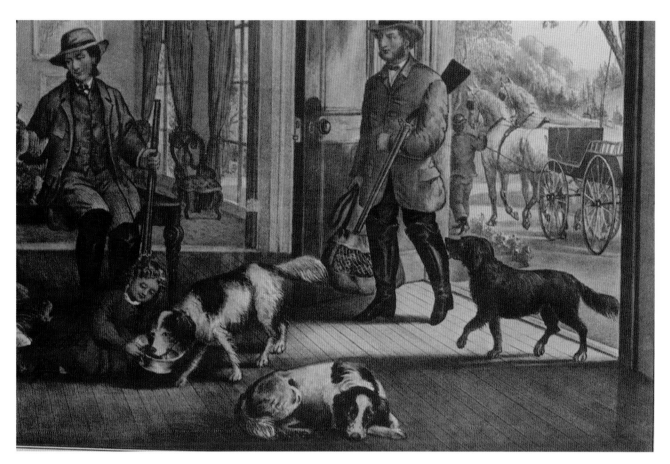

ABOVE: This Currier and Ives print shows a hunter returning home with his black dog of retriever type. RIGHT: A Tweed Water Spaniel. Water spaniels were seen in various colors and were skilled swimmers and retrievers.

boats, bringing their catch back to England as early as the sixteenth century, were called St. John's Dogs, Newfoundlands, Lesser Newfoundlands, Labrador dogs, or water dogs. Forget about assigning coat type and color to any of these names—even in the twenty-first century, no one has figured that out with any certainty! They were mostly medium-size (as retrievers are today), having various coats and colorings.

For convenience, we'll use the terms "St. John's Dog" or "Lesser Newfoundland" for what became the precursors of the retrievers. These dogs were strong enough to pull a sledge, had enough hunting instinct to help provide meat for the pot, were adept in the cold waters as they retrieved gear or carried lines, and were hardy enough to survive with little or no care in a harsh and unforgiving climate. Sometimes called "Newfoundland Retrievers," they were capable but slow, courageous but often willful. They came in black, red, or brown, or white splashed with these

colors, and often had tan or brindle ("tabby") markings. They came to England on ships along with the fish from the Grand Banks of Newfoundland, and by the end of the 18th century, the dogs also proved to be profitable cargo to sell at the ports where the boats docked.

The engraving of a dog named Brush depicts one of these early nineteenth century imports; he appears to be black and tan with some white markings. Interestingly, even today there are occasionally purebred Labrador Retrievers that show indications of these tan markings.

By the later part of the nineteenth century, clever dog men, always with an eye to develop the best qualities in their hunting dogs, had crossed the imported dogs with various British breeds. Certain gentlemen improved the Lesser Newfoundland by crossing them with the Foxhound and the Pointer for speed, style, and nose; from these crosses came the breed we know today as the Labrador Retriever. Others used a cross with a setter, from which came the Wavy-Coated Retriever; the Curly-Coated Retriever no doubt owes much to the curly water spaniels and similar types.

In a well-known engraving of dogs named Paris and Melody, early Wavy-Coated Retrievers, the influence of both Newfoundland and setter contributors can clearly be seen. The original Newfoundland crossed with Mastiff types produced the larger modern Newfoundlands. The Wavy-Coat (with the help of a hefty infusion of setter blood) became refined into the Flat-Coated Retriever, very much in parallel with yellow Wavy-Coats' becoming the stem of the breed we know today as Golden Retriever.

It is largely by only a whim of fashion that the yellows did not remain as Wavy-Coats or Flat-Coats; in the mid-nineteenth century, fashion decreed that black was the favored color for retrievers, and whelps of other colors were often destroyed. Yet, the gene for yellow coat color still runs in some Flat-Coated Retrievers today, with an occasional yellow pup born to black parents.

So, on to the Golden. No doubt you are impatient to hear of "our" breed, but only by an understanding of "whence they came" can a real understanding of the breed be reached. Even until 1900, the breed we call the Golden Retriever was virtually unknown by the dog writers of the times and certainly was not known to the general public. While The Kennel Club (England) did register "Retrievers" early on, all were lumped together under that broad label for a number of years. Labradors were the first to be sifted out and recognized as a "variety" of retriever in 1903. However, "unknown" to the public certainly does not mean "nonexistent"—the yellow retrievers were indeed kept, bred, and worked by a few families of the landed gentry, most of them connected by their own bloodlines. So our story moves now to Scotland.

The legend of the golden dogs begins in the Highlands of Scotland. Dudley Coutts Marjoribanks, a scion of an old Scottish family that made its fortune in London, a member of Parliament, and a figure in Victorian high society, was born in 1820, became a baronet in 1866, and was created Baron Tweedmouth of Eddington in 1881.

He loved hunting in the Highlands and first leased, then purchased, the 20,000-acre estate of Guisachan in 1854. In a few years, Marjoribanks had developed a tremendous estate centered on Guisachan House, with its spacious interior in the height of style and furnished with the finest of everything. Guisachan was essentially a self-contained community, with an extensive farmstead, a dairy, a school, the village of Tomich with sturdy cottages to house

Brush, A Celebrated Retriever is an engraving from a painting done by A. Cooper, R. A.

the workers, and a magnificent granite stable for his cattle and horses. The kennel of whitewashed stone had heated terracotta floors, wrought-iron partitions, piped-in water for the dogs, and its own huge kitchen. He bred superior horses, champion Angus cattle, Pointers, deerhounds, and terriers, as well as retrievers. An early environmentalist, he planted shrubs, flowers, and trees from all over the world, many of which still grow today. Guisachan had electric power from its own hydroelectric facility, the first in northern Scotland.

Many well-known and influential people visited Guisachan. Marjoribanks's eldest son, Edward (who later became the second Lord Tweedmouth), married Fanny Spencer-Churchill. Their nephew, Winston Churchill, spent many holidays at Guisachan—and

with his cousin Dudley, Edward and Fanny's son, got into trouble learning to drive a motorcar there.

In 1865, Dudley Marjoribanks was on holiday in Brighton on the southern coast of England with his son Edward, then sixteen years of age. While walking on the downs outside of town, they saw a man leading a young retriever of an unusual bright golden color. Marjoribanks had always had an eye for the unusual and the aesthetic, and this handsome dog intrigued him. On talking with the man, a cobbler, he was told that the cobbler had been given the dog in payment of a debt, and that the dog was the one yellow puppy in a litter of black Wavy-Coated Retrievers born on the estate of Lord Chichester. Perhaps this mention of nobility clinched Marjoribanks' interest— as a member of Parliament for more than ten years, he had been working to obtain recognition and elevation to the peerage to become known as Sir Dudley Marjoribanks (this honor would be his in 1866).

So the young yellow retriever made the long journey from the south of England, traveling the full length of the island to the Scottish Highlands, where he joined the black retrievers, the Pointers, and the deerhounds in the kennel under the watch of Simon Munro, head keeper for the estate. He was given the name Nous (meaning *wisdom* in Greek) and proved to be a useful and valuable addition to the team of hunting dogs. A well-known photograph shows Nous and a deerhound with Simon Munro on the steps of Guisachan House. Nous was not a large dog, but he was strongly made, with a heavy, very wavy coat

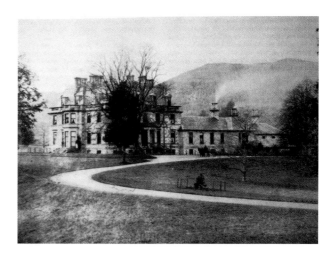

Photo of Guisachan House in its prime.

of rich golden coloring with paler shadings and the typical Golden expression. He would easily be recognized as a Golden Retriever even today.

Another photo from the same time shows a group of the Guisachan staff, including Munro, Duncan McLennan (who would serve at Guisachan for more than forty years), and others with four dogs: Nous on the left, what appears to be a Gordon Setter lying down, a deerhound standing on the far right, and another dog whose head can be seen just to the right of Duncan McLennan. This one could be light brown in color, and is somewhat retrieverlike in the little of her that can be seen; it is thought that this may be Belle, a Tweed Water Spaniel.

Belle is important to our story, as she was bred to Nous to produce the yellow offspring that carried on the Guisachan line. She was given to Dudley Marjoribanks by his cousin, David Robertson, who lived at Ladykirk on the Tweed River near Berwick, in the southeastern corner of Scotland. Tweed Water Spaniels were native to this area and were used not only as hunting dogs and retrievers but also by the shore fishermen to retrieve fish that had flopped from the nets and for many of the same tasks that the St. John's Dogs were used for in Newfoundland.

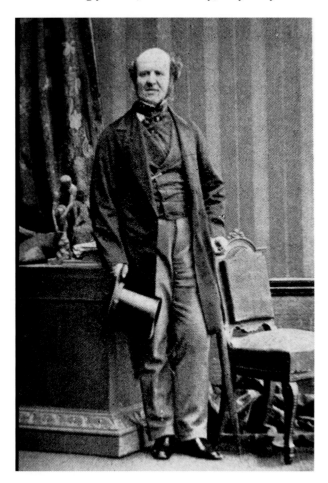

Dudley Coutts Marjoribanks, the first Lord Tweedmouth, born 1820, was a member of Parliament, owner of Guisachan, and creator of the strain that became the Golden Retriever.

They resembled slightly smaller versions of the ordinary English retriever. Their coats were close, often with a definite curl, and they had rather heavy ears. Their faces and the fronts of their legs were clean (unlike the southern Irish version of the water spaniel, which had long curls all around the legs). They were exceptional swimmers and diligent retrievers.

From a litter whelped in 1868, three yellow pups—bitches Primrose and Cowslip, and a male named Crocus—were kept. Crocus was given to Edward (perhaps as a gift for his graduation from Oxford); Cowslip and Primrose remained at Guisachan. One of them, probably Cowslip, is pictured in the famous painting by Gourlay Steele that once hung in the dining room at Guisachan, showing Mary Marjoribanks (Marjoribanks's oldest daughter) on horseback with a Golden Retriever and a small terrier accompanying her. A second litter by Nous out of Belle in 1871 also contained some yellow pups, including Ada, who was given to another of Sir Dudley's cousins, Henry Edward Fox-Strangways, fifth Lord Ilchester.

These are the beginnings of our Golden Retriever, recorded in Dudley Marjoribanks's own handwriting in the Guisachan record book that now lies in The Kennel Club Library. Quite likely there were some yellow pups given to friends and to others in the nobility, and there are no records left of these dogs' descendants. Very similar dogs have been depicted in paintings and photographs of that era. The Guisachan line was developed using another Tweed Water Spaniel and two outcrosses to well-bred black retrievers, including a grandson of the famed Zelstone (who can also be found prominently behind modern Flat-Coats). There was also one cross to a red setter (not necessarily Irish, as there were red setters native to England as well) owned by Edward, who maintained his own kennel at Bushey, near Oxford.

Simon Munro, the head keeper, on the steps of Guisachan House with Nous, around 1870.

From these earliest breedings descended several generations at Guisachan, faithfully recorded until 1890, when the record abruptly stops. Lord Tweedmouth died in 1894; perhaps he was ill and could not continue the record. Or perhaps those years were recorded in a different book that has since been lost.

After first Lord Tweedmouth's death, the title and the estates went to his oldest son, Edward. The dogs remained at Guisachan, and life continued much as before—for a while. Edward was active in the government, but after the death of his beloved wife in 1904, he sank into depression and debt, dying in 1909. Guisachan was sold to his longtime friend,

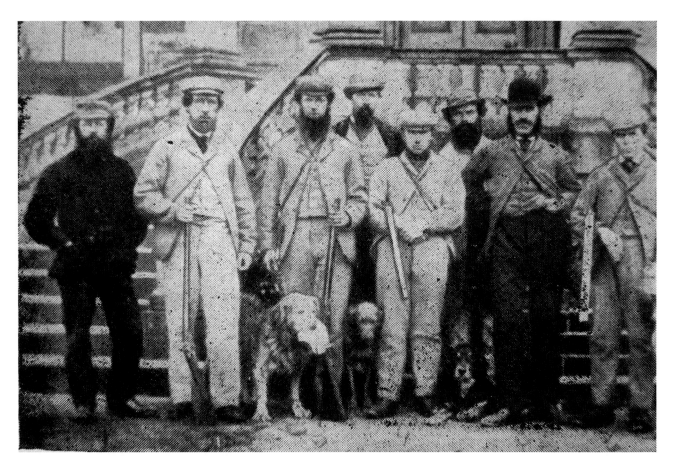

Guisachan staff with hunting dogs. Note the head of the dog lying at the right side of the photo.

Lord Portsmouth, who maintained the house and the kennel of retrievers and pointers for sporting purposes.

Life changed dramatically in Great Britain during and after World War I. Dogs were considered to be of no value to the war effort, and the young men of the time had far more serious work to do rather than participate in sport. And many of them never returned from the war. The estate was neglected, sold off piece by piece to pay taxes, and the dogs were dispersed. Not even Edward's sister, Lady Aberdeen, could save the house, and eventually Guisachan was sold, the house stripped of its elegant furnishings and its roof (so as to avoid taxes) in 1939 and left to the vagaries of time and weather.

However, the yellow dogs survived. Lord Ilchester's treasured Ada had left a line of descendants working the fields of Melbury, the Ilchester estate in southwestern England, for nearly half a century. Edward's Crocus also left descendants, and Edward's brother Archibald John Marjoribanks, Lord Tweedmouth's youngest son, took Sol (whelped in 1882) to Texas, where Archie managed a cattle ranch. And when Archie went to Canada to serve as Aide-de-Camp to his brother-in-law, Lord Aberdeen, the Governor-General of Canada, his Guisachan retriever Lady was a part of the family.

Descendants of the Guisachan dogs worked at various properties in England and Scotland as the nineteenth century became the twentieth. One of these was the estate of the newly created Lord Harcourt. On becoming heir to the considerable

A Tweed Water Spaniel in a painting by John Charlton. The painting resides in the archives of the GRCA.

fortune of his father in 1904 and taking his title, Lewis Harcourt decided to take up purebred dogs, and he chose yellow retrievers both for working and

Crocus is pictured with Lady Fanny Marjoribanks.

for the increasingly popular pastime of dog shows. It is said that one of his foundation bitches was a granddaughter of Lady, who had accompanied Lord Tweedmouth's youngest son, Archie, back to England. Several photographs of Lady are in the Golden Retriever Club of America's archives; she was a substantial bitch, deep golden in color, with the same wise expression typical of the Guisachan retrievers.

Another of Lord Harcourt's foundation dams was Culham Lassie. Lassie was a registered Flat-Coated Retriever of impeccable pedigree. When the yellows were formally recognized by The Kennel Club under the name Retrievers (Golden or Yellow), Lassie and a number of other yellow Flat-Coats were reregistered as Goldens. Judging from their photos, Culham Lassie and the foundation sire Culham Brass were quite typically Golden in appearance. However, others of the Culham line more closely resembled Flat-Coats. Of course, at that time, many of

the Flat-Coats were of a basic type still very similar to that of the Goldens.

About the same time as Lord Harcourt, others also began showing their yellow retrievers at the championship shows; this was around 1908, when the "yellows" were given separate classes. One of these exhibitors was a redoubtable young lady from Yorkshire, Winifred Maud Charlesworth; another was Donald Macdonald, the head keeper from Lord Shrewsbury's Ingestre estate. Some of the comments from judges in the published show reports at the time indicate that the dogs varied considerably, and at least one judge admitted in print that he was rather at a loss as to how they should be judged.

Donald Macdonald's Ingestre retrievers were of both black and yellow varieties. Probably every pure-bred Golden today can be traced back to Ingestre, particularly to the combination of Ingestre Scamp and Ingstre Tyne. Macdonald was a well-known gamekeeper, active in the Gamekeepers' Society for

The original caption of this photo of Ada called her "the property of the Earl of Ilchester" and "the daughter of Lord Tweedmouth's original dog." She founded the Ilchester strain of yellow retriever.

many years. He lived until 1956, seeing the Golden become a well-established and popular breed.

Mrs. Charlesworth started with a bitch of no known pedigree, whelped in 1906, named Normanby Beauty. Bred to Culham Brass in 1911, she produced Normanby Balfour, who became a widely used sire. From a litter by Culham Copper in 1912 came Noranby Campfire—the kennel name was changed from Normanby to Noranby before Campfire was born—who won his three Challenge Certificates (awards toward a championship in the United Kingdom) before the war. When trials were held again after the war, he came back at the venerable age of nine in 1921 to earn the qualifying certificate at a field trial. This gave him the title of champion—the first in the breed.

Mrs. Charlesworth developed a fair-sized kennel of dogs, and had been instrumental in forming the Golden Retriever Club (of England) just before the war. She was the club's secretary for many years, the first woman to run her own dogs in retriever trials, and the first woman to win a placement with a Golden at a trial. She wrote books and for the dog papers, judged both shows and field trials, and scandalized many by appearing in public in trousers!

The culmination of the Noranby strain was the breed's first female dual champion, Noranby Destiny, whelped in 1943, who completed her title in 1950. Destiny was a direct descendant in the maternal line from Noranby Dandelion (1913), bred from Donald Macdonald's working retrievers at Ingestre. Many other Noranby champions and field-trial winners made their names in the intervening years, and the Golden world doubtless would be a bit different without "Charlie" (Mrs. Charlesworth).

Official recognition of the Retriever (Golden or Yellow) in 1911 by The Kennel Club led to a surge of interest. Mrs. Charlesworth was one of the earliest to write about the breed, and she put forth in her writing the romantic story of Lord Tweedmouth's having obtained the foundation of his line from a group of pale golden "Russian Retrievers" purchased from a circus visiting Brighton. While it is true that Brighton was a popular resort town and may well at some time have had a circus with performing dogs, there is no evidence of a troupe of large Russian dogs having been there. And the Guisachan record book, in Lord Tweedmouth's own meticulous hand, makes no note of any such dogs purchased. Still, the tale of the Russian dogs was also given a substantial boost by Colonel William Le Poer Trench, who convinced The Kennel Club to recognize his dogs as the "Marjoribanks and Ilchester breed of Yellow Russian Retrievers."

Trench had bred and shown Irish Water Spaniels quite successfully some years earlier. Around 1883, he owned a retriever named Sandy that he had obtained from Lord Ilchester. The dogs that he had twenty years later, however, were not related to this dog and had no recorded pedigrees. All that is known is that St. Hubert's Rock and St. Hubert's May, as he called them, were said to have been from Scotland. Rock and May together produced at least two litters, and several of the St. Hubert's dogs were shown at championship shows. It is interesting that there were a few other dogs that were shown both as Yellow Russian Retrievers and as Golden Retrievers, and it is quite possible that some of the St. Hubert's dogs entered into early Golden bloodlines.

Several photographs of the St. Hubert's dogs survived, and some of them closely resemble the large, pale-colored pastoral dogs of Eastern Europe, such as the Kuvasz, the Tatra Mountain Dog, and some varieties of the Ovtcharka. Others are more similar to the Golden Retriever. Colonel Trench was so convinced of the Russian origin of his dogs that he sent a representative to the Caucasus to find and purchase more dogs, but according to the tale, either it was the wrong time of year to find the flocks with shepherds and dogs or the dogs purchased were killed by wolves. Anyway, the expedition was a failure.

Colonel Trench showed some of his dogs around 1912–1913, and one was given to Lady Aberdeen. After Trench's death in 1917, the "Russians" faded from view, although some of their descendants no doubt contributed to Golden bloodlines, as considerable interbreeding was still being done, and dogs from unregistered parents were being registered as Goldens all through the 1930s.

Lord Tweedmouth's younger son, Archie Marjoribanks, with Lady, around 1894. Lady has been said to be the granddam of some of the earliest registered Golden Retrievers.

The 1920s saw continuing interest in the breed after the lull of the war years; dog events were in abeyance between 1914 and 1920, during and immediately after World War I. W. Stanley Hunt (Ottershaw) had acquired Normanby Balfour and established a fair-sized kennel. As a butcher by profession, he was one of the few who could afford to feed numbers of dogs under wartime restrictions.

Just after the war, Louis Harcourt gave a puppy of Culham breeding to his friend Mr. R. O. Hermon, who trained and handled the dog he named Balcombe Boy. Boy was the first Golden to win both show and field-trial titles, becoming the first dual champion in the breed. Balcombe Boy became an important sire; among his offspring was Foxbury Peter, who went to Canada and completed his championship title there around 1927.

Eng. Ch. Michael of Moreton is a dog who cannot be ignored in Golden history. His sire, Rory of Bentley, another son of Normanby Balfour, wasn't even bred until ten years of age! Born in 1925, bred by Mr. H. L. Jenner (who later used the prefix Abbots), and owned by Mr. R. L. Kirk, Michael won seventeen Challenge Certificates (a remarkable number for those years), placed in field trials, and won the Crufts Gold Cup no less than four times. Michael himself sired eight British champions as well as the first American champion, Am./Can. Ch. Speedwell Pluto, of whom we shall hear more later.

Mr. and Mrs. Eccles' Haulstone kennel started with a son and a daughter of Balcombe Boy—Haulstone Dan and Haulstone Rusty. The Haulstone dogs, including FTCh. Haulstone Larry and FTCh. Haulstone Bob (FTCh. is the abbreviation for the British Field Trial Champion title), were successful both on the bench and at field trials during the 1920s and '30s. Their pedigrees carry the only recorded

Transcaucasian Ovtcharka. There are several varieties of ovtcharka, one of which may have been the "Russian Tracker" sometimes mentioned in conjunction with the Golden Retriever.

infusion of Labrador Retriever blood into Golden lineage; in the late 1920s, Haulstone Rusty was bred to the yellow Labrador FTCh. Haylers Defender. Haulstone Bob was a quarter Labrador, as his dam Haulstone Jenny was from the first cross. At that time, The Kennel Club would register such dogs as Interbred Retrievers—Bob was an Interbred. After three generations bred back to Goldens, the progeny of Interbreds could be registered as purebred Goldens, as was Larry; he was one-sixteenth Labrador. Bob, his son Haulstone Brock, and Brock's grandson Haulstone Bobby all earned the title of FTCh., Bobby doing so after World War II in 1953.

The 1930s were a time of growing strength in Golden Retrievers. Notable kennels such as Yelme (Major and Mrs. Wentworth-Smith), Sundawn (Reverend Needham-Davies), Stubbings (Mrs. Nairn), Woolley (Mrs. Cottingham), and Abbots (Mr. Jenner) produced major contributors to the breed. Mrs. Evers-Swindell (Speedwell), Lieutenant Colonel the Honorable D. Carnegie (Heydown), and the Honorable Mrs. E. D. Grigg (Kentford) set records hard to

match, producing bedrocks of the breed such as Eng. Ch. Heydown Grip (1927), a grandson of old Normanby Balfour; and Eng. Ch. Flight of Kentford, who went to India and became a dual champion there.

In 1929, Reverend Edward Needham-Davies sold a light golden-colored pup by Eng. Ch. Sundawn Dancer x Sundawn Dainty; he was named "Gilder" by his owner. Light-colored dogs were not popular at this time; many breeders felt that Goldens should be of a deep rich gold without light shadings, and most show winners were what today would be called dark golden. Young Gilder changed hands twice more before coming into the ownership of Major Wentworth-Smith, a noted gundog trainer, in 1933. While Gilder did win two Reserve Challenge Certificates at shows and had a placement at field trial, it is as a sire that his brilliance became undeniable.

Between 1933 and 1938, after which shows and trials ceased because of the threat of war (again), at least eight of Gilder's offspring earned championship titles, and his son Eng. Ch. Hazelgilt was within the proverbial inch of completing his field championship to become a dual champion. A number of Gilder sons and daughters, as well as many Goldens from Yelme and other kennels, were exported to the United States. With food and time in short supply, this was an alternative to destroying the dogs or having them possibly die in wartime bombings. Fortunately, enough of the Gilder line remained in the United Kingdom to continue the bloodline. Gilder himself lived to a good old age, even siring a litter in 1942 at the age of thirteen, although only two pups were kept.

Elma Stonex's Dorcas kennel started with the bitch Sally of Perrot, linebred on Michael of Moreton. Bred to Gilder and to his son Ch. Davie of Yelme, Sally became the fountainhead of the influential and consistently typical Dorcas line. Several other outstanding kennels after World War II were based on Dorcas.

Two other ladies starting in Goldens just before the war were Joan Gill (Westley) and Lucille Sawtell (Yeo). Both carried on the tradition of the dual-purpose Golden Retriever after the war, competing in both shows and trials. At that time, there was no "split" between show and field type. Both of these ladies were still active in the breed well into the last decade of the twentieth century.

Mention must also be made of Mr. and Mrs. William Hickmott (Stubblesdown), who had Goldens for decades before entering into competition after World War II. Their Stubblesdown Goldens won on the bench and contributed enormous talent in the field, culminating in DCh. (Dual Champion) Stubblesdown Golden Lass and FTCh. Stubblesdown Larry.

Heavily based on both Stubblesdown and Yeo through FTCh. Musicmaker of Yeo were the Wynford dogs of Miss June Watson. When she married and became June Atkinson, the dogs took the kennel name of Holway, a name that became a dynasty in field trials. The majority of British field-trial champion Goldens, and a high percentage of modern American ones, as well, have Holway dogs in their pedigree.

But what of the United States? While a few Goldens had been brought to North America in early years, the first to be registered with either the American Kennel Club (AKC) or the Canadian Kennel Club (CKC) were in the 1920s, when all were still registered merely as "Retrievers" of different varieties. Bart Armstrong of Winnipeg, Canada, imported a grandson of Eng. Ch. Noranby Campfire named Noranby Eventide, used him on all kinds of game birds—including Canada geese in ice-choked waters—and showed him to his championship. When

THE CULHAM PEDIGREES

Thanks to British breed authority Valerie Foss for the following from her essay on the history of the Golden Retriever:

In 1995 came an exciting discovery for Golden enthusiasts: the Culham pedigrees were found among Lord Harcourt's papers at the Bodleian Library in Oxford. We can now trace the line from Rose, in the first Lord Tweedmouth's last recorded litter, to Lord Harcourt's Culhams—so there is written evidence providing the link behind today's Golden Retrievers.

Rose, born in 1889, was mated to her sire, Nous 2. They produced Zoy 2, who was mated to Sal. In the resulting litter was Flow, later to be the dam of Haddow (sired by Sol, who was by Saxon x Lady). The family link comes through the first Lord Tweedmouth's youngest daughter. She became the Countess of Aberdeen, and the title of the eldest son of the Earl of Aberdeen was Lord Haddo. In pedigrees, the name is spelled both as Haddo and Haddow.

Lord Harcourt started his Culham kennel of Goldens in 1904 on Lord Tweedmouth's breeding, ten years after the first Lord Tweedmouth's death. Lord Harcourt went to Guisachan to shoot when the second Lord Tweedmouth lived there and also when Lord Portsmouth bought the estate. Lady Pentland, granddaughter of the first Lord Tweedmouth, had a letter from John McLennon, one of the family of Guisachan keepers, in which he says: "Mr Lewis Harcourt (later the first Viscount Harcourt) got the foundations of his breed from two puppies he bought from me when I was at Kerrow House. The mother of these pups was out of a bitch called Lady, belonging to your uncle, Archie Marjoribanks."

In 2006, there was an important find among the Earl of Portsmouth's family papers. In 1905, the second Lord Tweedmouth sold the Guisachan estate to the earl, his friend. Among the earl's records was a notebook titled *Yellow Dogs*. This filled in more blanks with Flax, a gift from the first Lord Tweedmouth, covering the years and retrievers from 1888 until 1925. Also found were some of Lord Tweedmouth's papers; of great historical interest were the *Game Books* of 1855 to 1887, which also served as shooting visitors' books.

the registration certificate arrived in America from the CKC, however, it listed his breed as "Wavy-Coated Retriever." Armstrong's Gilnockie kennels housed sporting dogs of several breeds, but he had a particular fondness for his Goldens that he shared with his friend, Christopher Burton.

In the United States, the first Goldens were registered in 1925, but it was a dog imported from England and owned in Canada that became the first AKC champion of record. On the recommendation of Christopher Burton, Speedwell Pluto had been imported by Samuel S. Magoffin of North Vancouver as his personal gundog. Entered in shows, Pluto finished his Canadian title in short order. Across the border, when the AKC finally recognized Goldens as a separate breed (1933), Pluto finished his AKC title in a blaze of glory: he was the first Golden to win a Sporting Group and the first to go Best in Show. Magoffin imported a number of well-bred bitches from England for his Rockhaven kennel, and he helped

establish his brother, John Rogers Magoffin, in Colorado with the kennel name that had been bequeathed to him by Bart Armstrong: Gilnockie. From the Magoffins' dogs stemmed the foundation of Golden Retrievers in the American West and Midwest.

Sam Magoffin's wife had two brothers and a sister living in Minnesota and Wisconsin. Mrs. Magoffin's brothers, Ralph Boalt (Stilrovin) and his twin brother Ben Boalt (Gunnerman, Beavertail), also took up Golden Retrievers, as did their sister and brother-in-law, Mr. and Mrs. Henry B. Christian (Goldwood), and their friends Edwin "Ned" Dodge (Giltway) and Harold Ward (Woodend). These dogs were worked in the field on both pheasants and waterfowl, this area being a prime game-bird habitat on the Northern Flyway of the central states. They were often hunted hard during the week, then tidied up and taken to shows on the weekends. Both dog shows and field trials were often reported in the social pages in those days, and the dog sport was very much a social event.

South on the Flyway in the Saint Louis area, the Wallace brothers, John K. and Mahlon B. Wallace, were early devotees of the golden dogs. John's first dogs from England arrived in the early 1930s. Within a few years, he had imported more than a dozen dogs, many from the Yelme kennel, who were sent to the United States for safekeeping as England trembled on the brink of war again. Among these were two English champions, Eng. Ch. Chief of Yelme (a Gilder son) and Eng. Ch. Bingo of Yelme. Bingo earned his American championship title, as well, and also placed in several field trials in stakes for amateurs, often handled by Mrs. Wallace. But Bingo's real claim to immortality was as the sire of Gilnockie Coquette, who became an extraordinary producer for the Stilrovin kennel. Her progeny included both

show and field champions and two dual champions—nearly three, as FC (the AKC's Field Champion title) Stilrovin Katherine had eleven points toward her show championship.

Back in Saint Louis, John Wallace's imports Speedwell Reuben and Eng. Ch. Speedwell Tango had produced a litter in November 1935. The last puppy to be sold from this litter—for the princely sum of $35—went to a young man named Paul Bakewell III and was registered simply as "Rip." The first field trial held in the Saint Louis area in April 1938 saw Rip placing second in a stake for amateur novice handlers. He hit his stride in 1939 with three consecutive second-place awards, finishing his title in grand style with a first-place finish on his "home turf," the Mississippi Valley Kennel Club trial in October. Rip was the first Golden to complete a field championship in America.

From his first points to last, a span of twenty-four months, Rip garnered a total of sixty-three points in Open stakes, including six first places—enough for six championships. Rip qualified for the first National Retriever Trial in 1941, but he died before the trial at barely six years old. That national trial was won by another Golden, FC King Midas of Woodend. Both Rip and King Midas left descendants of influence in the growing Golden world.

In 1938, Sam Magoffin (American by birth, although residing in Canada), his brother John, and a group of other Golden people formed the Golden Retriever Club of America (GRCA), incorporated in the state of Colorado. The club's 1939 yearbook lists forty-three members, with roughly equal numbers in the central and eastern regions and only eight members in the West. In the East, Michael Clemens (Frantelle) and E. F. Rivinus (Sporting Hill) spearheaded a campaign for Goldens with the help of Dr.

Large, who wrote a column in the AKC's *American Kennel Gazette.*

In 1940, the first GRCA national specialty show and field trial was held May 13–14, 1940 in Mequon, Wisconsin. The field trial was run both days, and the bench show was held on the evening of the thirteenth. There were forty-four entries in the field trial and forty-five entries in the show; one of the field judges, Edward D. Knight, also judged the show. Beavertail Gay Lady, bred and owned by Ben Boalt's Beavertail kennel, went Best of Breed from the Puppy Class over three champions, and Harold Kaufman's Goldwood Tuck (later a field trial champion) won the Open Stake at the field trial.

Again, World War II had a considerable impact upon dog activities. Most of the young men were in uniform, and with gasoline and tires rationed, travel to dog events was severely curtailed. Still, shows and trials continued on a limited basis. Some of those in the military managed to time their furloughs so that they could get home to run their dogs in major trials. Other young men continued with, or learned about, dog training in the military, as hundreds of dogs came into the military for use as guard dogs, sentry dogs, and other positions. After the war, many of

Culham Brass in about 1908.

these people continued with the new sport of obedience trials and as handlers at dog shows.

We're not just talking about men. In 1941, a young housewife in Massachusetts was introduced to the Golden Retriever when her husband purchased a puppy from the Goldwood kennel. Goldwood Toby accompanied Dr. and Mrs. Mark Elliott when Dr. Elliott was stationed near Indianapolis. Already an experienced hunting dog, he went with Mrs. Elliott to the local dog obedience classes and started earning titles, completing his Companion Dog (CD) and Companion Dog Excellent (CDX) in 1944 and his Utility Dog (UD) in 1947, becoming the first Golden to win that title. And of course, Rachel Page Elliott— "Pagey" to all in Goldens—eventually became one of the outstanding authorities on canine structure and movement. Her lectures with motion-picture studies took her all over the world, and her book *Dogsteps* (first published in 1973 and revised in 1983) is in its third edition. She also filmed and produced an excellent video study on the breed, as well as similar projects for other breeds.

After the war, growth in the Golden's popularity was slow and steady. This was still very much a dual-purpose breed, with dogs of the same bloodlines participating in all areas of activity. The midcentury mark was significant for Goldens, as an issue of the *Golden Retriever News* carried the banner headline: "A Golden Was National Field Trial Champion in 1950 & Again in 1951...Won the Most Sporting Groups in 1950 & Again in 1951...Was Top Obedience Dog in 1950 & Again in 1951."

The National Field Trial Champions were FC Beautywood's Tamarack in 1950, bred and owned by Dr. Leslie Evans, and Mahlon Wallace's FC Ready Always of Marianhill in 1951. The Sporting Group winner both years was Mrs. Russell Peterson's Ch.

Golden Knolls Shur Shot, a grandson of old Gilnockie Coquette. The top obedience dog was Ch. Duckerbird Atomic UD ("Tommy"), owned by Charles Frank. Tommy also was a grandson of Coquette and was the first of three generations of top-winning obedience Goldens for Mr. Frank.

Although still a "minority" breed in numbers of registrations, Goldens were more than holding their own in all aspects of competition. However, there was a trend toward tall, rather settery-looking dogs in show competition that worried many in the breed. Bad bites (incorrect dentition) and eyelid problems were also too often ignored. Much discussion ensued in the GRCA's club newsletter, and a revision of the old breed standard was undertaken. The expanded and more specific document was approved by the AKC, going into effect in 1955. For the first time, disqualification was instituted for dogs outside the given height limits, for dogs with undershot or overshot bites, and for abnormal position or direction of the eyelashes. Other aspects of conformation were also clarified. The revision was effective, with both judges and breeders now understanding the importance of eliminating these deviations.

In the United Kingdom as well, postwar recovery was bringing great things to the Golden world. "Granny" Harrison's Eng. Ch. Boltby Skylon and Lottie Pilkington's Eng. Ch. Alresford Advertiser headed some intense competition at the shows; as sires, these dogs also intensified type. In 1952, for the first time, a Golden won the British national championship—FTCh. Treunair Cala, bred and owned by Miss Jean Train (now Jean Lumsden).

The 1950s saw many new people coming into the breed and into organized dog activities. As the postwar economy improved and restrictions were eased, people had time and some extra money for such

pursuits. Into the 1960s, shows and other activities flourished. In the United States, highway improvements and the beginning of the interstate highway system, plus the burgeoning economy, improvements in veterinary care, and advances in readily available commercial dog foods, contributed to growth in purebred dogs both as a hobby and as a business.

In the East, names that are now considered historic in Goldens began. Mr. and Mrs. Josiah Semans's Golden Pine kennel started with a dog from the Midwest, Duke of Rochester. It was quite an upset when, at the prestigious Westminster Kennel Club show, this relatively unknown entry went from the classes to Best of Breed over a number of champions. (Now that's a sure way to get novices hooked on dog shows!) The Golden Pines kennel name is still active today, as Mrs. Semans passed it on to Nancy Kelly.

Reinhard Bischoff's first Golden, Greenfield Jollye, was called Lorelei, and that became his kennel name. Bred to DC (AKC Dual Champion) Stilrovin Rip's Pride, Lorelei produced Ch Lorelei's Golden Rip**. "Bisch" bought another bitch, named her Lorelei's Golden Tanya, and from a mating of

her and Lorelei's Golden Rip, came the extraordinary Rocky—Ch./AFC (Amateur Field Champion) Lorelei's Golden Rockbottom UD. Rocky is still one of only two Goldens to achieve that particular combination of titles, the other being his great-great-granddaughter Ch./AFC Riverview's Chickasaw Thistle UDT, owned by Jim and Sally Venerable.

The High Farms kennel of Ralph and Ruth Worrest and the Tigathoe kennel of Mrs. George Flinn (known as "Torch"), both in Connecticut, also started with dual-purpose Goldens and, in combination with Lorelei stock, built a strong foundation for eastern bloodlines. Rocky's son, Ch. Little Joe of Tigathoe***, was an influential sire. In Torch Flinn's opinion, Little Joe could well have been a dual champion had she taken the time to campaign him at trials.

Later, Torch devoted her life to field trials. She owned a number of field-trial champions, including the memorable FC/AFC Stilrovin Tuppee Tee, and she bred the memorable litter that included the last AKC dual-champion Golden, DC Tigathoe's Funky Farquar, and three other FC/AFC titlists. The dam of this litter, Tigathoe's Chickasaw***, was of High Farms breeding; the sire, FC/AFC/Can. FC Bonnie Brooks Elmer, was of old Midwestern field lines with a dash of Holway.

Goldens were also thriving in the Midwest and doing well in the West. Bill Worley's Sun Dance dogs from Indiana were amassing titles in both shows and obedience. Bill started with "Buck," Ch. Indian Knolls Roc Cloud UD, from Dr. Merle and Esther Long's Indian Knolls kennel ("Acres of Goldens" was their advertising slogan) in Illinois. Bred to Midwestern bitches, Buck produced a line of outstanding obedience-trial titlists, including Ch. Sun Dances's Rusticana UD, WC. Had the Obedience Trial Champion title been in effect at the time,

"Rusti," no doubt, would have earned it many times over. His owners, Al and Edi Munneke, were retired schoolteachers, and they traveled far and wide with Rusti. His record includes the amazing number of at least 135 Highest Scoring Dog in Trial awards and at least 36 perfect scores of 200. Both Al and Edi later became obedience judges, and Edi was president of the GRCA in the early 1970s.

California was a center for Golden activity early on, starting with the importation of Eng. Ch. Marine of Woolley in the 1930s for the Blue Leader kennels. Marine earned his American championship as well and, through his son Rockhaven Ben Bolt, contributed to Stilrovin and other Midwestern bloodlines.

Eric Johnson of Wildwood kennel was originally based in Wisconsin, but in 1945 he transferred to California and took with him Czar of Wildwood, a son of FC Stilrovin Super Speed out of a daughter of FC Rip. Handled by the professional Ben Brown, this "field-bred" Golden turned out to be a record-setter in show competition. Czar won six Best in Show awards and was well used as a sire before his untimely death before reaching four and a half years of age.

Eric Johnson had also imported from England a dog named Gilder of Elsiville. "Bonnie" (for "Bonnie Lad") had a less-than-stellar career in California, being as different in type from the tall, dark, sleek Czar as was imaginable. Eric sold the dog to his old friend Bart Foster in Minnesota. Bart had started in Goldens with a bitch he named Des Lacs Lassie, whom he used in his work as a wildlife conservation officer to catch wild ducklings for banding. Lassie finished her championship title easily and was the first Golden bitch to win an all-breed Best in Show (in fact, two of them) with twenty-two Group placements in her thirteen-month career as a champion.

Under Bart Foster's guidance, Bonnie completed his championship title and a number of Group placements, even a Best in Show. Bred to Lassie's three-quarter sister, Rock River Sue, he produced the outstanding dog Am./Can. Ch. Gilder's Wingra Beau, owned by N. Bruce Ashby. Ashby also owned Am./Can. Ch. Golden Knoll's King Alphonzo, a son of Ch. Golden Knolls Shur Shot CD. Beau, King, and Shot, as well as Lassie, were all shown by the professional Hollis Wilson of Amherst, Wisconsin. Wilson, one of those ex-military dog men, was renowned as a handler of Sporting breeds and, after his retirement from handling, as an outstanding judge.

The 1960s marked something of a turning point in Goldens. There was still the question of "type"—the dark, rather settery, silky-coated sort versus a lighter golden dog who was more compact in build and had more substance. Part of this trend came from the increasing number of imports from England, where lighter colored, more squarely made dogs were definitely in favor.

Increasing competition in the show ring and in field trials had begun a trend toward more specialized dogs for each area of endeavor. Field trials increasingly demanded time and finances beyond the reach of most, while conformation shows and obedience trials were more easily accomplished by the owner-exhibitor.

Back in the East, some major names had become notable in Goldens. Jane Englehard's Cragmount kennel housed some of the finest Golden Retriever show dogs, bred from a combination of Tigathoe, Golden Pine, and other Eastern lines. First Ch. Cragmount's Peter, and then the Englehards' import, Eng./Am. Ch. Figaro of Yeo, cut a swath at shows with important wins, including the national specialty in 1963, won by Figaro. The Goldendoor kennel of

Patricia Corey on Long Island fielded a winning team founded on similar lines and had its own import, Ch. Alresford Nord Desprez.

The son of Ch. Cragmount's Peter became a pivotal figure in show bloodlines. Ch. Sunset's Happy Duke (Ch. Cragmount's Peter x Glen Willow's Happy Talk, a bitch of Tigathoe breeding) produced two males whose lineage was as close to identical as possible without having the same mother—every line in the third generation of their pedigrees was identical. These two dogs were Ch. Misty Morn's Sunset CD, TD, WC ("Sammy"), whelped in 1967 and owned by Peter Lewesky, and Ch. Cummings' Gold-Rush Charlie, whelped in 1970 and owned by Larry and Ann Johnson. Charlie was the foundation for the Johnsons' Gold-Rush kennels in New Jersey, which is still active.

Both Sammy and Charlie were sired by Ch. Sunset's Happy Duke, and their dams were both sired by Am./Can. Ch. Cragmount's Double Eagle out of full sisters by Am./Can. Ch. Golden Pine's Easy Ace* x Ch. Rozzy-Duchess. Both Sammy and Charlie had exceptional show records, Sammy handled by Terry Correll (who, with his father, had also handled the Cragmount dogs) and Charlie by Bill Trainor, a dog man of high repute. Both Sammy and Charlie were prolific sires, widely used by breeders from all parts of the country. With their offspring and succeeding generations, what might well have been called a new era in Goldens at dog shows was beginning.

Indeed, the 1970s started a surge in Golden Retriever popularity that would require an entire book of its own, if one wished to pursue such an enormous topic. With a Golden named Liberty in the White House with President Gerald Ford, the general public was now aware of the handsome golden dogs and their great personalities. Goldens

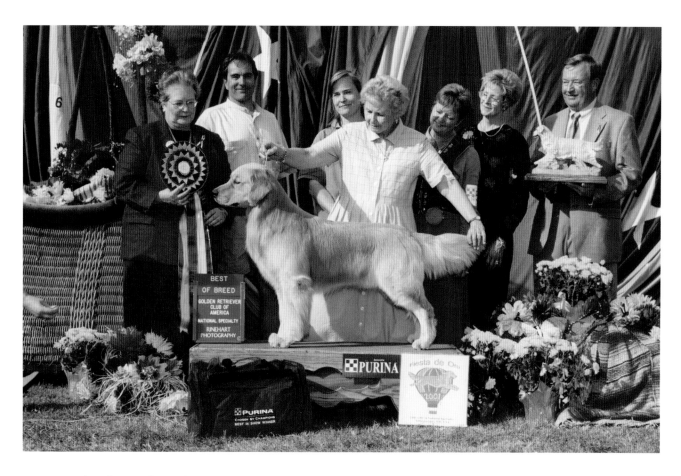

An example of a modern champion is two-time national specialty Best of Breed Ch. OTCH Highmark Mirasol Once A Knight, pictured winning in 2001.

became the "yuppie puppy," and the number of Goldens registered annually began to climb steadily, hitting a peak in the 1990s with nearly 70,000 individuals registered. The breed reached a high of number two on the list of annual AKC registrations, exceeded only by that perennial favorite, the Labrador Retriever.

Unfortunately, the usual problems of overpopularity accompanied the breed's increase in numbers. The GRCA has always been attentive to these problems, and has for many years had very active educational committees. It was the first parent club to institute the Public Awareness Letter, an

informational brochure that the GRCA paid to have included with every Golden Retriever's registration certificate sent out by the AKC. This program was so effective that it was soon adopted by a number of other breed clubs, and eventually in generic form by the AKC itself.

The GRCA has always been an active and diligent parent club; its Advisory Council on Hip Dysplasia, formed in 1961, was the prototype for the Orthopedic Foundation for Animals. Currently, with approximately 5,000 members, it is one of the two largest breed clubs in the country, and the GRCA's national specialty is a carnival of events spanning eight to ten days. For Golden folks, it's a combination of Old Home Week and a family reunion, with educational and social events as well as every sort of competitive event—always with the future of the Golden Retriever in mind.

Chapter Two

The Golden Retriever in Art

BY WILLIAM SECORD

W hile many breeds trace their history back through the centuries, the Golden Retriever as we know it today is a relatively recent breed, and very recent in its depiction in art. The retriever in general, and the Golden Retriever in particular, was developed in the late nineteenth century, but it does not appear in art with any regularity

Sir Edwin Landseer, English, 1802–1873; C. G. Lewis, engraver; *Breeze*, 1843; Engraving, 17½ x 23½ inches.

until the early twentieth century. Before the establishment of The Kennel Club in 1873 and the evolution of conformation dog shows, dogs were bred for function, and pointers and setters predominated in the pursuit of game birds in Great Britain and the United States. As Golden Retriever historian Valerie Foss has pointed out, the invention of the breechloading shotgun meant that game birds on the wing could be shot quickly and at a great distance from the sportsman. A need therefore arose for a more specialized sporting dog that could quickly and efficiently retrieve game birds, and hence the retrieving breeds as we know them today were developed.

Marcia Schlehr has expertly traced the evolution of the Golden Retriever elsewhere in this volume, but it suffices to say that the history of the Golden Retriever is more heterogeneous than not, as the dogs were bred by a variety of breeders/sportsmen who wanted dogs that could function well in the field. Among them was the prominent sportsman Sir Dudley Coutts Marjoribanks, later the first Lord Tweedmouth, who purchased the 20,000-acre Guisachan Estate in the Scottish Highlands in 1854. It was here that he developed some of the ancestors of our present-day breed. He bought his first Yellow Retriever, as they were then known, in 1865,

and over the years the breed was developed by interbreeding with, among others, the Tweed Water Spaniel and the Irish Setter. Goldens became popular in England around 1900, and they were known in America and Canada as early as the 1890s. The first Golden Retriever to be exhibited at a conformation dog show was in 1908, at the Crystal Palace Exhibition in England. The Golden Retriever Club in England was established in 1911, and the Golden Retriever Club of America in 1938.

Even by modern standards, dogs were very popular in nineteenth-century Great Britain, and a tradition of dog portraiture had existed since at least the eighteenth century, with such artists as

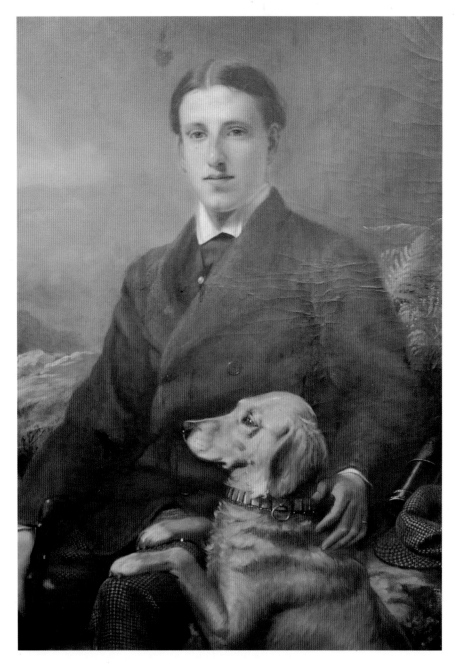

Hon. Henry Graves; *Fifth Earl of Ilchester*, **1873; Oil on canvas, 55 x 35 inches, Private collection, copyright The Ilchester Estates.**

Victoria in 1837, dog painting took on a new respectability.

Queen Victoria, who maintained homes in London, Windsor, the Isle of Wight, and Balmoral in the Scottish Highlands, was a great dog lover, having some seventy-five dogs in her kennels at Windsor at any one time. She also loved the outdoors and actively pursued a sporting life in Scotland with her beloved husband, Prince Albert. Her patronage of animal painters gave new respectability to the genre, and with the rise of the middle class and the establishment of great fortunes, the demand for dog portraits rose substantially. This demand increased further with the heightened interest in organized sporting activities, including field trials, and later the establishment of The Kennel Club and organized conformation shows. Newly minted merchants and industrialists spent huge amounts on their sporting activities and on the paintings that chronicled their hobbies.

One of the earliest depictions of what is certainly an ancestor of our present-day Golden Retriever is by Sir Edwin Landseer, the animal painter to Queen Victoria in the Scottish Highlands and a household name in Victorian England. *Breeze*, originally in the collection of W. Russell, Esq., was painted in 1842 and engraved by C. G. Lewis in 1843. It depicts

Francis Barlow, John Wootton, and, of course, the great George Stubbs, better known for his depictions of Thoroughbred horses. The dog as subject matter for the artist became more and more popular in the early decades of the nineteenth century, and with the ascendance to the throne of the dog-loving Queen

Maud Earl, 1864–1943; *May: Visiting the Coops, an Ilchester Retriever*, 1906; Photogravure, from *The Sportsman's Year*, 10 x 16 inches; Private collection.

a retriever-type dog with dead game, against a mountainous landscape. While only known from the black-and-white engraving, it is listed in Landseer's catalogue raisonné, done shortly after his death, as a retriever.

While not a dog painting per se, Henry Graves's portrait of the Fifth Earl of Ilchester, done in 1873, is an important historical record, for it includes a depiction of the Golden Retriever Ada, from a repeat mating between the first Yellow Retriever, Nous, and Belle. The painting is in a private collection in England, and was only photographed in 2009 when it was part of an exhibition at The Kennel Club Art Gallery in London. Ada was given to the Earl by his uncle, Lord Tweedmouth, and established a line of Goldens at

his Ilchester estate in southern England. Indeed, it is one of these dogs that is much later depicted in Maud Earl's *Visiting the Coops*, circa 1906. While the dog is not named, it is identified as an Ilchester retriever, and is one of twelve paintings that were reproduced as prints in Ms. Earl's portfolio entitled *The Sportsman's Year*, in which she illustrates sporting activities, one for each month of the year.

Maud Earl (1863–1943) was by 1906 well-known for her paintings of purebred dogs, having been commissioned by prominent dog fanciers and sportsmen to paint portraits of their dogs. The daughter of the Victorian artist George Earl (1824–1908), she is more closely associated with purebred dogs more than any other artist born in the nineteenth century. She exhibited in England and Europe and was a successful artist who painted many of the important dogs of her day. In 1915, she moved to New York, where she continued her career, eventually expanding her subject matter to

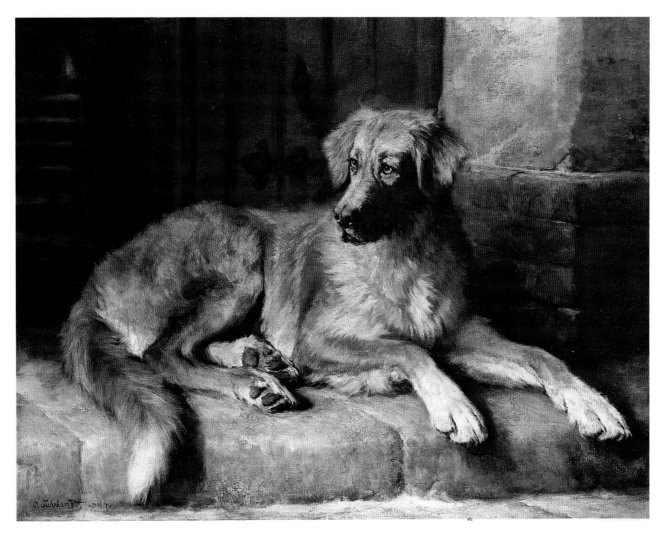

Carl J. Surhlandt, German, 1828–1919; *Waiting for Master*, 1884; Oil on canvas, 47½ x 44½ inches; Private collection.

include highly decorative paintings of exotic birds.

Other late nineteenth-century artists who depicted early Golden Retrievers were Carl J. Surhlandt (1828–1919), the German artist who traveled extensively in England, and the well-known John Emms (1843–1912). Painted in 1884, the Surhlandt depicts a young Golden Retriever on a doorstep; although unidentified, one can speculate that the dog was one of the many dogs and horses that he painted for the aristocracy while in England. Well-known in his native Germany, he also lived in Paris and St. Petersburg, where he was a member of the Academy.

Emms, by contrast, was a native of England. He exhibited at the Royal Academy in London and was well-known for his paintings of both horses and dogs. His head studies of Golden Retrievers, while unnamed, are dated 1898, some ten years before the breed was first exhibited at the Crystal Palace dog show. Emms was a very prolific artist, and these head studies are depicted in his later style of painting, in which he used a quick, expressive brushstroke to depict his subjects. The signature and date are quickly inscribed into the paint with the end of his brush.

Wright Barker (1884–1941) was another well-known painter to depict an ancestor of our present-day Golden Retriever, having completed at least three portrait commissions for St. Hubert's kennels. A serious breeder and exhibitor at Kennel Club shows, Colonel le Poer Trench subscribed to the theory, now debunked, that his Golden Retrievers originated in Russia and were brought into England as circus dogs. As Marcia Schlehr has pointed out, he called them the "Marjoribanks and Ilchester breed of Yellow Russian Retrievers."

While early Golden Retrievers were shown around the turn of the nineteenth century, they were first recognized by The Kennel Club as a separate breed in 1911. A number of English artists, among them Frances Mabel Hollams (1877–1963), Henry Crowther (fl. 1905), Lucy Dawson (circa 1877–1958), and R. Ward Binks (1880–1950), depicted these early show dogs.

Hollams had a unique and individual style, one that was designed to feature the animal itself, rather than an interior or a background landscape. Instead of applying gesso to a board or canvas and then building up layers of paint to create a final image, Hollams painted animal portraits directly onto a wooden panel, with the wood grain of the panel allowed to show through. *Bill*, a painting of a recumbent Golden Retriever, is typical of this style, for there is nothing to distract from the image of the dog himself. He is in a classic pose used by artists over the centuries—front legs casually crossed as he looks directly at us.

Henry Crowther specialized in the depiction of show dogs, and he has left a significant visual record of early English champions, typically posed in profile to show how they conform to the standard for their breed. His portrait of Haulstone Dipper, from the

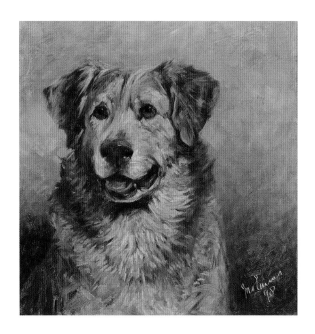

John Emms; *Golden Retriever Head Study*, 1898; Oil on canvas, 14 x 14 inches; Private collection.

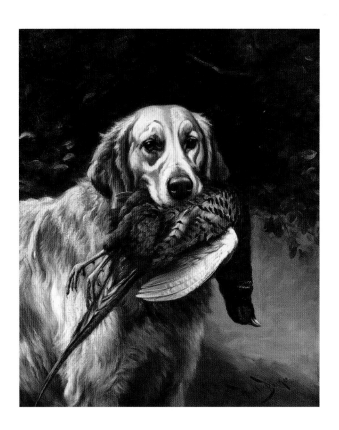

Wright Barker; *St. Hubert's Czar*; Oil on canvas, 26 x 20 inches; Private collection.

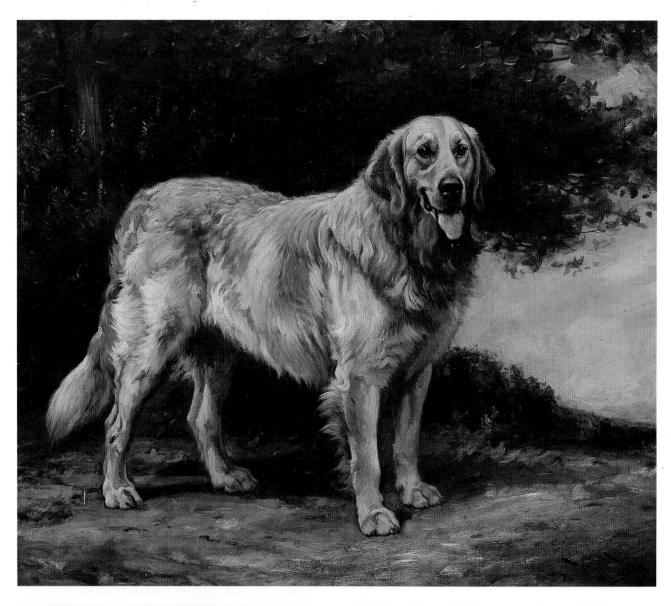

ABOVE: Wright Barker; *St. Hubert's Prince*, 1914; Oil on canvas, 42 x 51 inches; Private collection. **LEFT: Frances Mabel Hollams;** *Bill*; Oil on board, 13½ x 18 inches; Private collection.

well-known Haulstone kennels of Mr. and Mrs. E. Eccles, is typical of his work. Crowther usually posed the dog in a landscape, facing left or right, often with the name of the dog inscribed on the canvas. Like many animal artists, he traveled the country to famous kennels, painting the dogs and animals of his clients as he went.

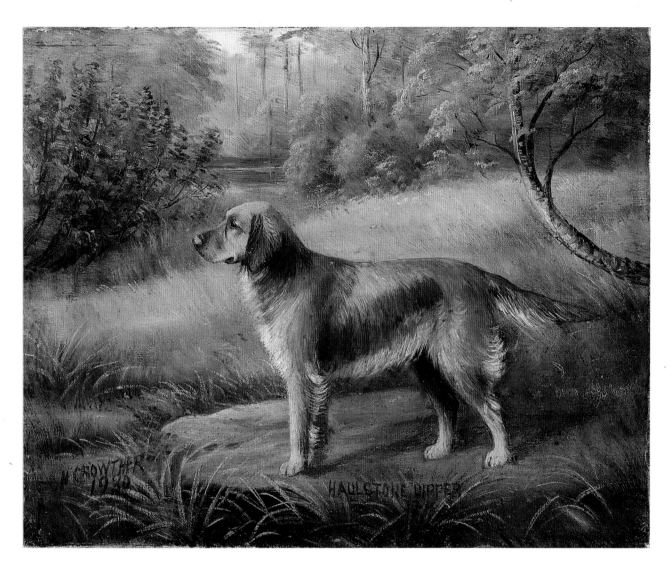

Henry Crowther; *Haulstone Dipper*, **1930; Oil on canvas, 12 x 15 inches; Private collection.**

Lucy Dawson, well-known for her illustrated books such as *Dogs, Rough and Smooth* and *Dogs, as I See Them*, was a painter as well as a brilliant draftsperson whose pastels and watercolors are expressive depictions of the breed. While her pastel is of an unknown Golden Retriever simply named "Julie," she also did an important watercolor of Ch. Noranby Campfire, dated 1919, the first English Golden Retriever champion. He was bred and owned by the aforementioned Mrs. Charlesworth, an important breeder who brought attention to the breed with active showing, breeding eight champions at a very early time in the history of Golden Retriever show dogs.

R. Ward Binks (1880–1950) was another artist who specialized in the depiction of dogs and other animals, and he painted several important Golden Retrievers during his lifetime. With the initial support of Lorna, Countess of Howe, Binks quickly established himself in the dog world, and he traveled extensively to visit his patrons. He painted for the Maharaja of Patalia, India, later going to America, where he worked for a number of clients, including Geraldine R. Dodge, for whom he painted over 200 dog portraits. His watercolor of Ch. Diver of Wool-

ley, dated 1918, is typical of his style, in which great attention is given to the depiction of the dog, but the background is only loosely sketched in.

Artists in both England and America continued to depict the Golden Retriever later in the twentieth century and to the present day. In England, artists as Bridget Olerenshaw painted important dogs of the day such as Ch. Camrose Fantango, one of the most influential stud dogs in the history of the breed in England, bred and owned by Joan Tudor. In the United States, artists such as Marguerite Kirmse (1864–1954), Franklin Voss (1880–1953), and Edwin Megargee (1883–1958) continued the tradition in the twentieth century. And while realistic art ebbed in popularity during the second half of the century, some contemporary artists depicted the dog in new and inventive ways. As the breed has become more popular over the years, other artists such as Robert Abbett, Pamela Hall, and Christine Merrill have expanded earlier precedents set by artists such as George Stubbs and Edwin Landseer, painting memorable portraits that chronicle modern-day dogs.

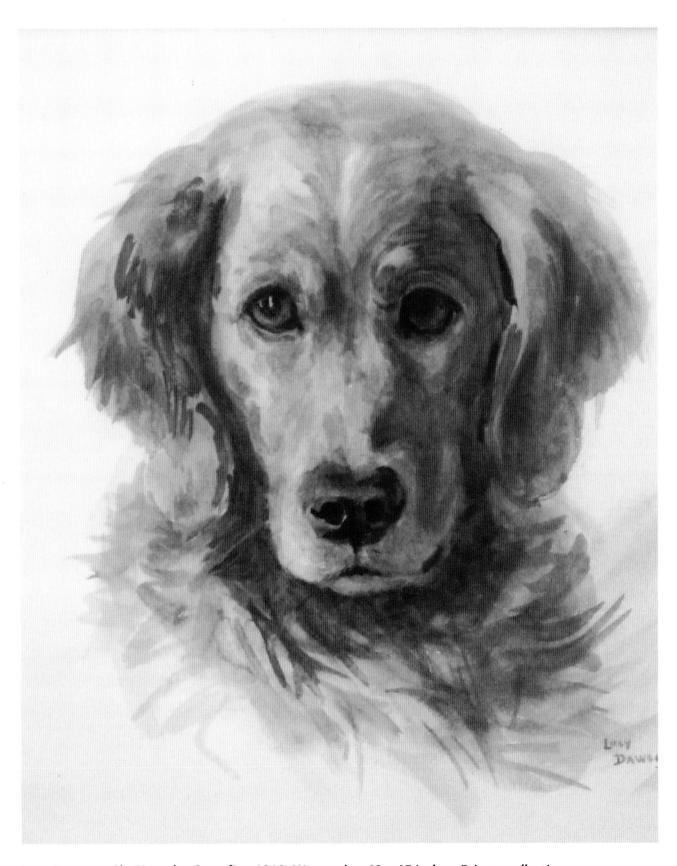

Lucy Dawson; *Ch. Noranby Campfire*, **1919; Watercolor, 18 x 15 inches; Private collection.**

ABOVE: Christine Merrill, contemporary American; *Golden Retriever Mother and Puppy*, 2005; Oil on canvas, 22 x 28 inches; Private collection
RIGHT: R. Ward Binks, English, 1880–1950; *Ch. Diver of Woolley*; Gouache, 10 x 13½ inches; Collection The Kennel Club, London.

CH. CAMROSE FANTANGO

Bridget Olerenshaw; *Ch. Camrose Fantango*, 1966; Gouache, 18 x 18 inches; Collection Joan Tudor.

Chapter Three

About the Golden Retriever Club of America

BY DEBBIE BERRY, GRCA DIRECTOR

he Golden Retriever received official AKC recognition in 1925, and has steadily grown in popularity since then. Thirteen years later, on May 6, 1938, the Golden Retriever Club of America (GRCA) was incorporated in the state of Colorado by James A. Woods, Frank Purvis, and John R. Magoffin.

From the beginning, the club was registered as a not-for-profit corporation. It is important to mention that the club's first president, Colonel Samuel S. Magoffin, John R. Magoffin's brother, is given credit as being the driving force in the GRCA's first several years.

As it was established and so it is today, the club's mission is to recognize that the Golden Retriever is a

Best of Breed at the GRCA national specialty in 1984 was the multiple Best in Show winner Ch. Pepperhill East Point Airily, owned by artist Dan Flavin and Helene Geary and bred by Barbara and Jeffrey Pepper.

gundog; to encourage its members to produce, by selective breeding, Golden Retrievers that possess the

appearance, soundness, temperament, natural ability, and personality that are reflected in the standard of the breed; and to do all that is possible to advance and promote the perfection of these qualities.

Today, in addition to a membership of well over 5,000 Golden fanciers, the GRCA has over fifty-five local member clubs throughout the United States. These clubs publish newsletters, hold regular meetings, and conduct educational programs on topics such as health, grooming, and training. Some clubs offer training classes and special seminars, as well as annual competitive events in conformation, obedience, field, and agility.

The GRCA is divided into three regions: Eastern, Central, and Western. The day-to-day business of the club is conducted by a board of directors consisting of a president, a secretary, a treasurer,

A Golden of good type, retrieving in the field. The aim of a breed club is to protect its breed's intended abilities and distinct characteristics.

and one vice-president and two directors from each region. Each region hosts an annual GRCA regional specialty, consisting of competitive events in all areas of retriever endeavor, and is encouraged to hold an educational program, as well.

In order to promote the ideal Golden Retriever, the GRCA sponsors a number of competitive events. The premier GRCA event of the year is the aforementioned national specialty. Along with regional specialties, it offers competition for Golden Retrievers in conformation, field, obedience, tracking, and agility. An educational program, the annual membership meeting, and the annual awards presentation are major features of the week-long national-specialty celebration. Special clinics, exhibitions, and social events are usually included as well. This big event, which is held in September or October, rotates among the three regions. It is a thrilling week during which Golden fanciers from all over North America, and often from other countries, gather to celebrate the Golden Retriever.

A primary objective of the GRCA is education. This is accomplished through a coordinated effort of several committees within the club, including judges' education, public education, field education, and member education. Seminars and published articles are the most common tools used in this ongoing mission.

Like many dog clubs, the Golden Retriever Club of America makes annual contributions to organizations whose work benefits the health and welfare of Goldens and all dogs. These organizations include the Morris Animal Foundation, the AKC Canine Health Foundation (research), and the American Dog Owners Association (promotion of health and safety for all dogs).

In 1997, the GRCA established the Golden Retriever Foundation. This is a tax-exempt foundation

Ch. Dalane's Savannah Smiles, owned by Gabrielle Moore and Jane Jensen, going Winners Bitch under the author at the 2001 GRCA national specialty.

whose mission includes, but is not limited to, the following:

- To foster and promote the public's knowledge and appreciation of dogs in general and Golden Retrievers in particular
- To further understanding of the diseases, genetic defects, injuries, and other ailments that afflict dogs in general and the Golden Retriever breed in particular
- To promote and assist the development, publication, and dissemination of educational materials about the proper care, treatment, breeding, health, development, and training of Golden Retrievers
- To foster and promote the rescue, rehabilitation, and placement of displaced Golden Retrievers

The Golden Retriever Club of America can be found at www.grca.org, where you will find information about the breed, information about the club, a list of club contacts, and more.

Chapter Four

The International Golden Scene

The Golden Retriever is not popular only in the United States and the United Kingdom. It is also one of the most popular breeds in Europe, Asia, South America, Australia, and New Zealand. Kennel clubs around the world count the Golden as one of the top breeds in registrations.

Am. Ch. Mariner Jewell of Casco Bay, owned and bred by John and Kathy Chase and Pati Fine, taking BISS at a Canadian specialty.

It is truly a universally popular breed. Goldens are most often seen as companion dogs, but their numerical impact in the show ring is noticeable. The Golden entries are frequently among the largest at championship shows around the world.

I have had the pleasure of judging the breed in a number of countries around the world and have seen a diverse group of Goldens in the different venues. It is always interesting to see how people in other countries have interpreted their version of the breed standard and how the breed's make and shape differs from country to country. Judging the breed provides an added dimension when compared with being a ringside spectator, because, as a judge, I get

to physically examine the dogs rather than having to rely solely on a visual assessment. Having judged the breed in Australia, Canada, China, Colombia, Hong Kong, Indonesia, Korea, Japan, and New Zealand, as well as more than 130 times in the United States, and having watched the breed being judged in the United Kingdom, Italy, Sweden, and Switzerland, I've had widely varied exposure to Goldens around the world. I have experienced a viewpoint much wider in scope than that available to most breeders.

Not surprisingly, the English style of Golden Retriever is what is predominantly seen throughout Europe and in Australia and New Zealand. The natural influence of the British Isles on the breed in these parts of the world is to be expected. Golden entries in Great Britain can exceed 600 dogs at all-breed shows, usually requiring two judges—one for dogs and one for bitches—to evaluate the breed. These large entries give visitors and exhibitors plenty of time to engage in discussions about the breed and the relative merit of individual dogs.

Presentation in Europe and Great Britain seems similar, with the same basic grooming techniques used at these shows. Because The Kennel Club is very stringent about the addition of any products to enhance or change the appearance of the coat, there is much less emphasis on grooming techniques in Great Britain, and certainly there should be nothing used to sculpt the coat before showing the dog. Unlike with Goldens in the United States, it is customary in the United Kingdom and Europe to remove a good deal of the natural ruff that grows on the dog's neck, giving a cleaner appearance to the neck and throat area and more emphasis to the forechest while making it more difficult to use the coat to cover up certain physical faults, such as throatiness. The American standard, of course, calls for an "untrimmed, natural ruff."

What did surprise me in judging Goldens overseas was the great influence of the American-style Golden in other parts of the world. I have made a number of trips to Asia, both to judge and to give educational programs in China, Hong Kong, Indonesia, Japan, and Korea. I also had a chance to see and judge Goldens bred in other Asian countries, such as Thailand. Because some of these countries were, at some point, English colonies or greatly influenced by the British, I mistakenly anticipated seeing a majority of the Goldens to be of English style. Contrary to my expectations, in many of these countries, the English-style Golden was the unusual one. The vast majority of the dogs were descended from American stock, as a number of dedicated breeders have carried on breeding programs based on the original imported stock.

Importing

In every Asian country where I have judged from about the mid-1990s, I hear the same complaint from breeders—something like: "It is very difficult to find quality stock from respected breeders. Many are unwilling to sell overseas to people they have not personally met. It is often difficult for us to be able to go to America and we have no way of knowing and meeting top breeders, or even knowing who the top breeders really are."

As some of you may know, I became involved with Petits Bassets Griffons Vendéens in 1984, seven years before the breed was recognized by AKC. As I learned more about the breed from reading standards, looking at winners overseas, and talking to breeders in Europe, I realized that my first importations of PBGVs were not of the great type I had expected when I purchased them. In attempting to purchase better-quality dogs, I found that

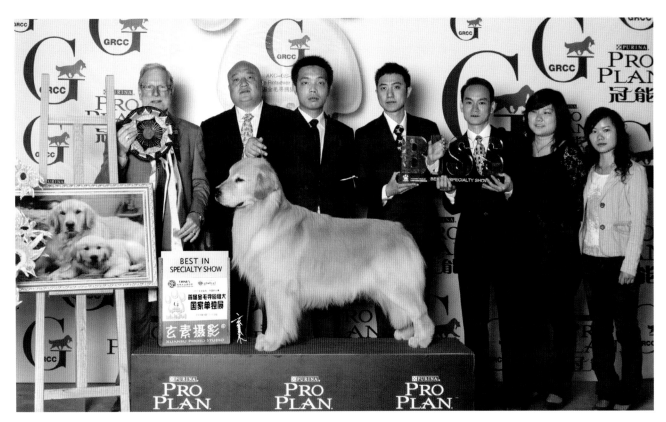

BISS at the 2009 Chinese specialty was the dog Freedom of Golden Spirit, bred by Marcos Nishikawa and owned by Yin Xiangdong.

people who I had not met were unwilling to sell me dogs of the excellence I sought. I was a "foreigner," and they did not know who I was nor did they know anything about my background in dogs in general or with the breed specifically. I had to be willing to "pay my dues" by gaining experience with the breed and meeting people before I could purchase what I wanted. It took a good deal of time and a trip to Europe before I found truly top-quality dogs owned by people willing to sell to me.

Not everyone interested in breeding has the time and finances necessary to do that kind of traveling. Even more difficult is finding a knowledgeable, top-quality breeder who pays appropriate attention to the requirements of the breed standard as well as to health issues and temperament. These top-tier

breeders do not tend to advertise, as they have more people interested in purchasing dogs from them than they have available stock, making them even more difficult to purchase dogs from. Further, most who are interested in spending the time and money necessary to purchase a dog overseas would prefer to purchase an adult dog rather than a puppy. This way, they can be more certain as to the quality of the dog or bitch as well as the long-term health status of the animal. As everyone who has been involved in breeding quality animals knows, even the most promising youngster can turn out to be a big disappointment as an adult or can develop a health issue that precludes an ethical breeder from using him in a breeding plan.

Finally, as too many have learned to their misfortune, there are breeders and exhibitors out there who are quite willing to take advantage of the newcomer, especially one from overseas who will have difficulty finding recourse if the dog delivered

is not as advertised or agreed upon. I have seen these kinds of situations in which an unsuspecting breeder in Asia purchases what has been advertised as a big-winning dog with complete medical clearances, only to discover that the winning record has been seriously inflated and that the dog is affected by a medical issue such as hip dysplasia or an eye problem, or has a questionable heart status. It costs a great deal to ship a dog from the United States to Asia, not to mention the purchase price, so the Asian breeder has already made a very sizeable investment. I personally know of one situation in which a breeder paid nearly six figures for a dog who turned out to have a health issue serious enough that the purchaser, being a principled breeder, would not use the dog at stud. The seller refused to take the dog back or even to refund any money, leaving an ethical breeder in Asia with a dog who he could not breed. In this instance, the overseas breeder was considerably more ethical than the American breeder.

If purebred dogs as we know them are to survive into the future, newcomers to breeding and to the dog sport must be welcomed and educated. Experienced breeders know just how difficult it is to consistently produce good-quality dogs. This can, realistically, only be accomplished with quality breeding stock. If a newer breeder starts out with inferior dogs, it should come as no surprise that the puppies produced by his breeding stock will be less than ideal as well. Well-known breeders have an obligation and a responsibility to the Golden Retriever breed to provide only quality breeding stock to those who have evidenced a sincere interest in breeding and who are willing to pay a reasonable asking price. Only in this manner will there be quality Golden Retrievers available to future generations around the world.

Asia

Showing dogs is a relatively new activity in much of Asia in comparison with the United Kingdom, continental Europe, and North America. The influence of the Western world on the populations of many Asian counties can be seen in various ways; for example, in the way people dress and in the interest they have in aspects of Western culture. As these Asian countries' economies have prospered, a middle class has gained the financial means to afford new leisure activities. The ownership of pets is on the rise in numerous Asian countries, with many people choosing to own dogs as pets. Purebred dogs are now commonly seen in many more affluent neighborhoods in Asian cities. This, in turn, has led to the formation of pet-owner groups and kennel clubs.

In some Asian countries, there are well-established national kennel clubs that serve much the same function as the AKC does in the United States and The Kennel Club does in Great Britain. Japan, South Korea, Hong Kong, Indonesia, India, Thailand, Taiwan, and the Philippines, for example, all have thriving kennel clubs registering dogs and administrating championship dog shows. There is also now great interest in dog shows in China, with newly formed clubs holding shows in many parts of that country.

Breeders in some of these countries have watched and learned from mentors in other countries with long-established kennel clubs. In some breeds, Asian countries have breeders who have progressed to the world-class level. For example, top-winning Toy Poodles in many countries, including the United States, are bred in Japan. Golden breeders in Asia have not yet reached this level, but many are working toward improving their breeding lines and are producing dogs of very good quality

that could win in difficult American competition. It won't be too long before big-winning Goldens are being produced in Asia.

Because of the limited Golden gene pool presently available in Asia and especially in China, it is important for Asian fanciers to attempt to import quality breeding stock from various lines to expand the potential for the outcross breedings that are necessary to maintain the health and vigor of the breed. This is true in each of the Asian countries I have visited. Unfortunately, not enough American breeders have been willing to sell dogs to Asian fanciers, despite sincere efforts from a number of breeders in Asia. Many of the dogs previously imported were already linebred and on similar lines. As a result, newer generations of Goldens are becoming more and more closely related, thus increasing the potential for the development of serious health-related issues.

The same is true of structural concerns and correct overall Golden type. While there are many quality Goldens in Asia, because there are few American kennels represented in the early twenty-first century, one style of Golden predominates. Unfortunately, this type has become exaggerated, and many Goldens are losing the correct head and expression. Too many have wedge-shaped heads that lack the proper stop, lack the proper breadth of topskull, and have small, slanted eyes and large, low-set ears. Some of these heads are reminiscent of Collie heads rather than what belongs on a Golden.

Bad fronts—those lacking proper layback of shoulder and length of upper arm—are as common in Asia as in other parts of the world. A good number of Goldens tend to be a bit short on leg as well, also a problem that is being seen in American-style Goldens everywhere. The Golden's typical short-coupled body proportions can also be wanting in Asia, just as everywhere else.

Many Golden breeders in Asian counties seem to be very interested in learning more about the breed. Seminars run by American breeder-judges who have been invited to judge in these countries are always well attended. Presenters report that audiences show an eagerness to learn that speaks well for the future of the breed in Asia. However, for the breed to progress and improve, top American breeders have a responsibility to provide quality dogs to serious breeders—after they have checked out the integrity of those breeders.

Indonesia

Serious breeders in Indonesia have spent a good deal of time, effort, and money to import a number of Goldens from the United States, despite the great distance involved. Breeders I've spoken to in Indonesia have researched reputable breeders and have done some genuine study on American bloodlines. They are constantly evaluating their own breeding stock and have a sincere interest in trying to expand the Golden gene pool in Indonesia using imports from top American breeders.

There is a Golden Retriever club in Indonesia that holds specialty shows as well as educational opportunities for members regularly. The Golden Retriever is one of the major breeds at Indonesian shows, and there is great interest in learning more about the breed. A number of well-known American Golden breeder-judges have been invited to judge in Indonesia and several, including myself, have presented educational programs to an enthusiastic reception from Indonesian breeders. Quite a few Indonesian breeders have also come to the United States to attend national specialties.

I have judged there twice, in Jakarta in 2005 and in Bandung in 2007, and had the opportunity to meet a number of Indonesian breeders when

I gave seminars on the breed during both visits. This was a group of people seriously interested in gaining more knowledge about their breed. Their dogs were well socialized and, with a few exceptions, were presented well and in good condition. All of the dogs seemed to have sound temperaments and were happy to be at a show with their owners and handlers, indicating good care at home. Presentation was generally good and there was much less tendency toward excessive grooming practices than in the United States. The entry in Jakarta was nearly 100 dogs; there were about 65 dogs entered in Bandung.

While there was not the depth of quality we are accustomed to seeing at larger Golden specialties in the United States, the overall quality of the entry was acceptable and there were a number of good dogs presented to me at both shows. The problems I saw in the breed in Indonesia were similar to the problems facing the Golden Retriever elsewhere. There were quite a few atypical heads and expressions. Heads often lacked adequate stop and proper chiseling under the eyes, and some heads had snipey muzzles and narrow skulls. As in the United States, eyes too frequently tended to be smaller than desired and often did not have the preferred slightly almond shape. Skulls frequently lacked the "slightly arched" appearance called for in the breed standard, with dogs having more apple-shaped skulls or—even less desirable—heads that had their highest point on the midline of the skull and then sloped strongly to the sides. The bodies were often typical of what I see in Goldens everywhere and, as is true in all places, I would have liked to have seen better forequarter construction in many of the dogs. These issues are fairly common wherever I have judged Goldens and, indeed, are fairly common issues in many breeds.

Hong Kong

I had the pleasure of judging in Hong Kong in the summer of 2007 at a show in which a significant part of the entry was Golden Retrievers. Despite Hong Kong's past history as an English colony, the vast majority of Goldens I saw in the ring were of American style. Some, in fact, were either direct American imports or the produce of dogs bred in the United States. Others were bred locally or imported from another Asian country and, again, had pedigrees showing their bloodlines back to American stock. I was a bit surprised at this; as previously mentioned, I had anticipated more influence from English stock.

The dogs were very varied in quality. While the number of dogs shown is not as large as in other countries—remember, Hong Kong is not that large of an area—and despite the challenges of owning a larger dog in a largely vertical urban environment, there is considerable interest in the Golden both as a pet and as a show dog. There are a number of serious Golden breeders who reside in Hong Kong.

Keeping dogs, other than Toy breeds, in Hong Kong can be a challenge, as space is at a premium and housing tends to be expensive. Many of the apartments are in buildings with as many as eighty stories, which can make taking dogs out for exercise a real chore. Yet nearly every dog I judged at the show, no matter what the breed, seemed happy and well socialized. Quite a few were in good physical condition as well, so they were getting plenty of exercise and time outdoors.

The Hong Kong Kennel Club (HKKC) runs shows on a regular basis. The club is a Fédération Cynologique Internationale (FCI) member and has had recognition from the AKC and The Kennel Club for a number of years. Hong Kong is still considered as a separate entity in relation to the rest of

China, and it will be interesting to see what kind of relationship develops between the HKKC and the developing dog-show scene on China's mainland.

Japan

Dog shows in Japan, run under the rules of the Japan Kennel Club (JKC), follow the FCI format at some shows and the JKC's own format with some unique additions at others. The JKC has been recognized by the AKC for many years.

The shows in Japan are mature and well established, with top-quality dogs of many breeds competing for the awards. One big difference is that rather than having intersex competition on the breed level, with one dog or bitch chosen as Best of Breed, there is a "King" and Queen" chosen in each breed that go on to separate Group level competition. Group winners compete for Best King and Best Queen in Show, and then one is chosen as Best in Show.

Breeders in Japan have come a long way in the relatively few years in which there has been serious involvement with breeding and showing dogs there. In numerous breeds, there are dogs to be found of the best quality, a large number of which are bred in Japan. In many breeds, bloodlines trace back to American imports as well as to dogs imported from Australia, Europe, and the United Kingdom. Local Japanese breeders have used these lines and progressed well with them.

A large and dedicated group of Golden fanciers exists in Japan, with a national Golden Retriever club as well as some local clubs around the country. A strong relationship has developed between the Golden Retriever Club of Japan and the GRCA, with the GRCA providing educational materials to the Japanese club. There are specialty shows for the breed, and Golden entries at all-breed shows are often quite large.

At the 2009 Japanese specialty, BISS and BOB King was (TOP) Ch. Cergiomendes JP's Sky Liberty; BOS and BOB Queen was (BOTTOM) Ch. Gold 'N' Points Fifty Ways.

Bloodlines in Japan are primarily based on those of a number of well-known American kennels. Breeders are aware of the pitfalls that can arise from health issues, and there are many dedicated Japanese breeders who screen their breeding stock for known health-related issues. The influence of these Japanese breeders can be found in other Asian countries, as Japanese-bred Goldens have been exported to fanciers throughout Asia. Japanese-bred Goldens have been successfully shown to their championships in America.

Korea

There are two active national kennel clubs in Korea. The Korean Kennel Club (KKC) has held successful shows for a number of years; recently, however, the Korean Kennel Federation (KKF) has received the recognition of both the FCI and the AKC and thus may become the dominant canine organization in Korea as time goes on. The KKF holds several international shows annually and has shows on many weekends throughout the year. Both specialty shows and all-breed shows in Korea are held on a regular basis.

I have judged on two occasions in Korea, most recently for the KKF in 2008. As in the other Asian countries mentioned, the Golden Retriever is a popular breed both in the show ring and as companion dogs. For example, Goldens had the largest breed entry at the all-breed international show I judged in 2008. The majority of the Goldens entered were bred in Korea, and a few were bred in Japan, but most were closely related to stock originally imported from the United States. Several well-known American kennel names can be found in the pedigrees of the dogs shown in Korea. In addition, in Korea and in many of the other countries mentioned, most of the dogs' registered names are in English, and almost all of their call names are English. There is also an active Golden Retriever club in Korea.

As expected of a newer dog fancy, the quality of the dogs seen at the show was mixed. A number of good dogs competed, some that could be competitive in the United States. There were no very light-colored or very dark-colored Goldens. However, there were more dogs short on leg than I would have liked to have seen; this is a problem that is becoming more common with American-style Goldens everywhere. All of the dogs were well socialized, with good Golden temperaments, and in good physical condition. As in the United States, there was an unfortunate tendency to overgroom most of the dogs, with much too much "fluffing and puffing" going on and considerable product added to many of the dogs' coats. This made assessing the coat quality difficult in many cases. This undesirable trend is a direct result of the influence of American exhibitors and handlers.

China

Dog shows are quite new in China, but there is an emerging dog fancy. The first club to offer registration services, through a service provided by the American Kennel Club, was the National General Kennel Club (NGKC). The efforts of this club began in 2008. The local dog clubs—and there are many—tend to be located in the bigger cities and are spread around the country. There are no uniform rules for dog shows other than those of the NGKC (which essentially mirror AKC rules), so the clubs are free to make up their own rules—and they do. The clubs I am familiar with in China use only foreign judges (there is no universally accepted system for approving judges in China yet), and shows tend to follow the format used at AKC shows; that is, they

BOS at the Chinese specialty was Perchata of the Donald Duck Kennel, bred by Chiing-Feng Liu and owned by Wang Kai.

have seven groups and follow the general outline of classes used by the AKC—a Puppy Class, an Open Class, and often a class for dogs that already hold championships in another country. There is also an FCI-recognized club in China whose shows are held following the FCI format.

I hope that the clubs throughout China will enter into agreements with the NGKC and utilize its services, as this cooperation is necessary for the sport to flourish in China. Such cooperation will be the beginning of a set of common rules for dog shows and the recognition of the pedigrees of purebred dogs in China. Given the size of the country, this could have, in time, significant impact on the sport of dogs worldwide.

As there are not yet uniform rules from show to show and there is only a relatively new central registry, many show organizers rely on the integrity of those entering their dogs to disclose the sire and dam of each dog. Puppies use the pedigrees provided by breeders as proof that they are purebred. Of course, a dog declared a "champion" by one club might not have that championship accepted by the other clubs.

An array of beautiful trophies and ribbons were presented to winners at the Golden Retriever national specialty in Beijing, China, in April 2009.

In China, as in the other Asian countries, the Golden Retriever is one of the most popular breeds. There is already a group of serious Golden breeders who strive to produce healthy, quality dogs. Most foundation stock comes from other Asian countries, with a few dogs from breeders in the United States. As the sport of showing dogs matures in China, I would expect these new Chinese breeders to be at the forefront of the fancy. The American breed standard is used at most Chinese shows.

At one show I judged in Chengdu in 2006, the Goldens generally seemed to be happy and well cared for. They were in good physical condition and most possessed typical, friendly Golden temperaments. The quality of the dogs was very varied, ranging from pet-quality dogs that would not have been shown by more knowledgeable fanciers to an extremely good dog who was bred and owned in Korea and was a direct descendant of a top-quality American kennel. That dog won both the Breed and the Group from me and, had I not been forced to leave early to catch a plane, I would probably have awarded him Best in Show. This dog could have done some serious winning in America as well.

The Golden Retriever Club of China was organized in 2008, and I had the honor of judging the first Golden Retriever national specialty, held in Beijing in April 2009. I found the dogs to be of very good quality and very well cared for. They had been raised with an emphasis on socialization and good health. The overall quality was certainly improved from 2006. The dogs, most of them imported, were of a quality that could win in the United States or elsewhere with little difficulty. The bitches were not quite up to the standard of quality seen in the dog classes. However, dedicated breeders are working to import top-quality bitches as well. Goldens bred in China were shown in a separate show because many were not yet registered with the NGKC. There were many very good-quality dogs and bitches in these classes, which bodes well for the future of the breed in China.

New Zealand

Having judged the Southern Golden Retriever Club's championship show in May 2009, I have had the opportunity to see some of the South Island's better Goldens. As expected, these dogs were of English type and a good number were cream in color. The Golden Retriever is one of the more popular breeds in New Zealand and has a strong and dedicated group of breeders working to maintain and improve the breed. As seen in Europe and Great Britain, a good number of dogs were a bit longer in body length in relation to height at the withers when compared to American Goldens. There were many dogs with very handsome heads and expressions, and a good number had proper, balanced bodies, resulting in good movement.

Very few dogs could be called short on leg (the legs from elbow to ground should be the same length as the distance from withers to elbow) but had good depth of chest and balanced angulation front and rear. As a result, there were fewer dogs showing a rolling motion of the back when gaiting, especially as compared with many American-style Goldens in

The author with his picks for (LEFT) Reserve Best in Show (who was also Best of Opposite Sex) and (RIGHT) Best in Show at the Southern Golden Retriever Club's show in Christchurch, New Zealand, in May 2009.

the United States and Asia. I was quite pleased to see this, as short legs and rolling backlines are becoming all too common in the American show ring.

The New Zealand breed standard is generally quite similar to the standard in Great Britain. There are two active Golden clubs in New Zealand: the Northern Golden Retriever Club on the North Island, and the Southern Golden Retriever Club on the South Island. The Golden Retriever breed is in good hands in New Zealand.

United Kingdom

It is not within the scope of this book to do any kind of comprehensive review of the Golden Retriever in its country of origin. There are a number of good Golden Retriever books written by recognized UK experts such as Valerie Foss and Joan Tudor.

EUROPEAN GOLDENS

Golden Retrievers are, of course, one of the most popular breeds all over Europe. I had the pleasure of watching the conformation judging of Golden Retrievers at three separate shows in Sweden, the last one being the 2008 World Dog Show held in Stockholm. The dogs entered came from many different European countries and represented many different kennels. Several were big winners in their homeland. The judges were from both the United Kingdom and Europe. Well over 300 Goldens were entered at each of the shows, giving me an overview of the breed in Europe. Not surprisingly, the vast majority of dogs were of the English style, though there was one entry that had been bred in America but was owned by a European.

There were many high-quality dogs to be seen and, to my eye, there was more uniformity of type seen at these shows compared with what is often seen in America. Because it was the World Show week and many exhibitors had traveled long distances to attend, it is not surprising that there was a good depth of quality dogs in each class. The judges certainly did not have to make major compromises to reach their decisions. Lighter-colored dogs predominated here, but unlike some of their English counterparts, many of the breeders of these dogs clearly paid considerable attention not only to maintaining good type but also to developing the physical structure of their dogs, as demonstrated by their ability to move properly. Compared to some of the dogs seen in the United Kingdom, the front assemblies seemed to have better angulation and more correct shoulder layback. Overall, front and rear angulation was more in balance, resulting in smoother gait and more reach in the front. However, like many English dogs, some were longer in body than I would have preferred. At the same time, it is interesting that the Best of Breed winner at all three shows was a stunning older bitch bred in Great Britain.

It was lovely to see the combination of correct type and good movement in many of the exhibits. The European breeders should be proud of the results of their breeding programs and their dogs' accomplishments.

Readers wishing to learn more about Goldens in the United Kingdom are referred to these excellent resources. All I shall do here is to very briefly share with you my own impressions of Goldens that I have seen at various all-breed shows during numerous trips to the United Kingdom over the years.

For a dog to become a champion in the United Kingdom, he must win three Challenge Certificates from three different judges. This is far more difficult than earning a championship in the United States or many other countries, as English dogs that already have their championship titles are shown in the same classes as those who have not yet earned championships. The third Challenge Certificate in the United Kingdom earns the dog the title of Show Champion. To become a full champion, Sporting breeds must also pass a field test.

Golden Retrievers often constitute the single largest or nearly the largest entry at English shows. The first thing an overseas visitor accustomed to seeing American-style Goldens will notice is the great number of very light-colored dogs. The English breed standard specifically permits the cream color, and some of these dogs are so light that those unfamiliar with the breed might well call them "white." This cream color is part of the accepted norm of the English-style Golden. Some might rightly ask why a dog called a "Golden Retriever" has a cream-colored

Southern Golden Retriever Club (Inc.)

Catalogue of the
44th Championship Show

Held at
Canterbury Kennel Centre, McLeans Island
Sunday 31st May 2009

Jeffrey Pepper with a Golden Pup

Judges:

Sunday 31st May 2009: Breed Classes: Mr Jeffrey Pepper (USA)
 Stake Classes: Mr Doug Swift (North Canterbury)

The cover of a catalog from a show in New Zealand featured the author with a Golden puppy.

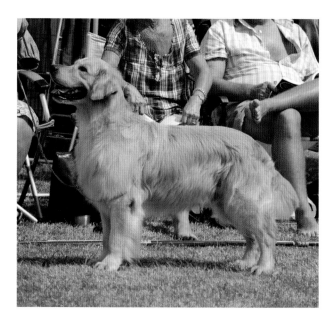

Not all English-style dogs are cream-colored, as shown by this dog competing in Sweden.

BEST OF BOTH WORLDS

It would be a benefit to the Golden if breeders of both styles would, in their own breeding programs, place some emphasis on combining the strengths of their personal style of Golden Retriever with those of the "other" style. American breeders could benefit from the introduction of English-style type, especially when it comes to heads. British breeders could benefit from paying more attention to correct gait, as demonstrated by many American lines.

coat. To that question, I have no answer. I feel that the breed should have at least a hint of gold color in his coat. However, what is important is not the color of the coat but whether or not the dog *looks* like a Golden Retriever. These dogs most certainly do look like Goldens, and when you get beyond the color, they are not very different from their American-style cousins. The overall similarities are far greater than the differences, and they are all unmistakably Goldens.

It is when the dogs move that the differences can, perhaps, be better seen. In the United States, we tend to place a good deal of emphasis on movement, sometimes overlooking better type in favor of a good-moving dog when judging. In the conformation ring, judges tend to give great consideration to just how well individual dogs move. At Kennel Club shows in the British Isles, the reverse seems true. Judges appear to spend a good deal of their time looking at dogs standing, and they seem to place much less emphasis on movement. Breeders in the United Kingdom often seem to pay more attention to

type and looks than they do to structure and ability to move correctly. This is especially apparent when the judges make their final decisions. In American shows, after completing their individual examination of the dogs, judges most often move the dogs around the ring and point to the winners as the dogs are moving. English judges, however, do not move the dogs as much and often announce their placements by walking up to a standing dog and handler and shaking the hand of the winning exhibitor. In so doing, the judges may be showing where they place their emphasis when making decisions.

It would be a benefit to the Golden if breeders of both styles would, in their own breeding programs, place some emphasis on combining the strengths of their personal style of Golden Retriever with those of the "other" style. American breeders could benefit from the introduction of English-style type, especially when it comes to heads. British breeders could benefit from paying more attention to correct gait, as demonstrated by many American lines.

The Gold Standard

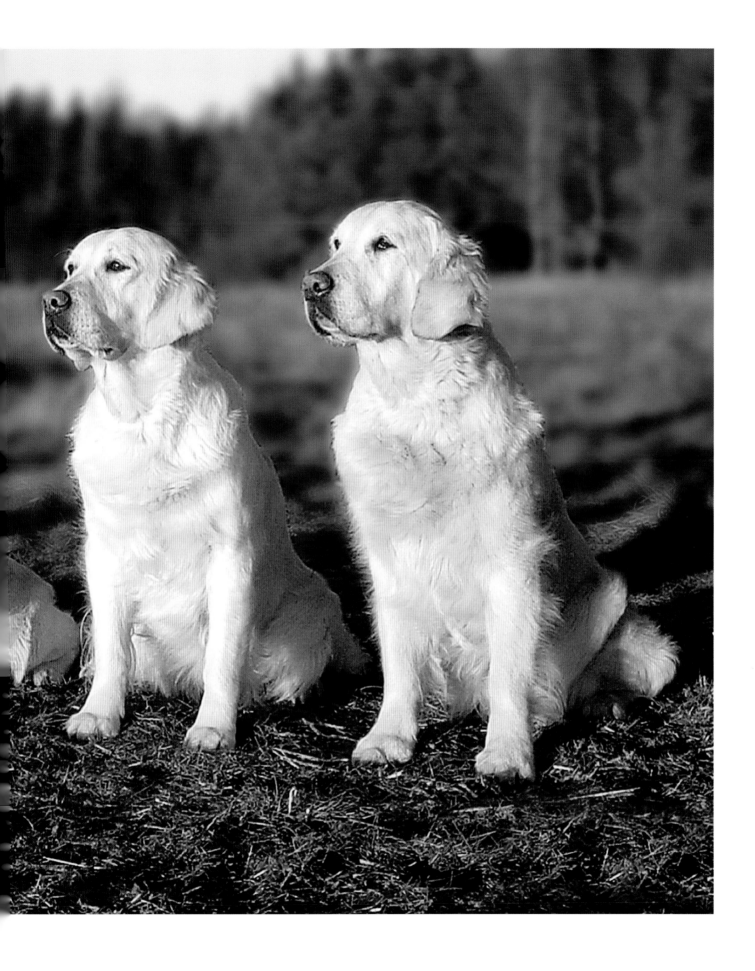

What Is a Breed Standard?

ou see a yellow dog being walked down the street, and you can imme-
diately identify it as a Golden Retriever. All Goldens do not look the same,
yet you are able to identify the dog's breed with little trouble. Did you ever
stop to consider why you are able to do that? Just what is it that makes a
Golden Retriever—or any other purebred dog for that matter—so readily

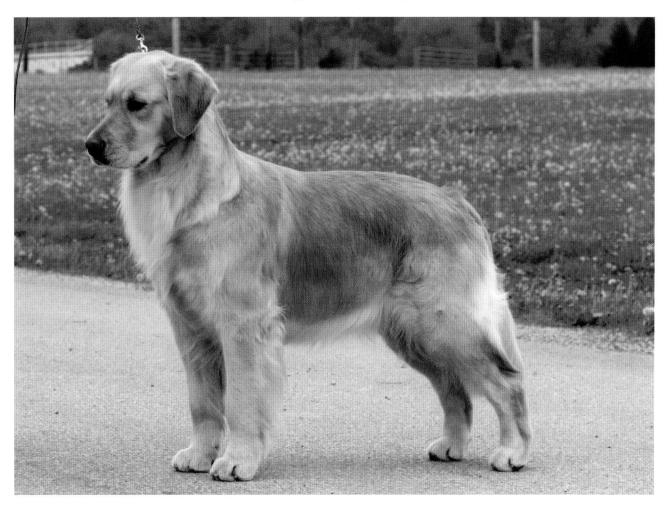

Ch. Malagold's Everlasting Love, "Sweetie," has a beautiful head and expression with the proper dark pigmentation.

identifiable? The simple answer is that you are
benefiting from the many, many years of efforts of
dedicated dog breeders who strive to adhere to breed
standards that define just what their breed should be.

The major advantage of a purebred dog is that
you know what to expect. With a purebred dog, you
know what the dog will look like as an adult. You
know, within a narrow range, the dog's adult size

and how much he should weigh when fully grown.
You know what color your pet's coat will be and how
long that coat will grow. You will even know the
quality of that coat—long or short, harsh or soft,

The requirements of the breed standard are the same for puppies as for adults, but in a smaller package. Note the nice balance of this youngster.

easily matted or easy to care for. You can predict with great accuracy how that dog will behave, how active he will be, and even how much he will bark.

Because you will know the dog's original purpose, you will be able to anticipate what his temperament will be like—active or sedentary, protective or happy to meet everyone, independent or eager to please. With a purebred dog, you can anticipate nearly all of the variables and, to a very large degree, know in advance whether or not a dog of that breed will be a good fit for you, your family, and your lifestyle. This way, you can avoid the difficulty of owning a dog who is unable to meet your expectations or the problem of trying to train a dog to do something that is against his instincts.

For thousands of years, man has bred his dogs selectively. He has chosen which dog will be mated to which bitch to achieve certain goals. In the process, he has, over the centuries, created breeds of dogs that are intended for many different functions and that are readily identifiable as distinct breeds. Until relatively recently, nearly all mating selections were made on the basis of the individual dogs' ability to carry out their intended function. So if a breeder's need is to produce a dog who will assist in herding farm animals, the decision about which dog to breed to which will be based on their individual herding abilities and instincts as well as on the body structure, size, and shape that are best suited for herding the intended animals.

Other factors enter into the decision-making process as well. Will the dog work without human supervision, perhaps making the sheep he protects members of his own pack, thereby protecting them from predators? Or will he work primarily under the direction of his master? Though both types of workers require the herding instinct, independent dogs will have different temperaments than dogs who work close to their masters.

The characteristics of the locale in which the dog will work also figures into the breeder's decision-making process. A shorter coat might be preferred for warm and dry climates. Working in open fields without major obstacles? Longer legs will be helpful for the needed speed, and flexibility will be less important. Working in confined areas or areas with obstacles? Perhaps shorter legs and a longer back will help to increase agility, and speed will not be as important. Does the area have a moist climate? If so, a waterproof coat will be needed to protect the dog from the rain and cold. Does the terrain have much briar and bramble? A longer protective coat will be needed to protect the skin and muscles.

A dog bred to chase game and work ahead of the hunter will need to give voice so that the hunter knows where the dog is; the dog will also need to be able to work independently of his master. However, a dog meant to retrieve shot game should be quiet so as not to scare away the game before it can be shot. A hunter on horseback requires dogs that have longer legs, enabling them to keep up with the horses, but a hunter who works on foot might want dogs with shorter legs who will walk at a pace that people can keep up with.

The coat color of the dog might be determined by the dog's function, as well. Dogs working in tall grass will be easier to see if their tails are carried

The Golden is meant to be an affectionate family dog, and his friendly nature is as ingrained in the breed as any hunting or working instinct.

high in the air and perhaps have white tips to make them more visible in the brown and green grass. For some dogs, a coat that camouflages the dog to a degree in his typical working environment might be very helpful. For other dogs, a readily visible coat might be necessary so that the hunter does not shoot a dog whom he has mistaken for the quarry.

Over time, man developed many different breeds, each for a specific purpose in a particular geographic area. With the probable exception of the Toy breeds, beauty was not likely a major consideration when breeds were first developed. As breeds became more established and performed their intended functions well, each breed developed a distinctive look. Now there was room to consider aesthetics as well as the ability to do the job at hand. Because the desired physical qualities are controlled by specific genes, and genes often have many characteristics linked together, the genes for the desired traits may also produce unintended unfavorable results that are linked to the favorable results, which

There's no mistaking that this is a Golden, but dogs bred primarily for field work may have a slightly different look than those destined for the conformation ring.

Purebred dogs have the same instincts as their ancestors, passed down through generations of careful breeding to preserve the desired qualities that make a breed what it is.

include proper color, temperament, and size.

In ancient times, breeds were probably created as man used dogs to help him survive the harsh environment. Dogs helped in the hunt to provide food for the family and gave protection when needed. In truth, often human families could not survive without the assistance provided by dogs. Later, as man learned more about the many functions of which dogs are capable, dogs were developed to handle other occupations such as guarding, pulling carts, and herding livestock.

Dogs were probably also welcomed for the companionship they offered mankind. Over the centuries, as people gained wealth and some leisure time, they used it to engage in activities that brought pleasure as well as food. By the nineteenth century, people had money to purchase goods, so hunting was only occasionally necessary to provide food for the table. Hunting had become a sport, though, especially for the aristocracy.

By the mid 1800s, man had learned how to control many aspects of dogs through selective breeding techniques. As a result, many new breeds were being developed to perform more specialized functions. As breeds became more standardized, a need developed to provide some permanent way to communicate just what characteristics were necessary in dogs of a specific breed. Thus, written descriptions of the requirements for each breed were developed. These documents were the precursors of what are called breed standards today.

The Golden Retriever breed standard contains the specific words that tell us what makes the Golden a Golden, not a Labrador Retriever or some other breed. It is not a "blueprint" in the literal sense, but it provides the framework upon which the dog is built. A blueprint contains very specific instructions and measurements, with every little thing detailed in advance, providing little flexibility for change. This level of control cannot be reached with living things. Rather, a breed standard might be more accurately described as a detailed conceptualization of what the final project will look like.

Perhaps it is better to think of the breed standard as the roadmap that guides us to the desired destination. We use it to find our way to the essence of the breed and to produce correct Golden Retrievers. The standard uses words to describe the desired attributes of the breed and, consequently, the

Strong fore- and hindquarters for swimming and the correct coat texture to repel wetness are desired in the Golden.

answers to our questions about just what the breed should look like. The breed standard describes the dog's intended function, color, size, shape, proportions, movement, and temperament.

So how do we use a breed standard? To begin, it is important to understand that breed standards are not written for novices, but rather for those already intimately familiar with the breed being described. The writers presume that those reading the breed standard are already familiar with at least basic canine anatomy, understand dog terminology, and have a familiarity with the breed, its function, and its history. It is important to remember that when breeds were first developed, written standards were

not necessary, as all those involved with the breed were familiar with the factors necessary to make up that breed. That is, there was no need to describe the correct height or weight or the look desired in the breed, as this was already known to the breeders.

As breeders began to compare their canine stock with dogs from another breeder, looking to select the best specimen of the breed, a standardized reference describing the requirements of a perfect example of the breed became necessary. Those newly interested in a breed or those wanting to learn more about it also needed an authoritative statement that described the desired characteristics of the breed.

By the end of the nineteenth century, informal comparisons of dogs between breeders evolved into our first dog shows. At the earliest shows, there were no written standards, and those chosen as judges relied on their detailed knowledge and experience with the individual breeds to make their decisions. Eventually, as shows became more popular, and more consistent results were expected, those judging at shows needed a common frame of reference no matter where the show was being held. To accommodate this need, the acknowledged experts in each breed gathered and together developed a written statement—a *breed standard*—that described the perfect dog of that breed. And so, we developed the first versions of our Golden Retriever breed standard.

The intended function of each breed was the foundation upon which the breed's standard was created. Early descriptions dealt largely with the structure required for the breed to best achieve its intended job. The performance of the dog was considered more important than the way he looked. However, the desired size, shape, and color of the breed were also delineated in early standards.

Each breed's standard was unique. Some were quite short and others considerably more detailed. As mentioned, all relied on the basic assumption that those reading the breed standard were familiar with more than just the basics.

In the United States, the American Kennel Club has set guidelines for the writing of breed standards. The national kennel clubs in many other countries have done the same. Included in the guidelines is the basic format of the standard. For example, each AKC standard begins with a general description of the breed, its history, and its intended function. This is followed by specified sections dealing with the various parts of the dog, starting with the head and working back to the tail. The correct gait and temperament for the breed, as well as the height, weight, coat type, and coloration are also included. In some breeds, but by no means in all, specific disqualifications are listed. Disqualifications often deal with deviations from the specified size and weight range and from those characteristics that make the breed unique.

Because we are dealing with living things, breed standards must always allow room for interpretation. Standards purposely use descriptions such as "moderate," "balanced," and "varying shades." This allows the natural differences we expect in all living things while also permitting the various styles (which some call *types*), or variations that show up as each breeder emphasizes his preferences within the confines of the standard.

The Golden Retriever breed standard in the United States hasn't been changed since 1981, and that version was little changed from prior versions. Standards should be changed on a whim or to meet the look of current dogs. They are the specifications that all breeders and judges should be following when producing or evaluating dogs.

Chapter Six

Golden Anatomy and Nomenclature

he purpose of this chapter is not to provide the reader with a full course on canine anatomy, as that would require at least one book's worth of material to cover correctly. Rather, my purpose here is to provide you with some practical knowledge of just how the dog is put together. If a more complete study is of interest to you, consider exploring one of the

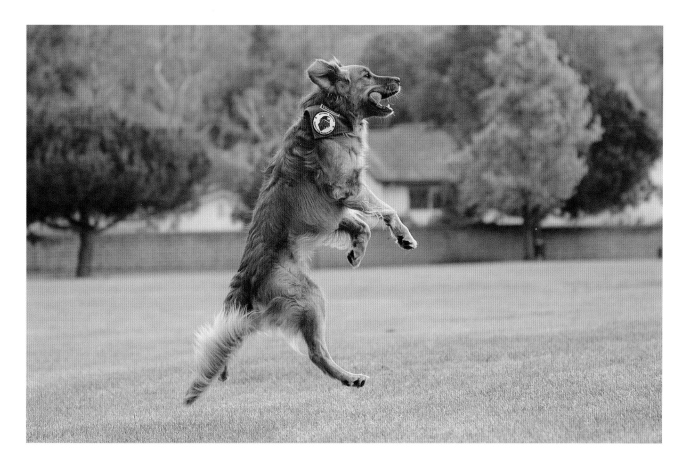

SAR dog Baxter takes a flying leap. Correct structure makes a dog better able to perform any task, not just win in the show ring.

very thorough books on the subject or taking a college-level course at your local university. See the bibliography at the end of the book for a few suggested texts.

People tend to think of the conformation ring as the only arena where the breed standard comes into play. However, as you read through the chapters on the field and on agility and obedience competition (each written by experts who have worked with Goldens for many years), you will notice a common theme. The dog who truly excels at anything is the dog with the necessary combination of the desire to do the job and the structure that allows him to do it most efficiently.

True enthusiasts of any pursuit involving their dogs will greatly benefit from an understanding of

just what makes their dogs tick. All too often, we make assumptions about canine structure. While it is most certainly true that dogs in performance events and in the field can do well because of their "heart"—their strong desire to follow their natural instincts (be it prey drive or just the natural exuberance of wanting to run)—dogs that succeed day after day do so because they have the correct structure to perform their job. For example, to truly excel in the agility ring, you need the right dog. Knowing which dog has the potential to win requires a good working understanding of canine structure.

Correct type and structure is just as important—or maybe even *more* important—in the field as it is in the show ring. If a dog with the necessary drive also has the correct structure, that structure will allow the dog to work longer without tiring, to move a bit faster, to have a bit more flexibility, and to have

While outward appearance paints an overall picture of a dog's construction, only a hands-on exam tells the full story.

the body strength required to complete the task in an efficient manner.

Understanding what goes into creating the mythical "perfect Golden" that all breeders strive to produce begins with a thorough understanding of the requirements of the breed standard. And understanding the requirements of the standard requires thorough knowledge of just what each description in the standard refers to. Therefore, comprehension of the nomenclature used in breed standards is required to produce winners.

In this chapter, I highlight many of the terms used in the Golden Retriever breed standard. As is true of many pursuits, there is a jargon particular to

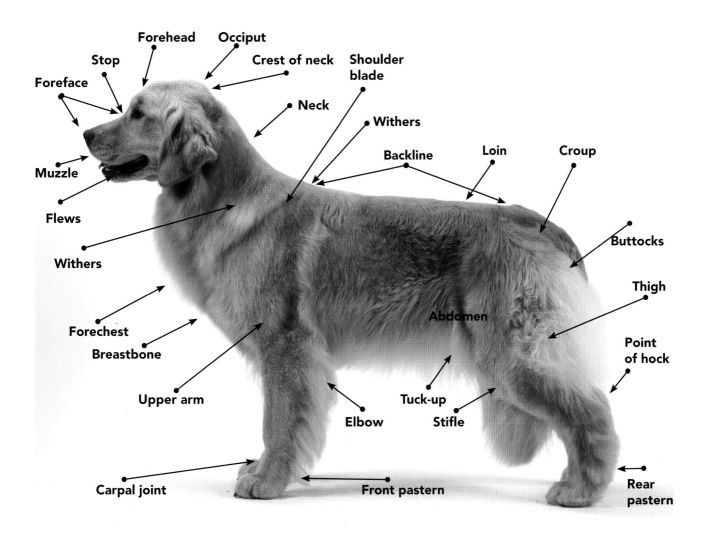

Forehead Occiput

Stop Crest of neck Shoulder blade

Foreface

Neck

Withers

Muzzle

Backline Loin Croup

Flews

Buttocks

Withers

Thigh

Forechest

Abdomen

Breastbone

Point of hock

Upper arm

Tuck-up

Elbow Stifle

Carpal joint

Front pastern

Rear pastern

Points of anatomy used in the Golden standard. See page 103 for a diagram of skeletal points.

dogs that goes well beyond the terms used in a formal breed standard. Those who have been "in" dogs for some time naturally understand these terms and need no explanation of what they mean in everyday English. For those not involved or newer to dogs, some of the words may seem quite foreign at worst and nonsensical at best.

On this page, you will find a diagram of terms commonly used when referring to the various parts of the dog. In many cases, these are not the technical anatomical terms used by veterinarians but rather the more common terms used by the writers of breed standards and those involved in the sport of dogs. Few breed standards actually define the words they use in describing their breeds, as the writers assumed that those who were reading a standard would already be familiar with the terminology.

Withers

Croup

Point of buttocks

Scapula

Point of shoulder

Humerus

Coupling

Stifle

Hock

Point of hock

Metatarsus

Metatarsus

Pastern

Historically speaking, dog breeders tended to be people who were involved with other animals, especially horses. Much of the terminology we use in dogs was borrowed from horsemen, even though some terms do not directly relate to the same physical structures in both species. While dogs and horses have many parts of their anatomy in common, this is not always the case.

At the time that standards originated, horses were the primary source of transportation for those who could afford to own them, and horses were also used as draft animals to work on farms. A family's livelihood often depended on the health and physical

Much of the terminology used for horse anatomy is seen in breed standards for dogs.

condition of its horse. Therefore, intimate knowledge of what made a horse sound and able to work was vital to most, and the skill (or lack of skill) of evaluating a horse could have a profound effect on a family. Over the years, it has become customary for breed standards to use horse terminology even though a depth of knowledge about the horse is no longer common.

If you wish to really learn the ins and outs of dogs and dog breeding, you will have to develop an

understanding of the words that those involved in the dog sport tend to use. One way to gain this understanding is to develop a mentor relationship with someone who is more experienced in the sport than you are. Another way is to use a glossary of terms to enhance your understanding. There is an excellent glossary in recent editions of the AKC's *The Complete Dog Book*. It will also be helpful for you to attend seminars on dogs; these are often offered by local all-breed kennel clubs as well as by many of the Golden Retriever clubs throughout the country.

So let us look at the dog, beginning with the head and working back to the tail, and define the terms used in the standard as they refer to the specific parts. The labeled picture of a Golden Retriever shown on page 77 will point out the exact location of various parts of the dog. Memorize these terms and locate each of these parts on your own dog. Learning the meanings of the terms will help you understand correct type and structure. You might want to make a copy of the labeled photo to use as a reference when you're reading the other chapters in this book.

When comparing a dog to the breed standard, it is always important to keep in mind that the form of the dog required by the standard is based on the function of the dog and, to some degree, the preferences of the originators of the breed. For example, the shape of the Golden Retriever is determined by the breed's intended function—to retrieve upland game on land and waterfowl in the water—but the color and pigmentation is at least partly dictated by what the founders of the breed found attractive as well as useful in the field. These factors—the intended function of the breed and the personal desires of the founders—combined with personal interpretation of the standard is what makes the Golden Retriever a distinct breed.

There is nothing exaggerated or abrupt about the correct Golden head.

Head

In the diagram, notice that the *foreface* is the entire area of the head forward of the eyes, including the jaws, nasal bone, nose, and mouth. The standard asks that this area be "nearly as long as the skull." *Muzzle* is a more common term for the *foreface*. In the Golden, we prefer a straight muzzle, or straight nasal bone, rather than a "Roman nose" in which the muzzle has a rise midway down its length, creating a convex outline to the nose. The standard asks for a *stop* (the step up from the plane of the muzzle to the plane of the skull, often enhanced in appearance by the eyebrows) that is "well defined but not abrupt." An example of an abrupt stop would be that found in the Pointer. The *flews* are the upper lips toward the front of the muzzle. The *incisors* are the six upper and six lower teeth at the front of the mouth that together form the bite.

The *occiput* is the posterior point of the skull, or the part of the topskull at the back of the head. A prominent point (the bony bump) at the back of the skull, which is not called for in the breed standard, is called an *occipital protuberance*. This is too often

seen on Goldens lacking the desired slightly arched skull "both laterally and longitudinally without prominence of frontal bones (forehead) or occipital bones" called for in the breed standard.

Body

There are some common misunderstandings of terminology that can create problems when discussing dogs and the standard. Perhaps the most misused term is *topline*, as opposed to *back* or *backline*. Let's look at the dog and define the location of each of these parts. The *topline* is specifically referred to in the standard and describes the entire silhouette of the dog, beginning where the back of the skull meets the top of the neck and continuing to the base of the tail. The *back* is that part of the topline between the withers and the loin. The *loin* begins at the end of the rib cage and ends at the pelvis, and is the part of the backline that is not supported by the rib cage. The *backline* is the part of the topline from the withers to the croup. The *croup* is the fleshy area above the pelvic girdle, or the flesh above and behind the hips and below the tail. The slope of the croup follows the angle of the bones forming the pelvic girdle.

When you hear people talking about dogs, they often say that a dog has a "level topline." This is technically an incorrect use of the word *topline*. The topline must slope smoothly down the neck to the withers and then continue along a level backline (withers to croup), so we are really talking about a level *backline*, not a level *topline*.

The *neck* runs from the back of the skull to the backline. At the top of the neck is the *crest* (the slight rise of the spine that creates the curvature of the neck). The shape and length of the neck is controlled to a degree by the layback of the *shoulder blades* (or *scapulae*).

The construction of the front is often misinterpreted by those new to dogs. More than a few assume that the shoulders and forelegs have ball-and-socket attachments similar to those of humans. This is not the case. In dogs, the scapulae (shoulder blades) are not held in place by sockets but by a series of muscles and tendons, which is what permits the slightly varying placement of the shoulders. Upright shoulders will not only make a dog appear taller (because height is measured at the "high point of the withers"—the *withers* being the highest point of the shoulder blades) but will also make the dog's neck appear shorter and may cause the head to be held more upright when the dog is gaiting, thus creating a movement fault as well.

Shoulders that are "well laid back," as required by the breed standard, are shoulders that lie back along the rib cage, facing the rear of the dog and finishing the smooth curve from the crest of the neck into the backline. They are not in an upright position (or vertical, which would make the withers higher).

The shoulder blade is attached with muscles and tendons to the *humerus* (or *upper arm*). If you look at the drawing of the dog's skeletal system on page 103 in Chapter 7, you will notice that the "bottom" of the scapula (the part opposite the high point, or withers) points toward the front of the dog. The top of the upper arm joins the scapula here and then points down and rearward on the dog, thus creating the point at which angulation is measured. The open "V" shape created on the rearward side of these two bones is where we measure. Traditionally, we look for an angle approaching 90 degrees here (although x-ray studies by Rachel Page Elliott indicate that the actual angle is closer to 110 degrees on average). This angle allows the dog to reach his legs forward to pull his body along as he moves.

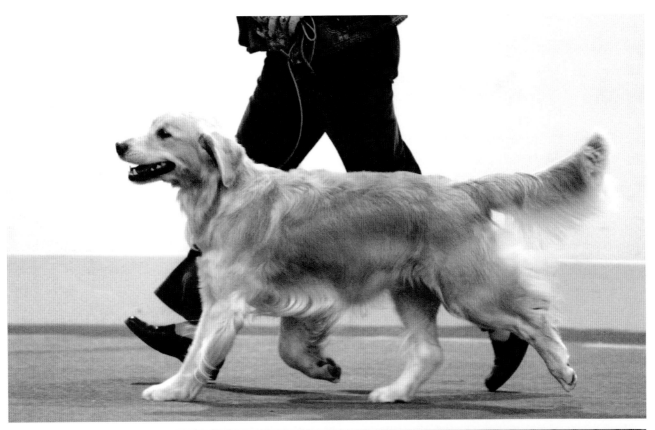

ABOVE: Cricket in motion shows the desired level topline on the move as well as balance between the movement of the front and rear legs. **RIGHT:** A side view of Cricket shows detail of the chest and how the topline slopes from the neck to the shoulders to the back.

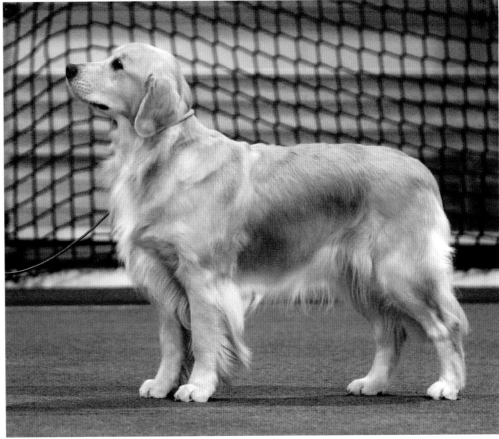

To move properly, there must also be adequate length of the upper arm. The ideal is achieved when the length of the scapula and the length of the upper arm are nearly equal. Just as important, the approximate angulation of the front needs to be in balance with the angulation of the rear legs for the dog to move with the greatest efficiency.

The Golden standard asks for a backline that is "strong and level from withers to slightly sloping croup, whether standing or moving." The croup slopes slightly to allow for the desired tail set described in the standard and to help create the necessary angulation in the bones of the rear legs. Thus, the backline should be level; it should not show any tendency to slope downward from withers to croup in the fashion of some setters.

There are various words used to describe the front of the chest. The *chest* is the part of the body that is formed by and enclosed by the ribs. The words *sternum* and *breastbone* are used interchangeably and refer to the row of bones that form the floor of the chest, while the *manubrium* is the forwardmost point of the *forechest* (the chest assembly in front of the forelegs). In practical terms, when using one of these words for the purpose of measuring the length of the dog, we are talking about the point of bone you feel in the forechest area (called the *prosternum*). The standard's requirement for the *brisket* to be "at least as deep as the elbows" means that a deep chest is desired and that this is the minimum depth of chest expected on a mature dog.

When we talk about the correct body length proportions in the Golden, the standard gives us a specific ratio of desired length to height as 12 to 11, measured from the breastbone to the point of buttocks. In practice, this means that a dog who stands 22 inches tall at the withers should measure 24 inches long from sternum to buttocks, or just

slightly off square. The *prosternum* is the point of bone that you feel when you run your hand down a dog's front from the neck to the elbows. The point of buttocks is the *ischium*, the bony protuberance felt under the tail that is the rearmost point of the pelvis. A tendency to use the proportion ratio as measured between the withers and the croup, rather than between the breastbone and the buttocks, will create a dog who is much longer than desired under the breed standard.

The *loin* is the unsupported area between the last rib and the pelvic girdle. The *lumbar vertebrae* are the parts of the spine that form the topline in this area. On Goldens in really good condition, there is often a very slight rise of muscle tissue over the loin area that can be felt on examination. This is desirable and should not be confused with a rise in the backline as a whole. The breed standard calls for a short loin because this is an unsupported area of the back. A fault of the loin often seen is a too-long loin; however, a dog with too short a loin will lack the flexibility necessary for quick turns. Another term for the loin area is *couple*; when we talk about a "short-coupled dog," we really mean a dog who is not long in loin. In a Golden, the ideal length of loin is approximately the width of a man's hand with the fingers very slightly spread apart.

Looking at the legs, it is important to know what the *pasterns* are. The pasterns are the "wrists" of the dog, technically "the metacarpal bones of the front leg between the carpus and the foot and the metatarsal bones of the hind leg between the hock and the foot" (from the AKC's *The Complete Dog Book*). Note that the pasterns exist on both the front and the back legs. We tend to use the word *hocks* to refer to the rear pasterns. The *point of hock* (or *tarsal joint*) is the collection of bones that form the joint between the second thigh and the rear pastern (or *metatarsus*).

This slightly angled view shows this dog's parallel hocks, the angulation of the back legs, and the set-on of the tail.

The standard is quite explicit regarding the requirements for the rear construction on the Golden: "The femur joins the pelvis at approximately a 90-degree angle. Stifles well bent, hocks well let down with short, strong rear pasterns." (Again, according to Rachel Page Elliott's work, the actual angulation is closer to 110 degrees.) The *femur* is the upper rear leg bone, the top of which forms the hip joint and the bottom of which forms the top of the *patella* (knee). The *stifle joint* is what joins the femur with the *tibia* (lower leg or second thigh). A "well-bent" stifle is one in which the angulation between the upper leg and lower leg is about 110 degrees (putting it in balance with the angulation of the forequarters). The femur points toward the front of the dog while the return toward the rear is created by the tibia. A properly standing dog will also have his rear pasterns approximately vertical to the ground.

We tend to use several terms to define faulty rear construction, all of which lead to movement faults. The standard specifically mentions three that relate to the structure of the rear legs: *cowhocks*, *spread hocks*, and *sickle hocks*. *Cowhocks* occur when the hock joints have a tendency to point toward each other when the dog is both standing still and moving—think "knock-kneed." *Spread hocks* are just what you imagine: when the hock joints tend to face outward, away from each other. The term *sickle hocks* refers to an inability to straighten the hock joint on the rearward reach of the leg and to rear pasterns that cannot be set perpendicular to the ground when the dog is standing still.

Again, a complete understanding of the ideal Golden Retriever is not possible unless you have a full understanding of the meaning of the words contained in the breed standard. In this chapter, I have attempted to cover these very important points. However, this has been just a passing glance at the subject of the breed standard. Your learning has just begun. Now that you are equipped with the necessary basic tools, you'll apply them in the next chapter to the AKC's Golden Retriever breed standard.

The AKC Standard in Depth

To properly evaluate a Golden, whether as a potential breeding animal, as a show dog, or even as a companion, one must be thoroughly familiar with the breed standard. Conformation judges and breeders alike must fully understand each aspect of the standard and the nuances of type to maintain the qualities of the correct Golden Retriever, but everyone who breeds

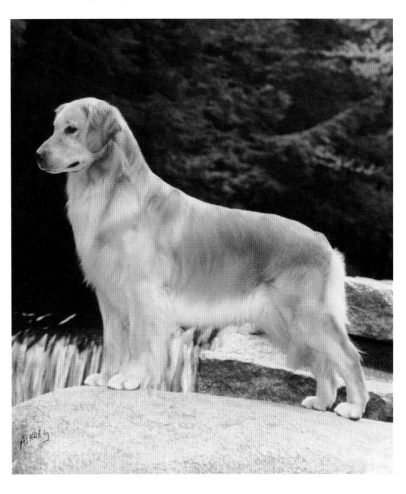

A beautiful bitch in her prime, this is 1984 national specialty BOB Ch. Pepperhill East Point Airily, bred by Barbara and Jeffrey Pepper. Notice the excellent topline, flowing smoothly from head to tail with no lumps or bumps.

Goldens, for whatever purpose, should also know the breed standard intimately. The breed hallmarks of the Golden Retriever must never be ignored. Breeders must be totally honest with themselves when evaluating their own dogs—something that is more easily said than done.

To achieve a complete understanding of the standard and be able to properly assess a Golden Retriever, we must always remember that the original intended function of the Golden is the basis upon which the requirements of the standard were written. Few aspects of the structure required of a Golden relate solely to the breed's beauty. In nearly every case, the form of the dog required by the standard relates directly to the breed's function. In the early development of the breed, most decisions about breeding were based on the attempt to improve the Golden's ability to perform this function. Truly, the physical form of the dog follows the intended function of the breed. With this statement always in mind,

let's study the requirements of the breed standard one section at a time. Sections of the standard appear in italics, with my comments in regular type. Additionally, the uninterrupted standard appears in its entirety on the last pages of this chapter as a reference.

General Appearance

The opening paragraph of the standard reads:

General Appearance—A symmetrical, powerful, active dog, sound and well put together, not clumsy nor long in the leg, displaying a kindly expression and possessing a personality that is eager, alert and self-confident. Primarily a hunting dog, he should be shown in hard working condition. Overall appearance, balance, gait and purpose to be given more emphasis than any of his component parts.

Faults—Any departure from the described ideal shall be considered faulty to the degree to which it interferes with the breed's purpose or is contrary to breed character.

This section immediately tells us what a Golden is about. The first sentence clearly lays out what is expected in an excellent Golden Retriever. There are two key points found in the second sentence to which breeders and exhibitors in any venue should pay attention. First, "primarily a hunting dog" signifies that the original purpose of this breed was to be a gentleman's hunting companion who would be equally comfortable in the field, in the water, or as a companion at home. A Golden needed an even temperament so that he could also work with other dogs owned by guests of his master without any undue arguments. A sound temperament, for both working and being a loving companion, is a hallmark of the breed.

The second part of this sentence reads, "…he should be shown in hard working condition." This is an admonition to those who show their dogs in the breed ring and a warning to those who participate in activities such as field trials, obedience, or agility—a Golden should never be allowed to become too "soft," overweight, or out of condition.

This is just as true for those whose dogs are solely companions. The Golden is not a sedentary dog; he requires regular exercise to be happy and healthy, and an out-of-shape, fat Golden is neither happy nor healthy. Your Golden, whether competitor or pet, needs to be in good condition.

The third sentence points clearly to the need to look at the dog as a whole. The biggest trap for those evaluating a Golden is to look solely at the various parts of the dog to reach a decision on his merit. What is important is how well the pieces integrate with each other to form a harmonious whole. A beautiful head and expression on a weak, narrow, poorly angulated body does not make a good dog. For a Golden to be well balanced, all of his parts must fit together as a complete package, with no one feature dominating the rest of the dog, and the effect should be seamless. In the best dogs, the whole is actually greater than the sum of the parts.

Next, faults are mentioned. It is noteworthy that the authors of the standard did not concentrate on specific faults but rather laid out the general principle that "Any departure from the ideal shall be considered faulty to the degree to which it interferes with the breed's purpose or is contrary to breed character." Here again, the authors emphasize the whole dog and his ability to perform his intended function—to be a hunting dog and a companion. The concept to remember, especially for breeders and judges of the breed, is that Goldens should appear able to perform their job as retrievers of game and be considered as a whole, not as a collection of parts—as is necessary when discussing the breed in writing. Fault judging—simply looking for faults in a dog—is easy to do, but is the worst method of evaluating a dog. Every dog has faults. The goal is to evaluate the virtues, not the faults, of the dog.

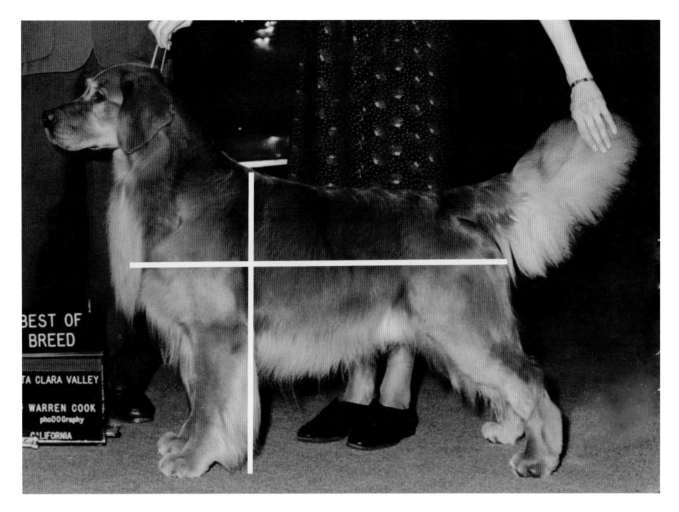

The yellow lines illustrate the desired proportion as stated in the breed standard: "Length from breastbone to point of buttocks slightly greater than height at withers in ratio of 12:11."

Size, Proportion, Substance

After the section on general appearance, the various parts of the dog are considered.

Size, Proportion, Substance—Males 23–24 inches in height at withers; females 21½–22½ inches. Dogs up to one inch above or below standard size should be proportionately penalized. Deviation in height of more than one inch from the standard shall disqualify. Length from breastbone to point of buttocks slightly greater than height at withers in ratio of 12:11. Weight for dogs 65–75 pounds; bitches 55–65 pounds.

A statement in this paragraph worth noting is "Dogs up to one inch above or below standard size should be proportionately penalized." This means that a male over 24 inches tall or under 23 inches tall is to be considered faulty to the degree that his size is contrary to the ideal measurements. Therefore, a dog who stands 24¾ inches tall at the withers (three-quarters of an inch above the desired range, and only a quarter of an inch away from disqualification) is considerably more faulty than a dog who stands 22¾ inches tall (only a quarter of an inch below the desired range). In this instance, the too-tall dog

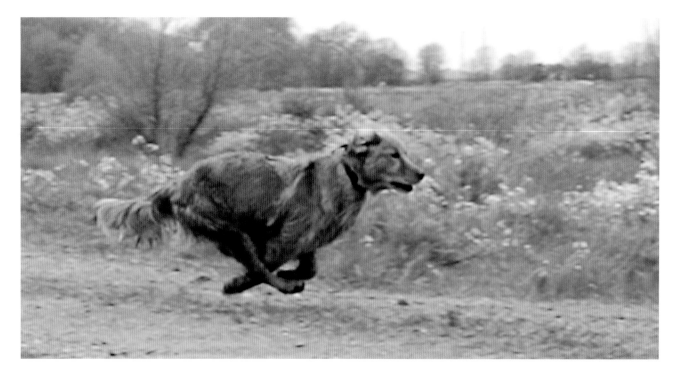

should be penalized to a greater degree than the too-short dog. The greater the divergence from the standard, the greater the fault. Simply put, a dog or bitch whose height nears the criteria for disqualification should be seriously faulted.

A dog less than 22 inches tall or more than 25 inches tall at the withers when measured in the ring by a judge using an approved measuring device is disqualified from competition. A bitch standing less than 20½ inches or more than 23½ inches at the withers is disqualified. Generally speaking, dogs with disqualifying faults should not be used for breeding purposes, as they are quite likely to pass such faults on to their offspring.

Moving on to proportion, the correct proportion of length to height in a Golden is a frequent topic of consideration for those involved with the breed. The proportion given (12 to 11) is important to remember, but is not always easy to translate into the real world. The Golden is a compact, short-coupled dog. What is desired is a dog who is slightly longer than he is tall, just off square when you look at him in

Proper weight keeps a Golden healthy and enables him to run and play like a Golden loves to do.

silhouette and compare his height at the withers (highest point of the shoulders) to his length of body from forechest to buttocks.

For example, a bitch standing about 22 inches tall at the withers should measure about 24 inches from sternum to buttocks. When you stand back and look at her in profile, she should not give you a significantly rectangular impression. A Golden is a compact dog and should never appear rangy. With a bitch, I will sometimes allow just a little additional length of body to accommodate puppies when she's pregnant, but I certainly would not fault the bitch who is as compact as a Golden should be.

Remember also that the length of the dog's legs has a direct effect on overall proportion. If we take a bitch that measures 24 inches from sternum to point of buttocks and change her height from 22 inches to 20 inches, she will appear much longer

in body, even though her length is the same. Short legs, which are becoming a common fault in the breed today, change the proportion of the dog. Short legs also have a negative effect on movement, decreasing the amount of ground covered with each stride, thus requiring more steps (and more energy) to cover the same distance. Some might like the faster movement of the legs and feet that is a consequence of shorter legs, but this is not correct movement for the breed. As a guideline, the distance from the elbow to the ground should be about half the height of a dog or bitch measured at the withers. Anything less indicates short legs and is a fault that should be taken seriously.

Does your dog fall into the weight ranges mentioned in the standard? Many do not. These numbers might reflect the somewhat lighter-built dogs of yesteryear, and today's more substantial dogs should, perhaps, carry an additional few pounds. However, the Golden is a dog of moderation, not meant to be a heavy or coarse dog. Judges should not favor nor reward overdone dogs. Excess weight is a health issue and will certainly have a negative effect on the skeletal and cardiovascular system of your dog as well as his performance in the field or in any type of competitive event.

Now, I realize that most Goldens get great joy from eating. Those pleading eyes and that sorrowful expression can be hard to resist, but resist you must. Few things will shorten the lifespan of your beloved Golden more quickly than excess weight. Dogs are considerably less equipped to handle the stresses of obesity than we are. The overweight dog is not a healthy dog.

Excess weight places considerable strain on the joints, soon causing painful arthritis symptoms that will slow your dog down. It's a vicious cycle, as the

LOOK AND FEEL

Don't be fooled by the dog's coat length or fullness. Hair on the forechest can create the impression of prominence that isn't there on physical examination. Don't just look at the dog—feel for the broad sternum required by the breed standard before making a judgment about the dog's proportions.

pain will cause him to be less active, so he will continue to gain weight from a lack of activity. Further, the canine cardiovascular system is certainly not meant to perform optimally in obese dogs, which can easily lead to a shortened life span. And, for those of you who show your dogs in conformation or work your dogs in performance events, remember that excess weight will nearly always lead to movement faults and poorer performance in your dog, reducing your chances for a win. Believe me, judges don't like to see fat dogs in their breed rings. Over the years, I can think of a number of times when I have ranked a "kitchen dog" lower in a class because he was so out of shape. The standard asks for dogs to be shown in "hard working condition," not soft and flabby.

Head

The head is the index to the breed. The uniqueness of the head is one of the primary characteristics that create the defining "look" of each individual breed. There are six different breeds with the last name "Retriever," and each possesses a distinctively different head type. It is never correct to have, for example, a head reminiscent of a Flat-Coated

Retriever on a Golden—or vice versa. Each breed's head is unique. I believe that if I see a dog's head in profile in a car two vehicles away from mine, I should be able to quickly identify what breed he is without knowing his color.

You will notice that the section dealing with the head is longer than most other sections of the standard, an indication of the importance placed on a correct head. Let's begin our discussion of the head by looking at the standard's requirements:

Head—Broad in skull, slightly arched laterally and longitudinally without prominence of frontal bones (forehead) or occipital bones. Stop well defined but not abrupt. Foreface deep and wide, nearly as long as skull. Muzzle straight in profile, blending smoothly and strongly into skull; when viewed in profile or from above, slightly deeper and wider at stop than at tip. No heaviness in flews. Removal of whiskers is permitted but not preferred. Eyes friendly and intelligent in expression, medium large with dark, close-fitting rims, set well apart and reasonably deep in sockets. Color preferably dark brown; medium brown acceptable. Slant eyes and narrow, triangular eyes detract from correct expression and are to be faulted. No white or haw visible when looking straight ahead. Dogs showing evidence of functional abnormality of eyelids or eyelashes (such as, but not limited to, trichiasis, entropion, ectropion or distichiasis) are to be excused from the ring. Ears rather short with front edge attached well behind and just above the eye and falling close to cheek. When pulled forward, tip of ear should just cover the eye. Low, houndlike ear set to be faulted. Pink nose or one seriously lacking in pigmentation to be faulted. Teeth scissors bite, in which the outer side of the lower incisors touches the inner side of the upper incisors. Undershot or overshot bite is a disqualification. Misalignment of teeth (irregular placement of incisors) or a level bite (incisors meet each other edge to edge) is undesirable, but not to be confused with undershot or overshot. Full dentition. Obvious gaps are serious faults.

This is a long section, so we'll look at it in parts. However, remember that, as with the rest of the dog, we are not looking just at individual parts but, most importantly, at how these components fit together to create a harmonious whole. Very good parts combined with very faulty parts do not create the desired head—or dog. As always, be careful to look for the positives before looking at faults. In the end, we want as many positives as possible.

The skull should be broad and slightly arched. The area between the ears should appear somewhat flat when the ears are erect. The head should never look narrow nor should it appear to come to a point at the center or the back of the skull. The occiput should blend into the skull rather than being an obvious "bump" at the back of the skull. Further, the skull should not appear to be apple-shaped or have the rounded appearance of a dome. There should be good fill of muscle on either side of the center line of the skull, which is what gives the head that broad and largely flat appearance. The standard asks for a head that is "slightly arched," and the arch should be at the sides of the skull, not in its overall appearance. Just as important, the head should never be wedge-shaped (narrowest at the nose) when you look down at it.

There is a bone that runs down the center of the dog's skull, and on either side of that bone is flesh that fills in the space between this center bone and the sides of the skull. Together, these elements create the desired look. This tissue develops as the dog ages and then begins to atrophy as the dog enters his senior years, creating a skull that is higher at

Head study of a champion male.

its center and then drops off as the muscle mass disappears. This is normal. However, if there is not enough fill when the dog is younger, the normal aging process will create a foreign look to the head.

The standard requires a noticeable stop (the junction of the muzzle and the skull) that is "well defined but not abrupt." There should be an obvious place between the eyes where there is a rise from the level plane of the muzzle to the nearly level planes of the head. This junction should not be gradual and long but clearly present. The appearance of the stop is enhanced by the eyebrows. The "one-piece" head that is correct in the Flat-Coated Retriever and does not have this well-defined stop is undesirable in a

Golden Retriever. Unfortunately, lack of definition in the stop combined with a lack of chiseling under the eyes has become a rather common fault and is seen frequently in both pet and show Goldens. The lack of chiseling is what creates the undesirable wedge shape of the head, which changes the expression of the dog, especially as it is often associated with poor eye placement, size, and shape. Care must be taken that this does not become an accepted attribute of the head, as it is very uncharacteristic of the breed.

The muzzle should "be straight in profile" and should never have a "bump" at the end or a Roman-nose look. There should be good underjaw, and it should be just a bit wider at the stop than at the tip when viewed in profile. The muzzle from nose to stop should appear to be about the same length as the

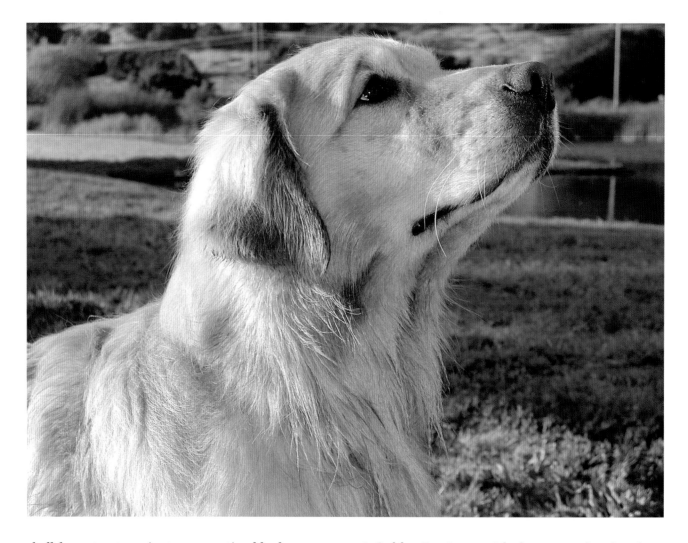

A Golden Retriever with the correct head and expression.

skull from stop to occiput, never noticeably shorter. The short, bearlike muzzle sometimes seen in Goldens might appear cute to some, but it is not a functional mouth for a Golden Retriever. Remember, the Golden is intended to retrieve game—usually birds. A small, short jaw or a weak or narrow jaw will have difficulty grasping and holding a large bird without damaging it as it is carried back to the hunter. The same concerns relate to muzzles lacking in underjaw and proper depth, and mouths lacking proper dentition. The Golden needs a strong muzzle and mouth to perform his function.

The standard permits the removal of facial whiskers but indicates that this is "not preferred." This was one of the relatively few things added to

A Golden Retriever with the correct head and expression.

the standard when it was last revised in 1981. The reason for this change was that the whiskers perform a necessary sensory function, especially in a working dog, and so should be left intact. In the show ring today, most exhibitors cut the whiskers, opting for the "clean look," but most judges actually do not care one way or the other, and judges should never penalize a dog with whiskers intact. I have never heard of a judge not giving an award to a dog solely because his whiskers were or were not trimmed.

The lips, or flews, should never be too heavy, deep, or thick. Their construction should channel

saliva back into the mouth. A Golden should not drool excessively. This is not just for aesthetics (who wants drool all over their hands or legs?); it also relates to function. Dry lips do not hold feathers or dirt the way a drooling mouth does. Again, the correct muzzle is not just something to look at but is required for the Golden's intended function.

The Golden's eyes are the window to his temperament and soul. The standard clearly requires that the eyes convey a "friendly and intelligent expression." The eyes should be "medium large with dark, close-fitting rims, set well apart and reasonably deep in sockets." The requirement for the eyes to be deep in the sockets and the rims to be close-fitting is, again, directly related to the breed's function. Protruding eyes are more prone to damage, especially when the dog is working in tall grass or brush. The desired tight eye rims help keep grass and plant seeds out of the eyelids, thus preventing damage to the eyes and vision. Note also that the standard asks for "medium large" eyes. A small, triangular, slanted, or squinting eye cannot provide the desired soft expression that is an important component of breed type.

All eyeballs are round, so the perceived shape of the eyes is controlled by the shape of the lids. While the standard does not specify the desired eye shape for the Golden, somewhat almond-shaped lids and eyes that appear fairly large are required for the desired expression.

Eye color also matters. Light eyes (eyes that are yellow or amber in color) detract significantly from the correct expression, while a dark eye contributes greatly to the desired expression. When the dog is looking straight ahead, no white should show in a Golden's eye. There should be good dark pigmentation surrounding the eye. The haw, or second eyelid, should not be prominent. Eyeballs bordered by lids that create slanted or narrow, triangular-shaped eyes are specifically faulted in the standard, as they do not convey the desired look of friendliness and intelligence. Judges and breeders would do well to remember that the correct expression is an important part of the distinctiveness of the breed.

Because of the history of eye problems in the breed, the standard requires "dogs showing evidence of functional abnormality of eyelids or eyelashes…to be excused from the ring." This should be directed more at breeders than at judges. Few judges are experts in eye diseases such as trichiasis, entropion, ectropion, and distichiasis, so it is a very rare occurrence that a judge would excuse a dog from the ring because of one of these issues. Breeders, of course, should try to stay away from any of these eye problems.

The correct shape and placement of the ear again relates directly to the breed's function. The standard requires ears that are "rather short" and attached "well behind and just above the eye." To determine the correct length, the standard points out that "when pulled forward, tip of ear should just cover the eye." This means the eye on the same side of the head, not the opposite side! Long, low-set, or heavy ears should be faulted. Ears that are too long will trail in the water when the dog swims. Low-set ears will allow water to run into the ear canals, perhaps causing the dog to shake his head and potentially lose the bird in his mouth. In addition, water in the ear canals may cause infection at a later time.

Despite what you see in the show ring, there is nothing in the standard that requires the ears to be erect at all times. In fact, correct ear set cannot be determined when a dog is being baited or alerted to keep his ears erect. Judges should evaluate the ear set when the ears are at rest, as excess length and incorrect ear set can be hidden when the ears

are erect (which, indeed, may be the reason for the baiting).

While not addressed directly in the standard (except in the case of the nose), correct dark pigmentation plays a strong role in the Golden's desired expression. Not only should the nose be black ("pink nose or one seriously lacking in pigmentation to be faulted") but the lips and eye rims should also be black. Flesh-colored eye rims particularly detract from the correct expression. A lack of pigmentation in the lips or eye rims should be faulted by both breeder and judge. Good dark pigmentation is part of a good Golden.

Goldens are subject to "winter nose," in which the nose loses substantial pigmentation in the wintertime and therefore looks somewhat pink in color. In the show ring, some exhibitors resort to "painting" their dogs' noses with chemicals to create the appearance of a black nose. Let me point out here that most judges are not fooled one bit by this. If a dog has correct black pigmentation around the eyes, on the lips, and at the base of the nose, the judge knows that the pink nose is a "winter nose" and will

Note the two dropped incisors in this misaligned bite. This is a common fault in the breed.

not fault it. Not only is the judge not fooled by coloring but AKC rules also prohibit the use of chemicals or dyes to alter the appearance of a dog; judges are supposed to excuse from the ring any dog who they think has been artificially altered in any way.

There are only two disqualifications in Goldens: being outside of the specified size range and having an incorrect bite. The required bite in a Golden is a "scissors bite, in which the outer side of the lower incisors touches the inner side of the upper incisors." An undershot bite (in which there is a noticeable gap caused by the lower jaw and teeth extending beyond the upper incisors) or overshot bite (in which the upper jaw creates a gap by extending too far beyond the lower) bite is a disqualification. A bad bite is a fairly serious problem and can affect the dog's quality of life; in addition to inhibiting a dog's ability to retrieve, it can make it more difficult for the dog to eat. A level bite (where the upper and lower incisors meet each other edge to edge) is "undesirable, but not to be confused with undershot or overshot." A level bite will cause the teeth to wear down very quickly, sometimes exposing the inner nerve, which can be painful for the dog.

Further, the standard states, "Full dentition. Obvious gaps are serious faults." Judges of Goldens are expected to check for a full complement of teeth in the dog's mouth. This does not mean that it is necessary to open the jaws and count the teeth. Rather, when the judge examines the dog's mouth, he is expected to lift the lips to look for obvious gaps where teeth should be. The requirement for full dentition and the faulting of obvious gaps created by missing teeth was added in the 1981 revision of the standard and goes along with the "form follows function" nature of the standard, as teeth are necessary for the dog to hold game in his mouth while retrieving.

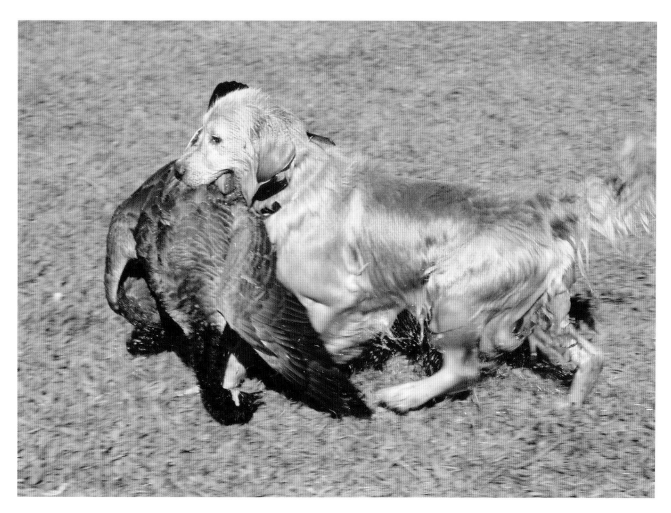

Great strength of jaw and neck is needed for this Golden to retrieve a Canada goose that probably weighs more than 20 pounds. And, yes, this is a multiple Group-winning champion show dog.

Missing teeth can have several effects on the lower jaw. First, they can create a weakness in the jaw. Second, too many missing teeth, especially the large molars, can make it more difficult for the dog to hold a bird. What should a judge—or breeder—do when he sees the "obvious gaps" mentioned in the standard? This will depend on each judge's individual interpretation of the standard. The standard uses the word "gaps," in its plural form, so I take this to mean that more than one gap should be faulted. How severely? Again, this depends on the judge, but

if there are several large molars missing, for example, I treat this as a fairly serious fault. But one missing small premolar would certainly not concern me as much. How many missing teeth is too many will depend on the judge, but I often think "three strikes and you're out" (of contention as a winner), because missing teeth are considered a "serious fault" and thus may affect placement in the class.

Again, the head is the index to the breed. From my point of view, the correct head is a very important part of the picture when evaluating a Golden, whether in the show ring or from a breeder's viewpoint. Many Golden breeders have ignored the heads on their dogs while placing greater concern and emphasis on the overall body for far too long. As a result, many judges comment that they have

difficulty judging the breed because they see so many different head styles. More importantly, we run the great risk of losing the correct head and expression that has been a part of the Golden Retriever since the breed first began in the mid-1800s. To lose this typical head would, in my mind, be a great tragedy. Unfortunately, this is a process that has, without question, begun.

Body

The Golden Retriever breed standard discusses the structural requirements for the dog's body in three sections, and I will do the same here. First, we will deal with the neck, topline, and body section, then move on to the forequarters, and finally discuss the hindquarters.

Neck, Topline, Body

***Neck, Topline, Body**—Neck medium long, merging gradually into well laid back shoulders, giving sturdy, muscular appearance. No throatiness. Backline strong and level from withers to slightly sloping croup, whether standing or moving. Sloping backline, roach or sway back, flat or steep croup to be faulted. Body well balanced, short coupled, deep through the chest. Chest between forelegs at least as wide as a man's closed hand including thumb, with well developed forechest. Brisket extends to elbow. Ribs long and well sprung but not barrel shaped, extending well towards hindquarters. Loin short, muscular, wide and deep, with very little tuck-up. Slabsidedness, narrow chest, lack of depth in brisket, excessive tuck-up to be faulted. Tail well set on, thick and muscular at the base, following the natural line of the croup. Tail bones extend to, but not below, the point of hock. Carried with merry*

action, level or with some moderate upward curve; never curled over back nor between legs.

The neck not only has to carry the head, it has to have the strength necessary for the dog to hold and carry a heavy bird in his mouth. The neck should have a crest just behind the skull and then should "merge gradually into well laid back shoulders, giving sturdy, muscular appearance." A "goose neck" (one that is thin and lacking strength), a short neck, or a neck that appears to rise vertically from the backline like the vertical part of an "L" is neither functional nor pretty and is undesirable.

The neck should gradually broaden as it approaches the withers; it should not be the same width near the head as it is near the backline. Even more importantly, the neck should form a gradual curve as it merges smoothly toward the backline. When you run your hand down the topline from the head to the backline, you should never feel any obstruction; your hand should glide smoothly into the withers. If you feel a bump, you have very likely found a set of upright shoulders with poor layback, resulting in a lack of desired angulation. Visually, it should be impossible to tell exactly where the neck ends and the back begins; they just flow together. This gradual merging can only occur with properly laid-back shoulders. Upright shoulders will create the "L" look and will make the neck look shorter, as well.

It should also be noted that the standard asks for "no throatiness." Excess skin hanging under the throat is undesirable in a Golden. The jawline should merge smoothly into the front of the neck.

Head carriage is controlled by the structure of the neck and of the forequarters. For proper balance while both standing and moving, the head needs to be carried somewhat forward of the body. This provides balance and allows the dog to carry a bird over

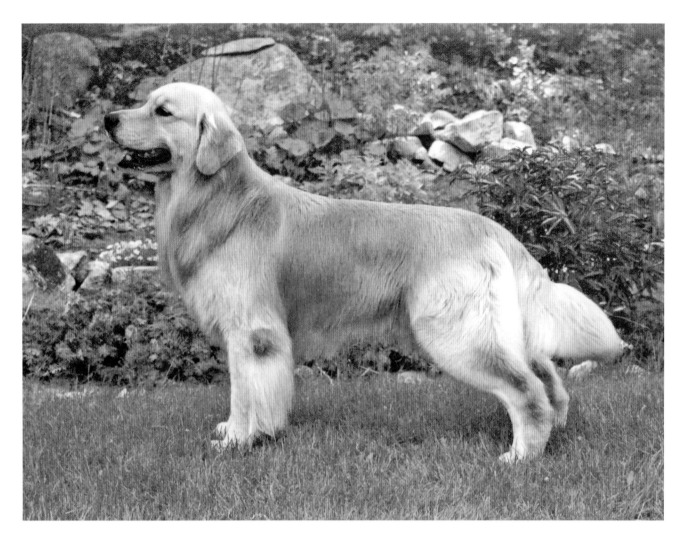

This is a very correct and desirable silhouette that is only possible with correctly laid-back shoulders.

long distances if necessary while permitting correct movement. When gaiting, the Golden's head will move farther in front of the body to maintain correct balance and efficient reach and drive. A head that is carried over the shoulders is the result of incorrect structure and is not desirable. It should be noted here that incorrect handling of a dog in the show ring can artificially create this faulty-looking neck. If a handler baits the dog so that the head is over the shoulders, the faulty neck carriage must follow. The same is true if the dog is "strung up" by the lead (so

that his head is pulled back over his shoulders) when gaited, which will also cause the front feet to come off the ground much more than is desirable.

As with so many other areas, each body section of the dog is directly related to the other parts of the dog. I hope the message here is clear: correct neck carriage cannot exist without correctly laid-back shoulders in the same way that a correct forechest cannot exist without the correct angulation of the front assembly.

Looking now at the backline, it should be "strong and level from the withers to the slightly sloping croup, whether standing or moving. Sloping backline, roach or sway back, flat or steep croup to be faulted." Here is another area too often ignored by

breeders and judges. In the show ring, we too frequently see Goldens stacked (posed) with their rear legs pulled too far back behind their bodies. This inevitably leads to a topline that slopes downward from the shoulders, which is clearly not desired by the standard. Many breeders seek sweeping rear angulation that is in excess of what is stated in the standard. This causes many balance problems, one of which is a crouched look to the rear quarters combined with a topline that slopes downward toward the croup. Another such problem is poor movement. One should be able to draw an imaginary vertical line from the buttocks straight down alongside the back of the rear pastern to the ground when the dog is standing.

The section of the standard on body is quite detailed and should provide a good understanding of the Golden's desired body shape. One of the most important words in this section is *balanced*. Balance is the harmony between the various parts of the body, creating an appearance in which everything fits together perfectly, with no individual part standing out in comparison with the others. Everything blends together to form a harmonious whole. Only the best dogs will have truly balanced bodies. This balance is unmistakable and can be seen both when the dog is standing in profile and when he is moving.

Note that the body is to be "short coupled," meaning that the loin—that area of the back between the last rib and the rear assembly—should be short. The long rib cage is desirable for protecting the vital organs, providing the organs with adequate space, and providing support for the spine. The width and depth of chest, as well as the spring of rib, are necessary to provide room for the heart and lungs to expand, which is directly related to the stamina necessary for a working dog. The "well developed

forechest" is related to the breadth of chest and the proper angulation of the shoulder and upper arm, both of which are required for correct movement. You cannot have one without the other.

It is important that the rib cage extend well back toward the rear, and that the loin (which is the unsupported part of the back behind the ribs and in front of the rear legs) should be short—perhaps just over the width of a man's hand, excluding the thumb. Excess length in loin can create a weakness in the backline and could be especially detrimental to a bitch in whelp. Remember, a litter of ten to twelve pups is quite normal in the breed, and during the later stages of pregnancy, the unborn pups add significant weight for the bitch to carry around.

The underline is too often ignored when talking about the Golden standard. The standard indicates that "very little tuck-up is desired." This, when combined with the requirement for a deep chest, means a bottom line that is at or just below the elbow. Because Goldens are often well feathered in this area, if the exhibitor or judge does not pay attention to the amount of hair hanging beneath the dog, it is possible to create the impression of good depth of chest when it is not present. However, excess hair beneath the body can create the appearance of short legs when this is not actually the case. Many dogs would benefit from their handlers' awareness of this potential issue and some judicious trimming when it is necessary.

At the end of this section is the tail. The tail, an extension of the spine, serves many functions in the Golden Retriever. First, it is a clear indicator of the temperament of the dog, and of the breed in general, and it communicates many things, from contentment to fear to anxiety to boundless joy. The happily wagging tail of the Golden is very

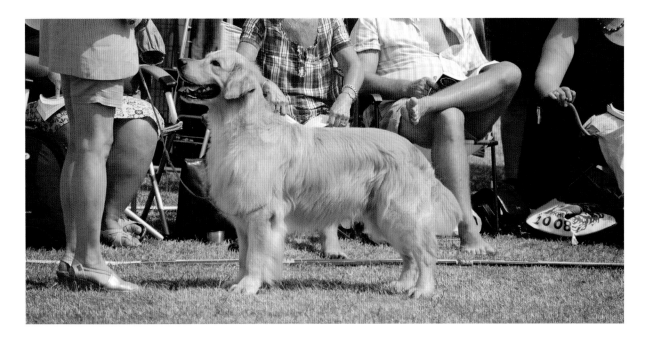

ABOVE: An example of a strong and level backline with slightly sloping croup on a standing dog.
BELOW: Nearly flawless movement with the level backline required by the breed standard. Note the balanced extension front and rear and the correct head and tail carriage.

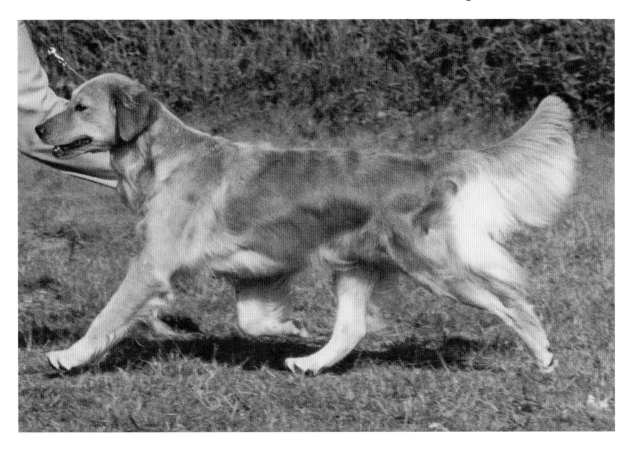

much a part of his personality and of the appeal of the breed.

The tail is not there just to wag. It has functions that directly relate to movement as well as demeanor. The tail acts as a counterbalance for the dog when he is twisting and turning or headed around a curve while running. In the water, the tail acts as a kind of rudder, helping to steer the dog in the direction he wants to swim. Therefore, the standard requires the tail to be thicker at the base and carried "...level or with some moderate upward curve; never curled over the back nor between the legs." Far too many Goldens habitually carry their tails too high—say, at a position equal to one o'clock or even twelve o'clock—or even curled over the back. This is atypical for the breed. Remember, the tail is a rudder—not a sail!

Forequarters

Forequarters—Muscular, well coordinated with hindquarters, and capable of free movement. Shoulder blades long and well laid back with upper tips fairly close together at withers. Upper arms appear about the same length as the blades, setting the elbows back beneath the upper tip of the blades, close to the ribs without looseness. Legs, when viewed from the front, straight with good bone, but not to the point of coarseness. Pasterns short and strong, sloping slightly with no suggestion of weakness. Dewclaws on forelegs may be removed, but are normally left on. Feet medium size, round, compact and well knuckled, with thick pads. Excess hair may be trimmed to show natural size and contour. Splayed or hare feet to be faulted.

The forequarters are probably the anatomical component that needs the most improvement in Goldens—as they are in most breeds. A good front assembly seems to be one of the areas that breeders find very difficult to incorporate into their lines and, unfortunately, is equally easy to lose once attained. In my experience, a good front (a front with proper angulation combined with correct and equal length of the scapula and the upper arm) appears to be genetically recessive rather than dominant, making it very difficult to maintain in a strain. Breeders should concentrate more on having good fronts and good angulation—front angulation equal to the angulation of the rear—in their breeding stock.

There was a time, perhaps in the late 1970s, when Golden breeders realized a need to breed for more angulation in their dogs. Dogs at that time had less angulation, both front and rear, but often did have a good balance between the two. The breeders realized that adding angulation in the rear made for a dog who could potentially move better and was visually more "showy." Breeders soon learned that improving rear angulation is not extraordinarily difficult, and therefore did not pay as much attention to the front assembly. As a consequence, the rush to breed greater rear angulation led to a loss of the very important balance of angulation between front and rear. This resulted in movement faults and the unbalanced front movement of many Goldens today. With this in mind, let's look at what is necessary for a good Golden front. Because the forequarters are quite probably the most misunderstood part of the anatomy of the dog, I will cover this subject in a bit more detail.

Less-than-ideal placement of the scapula and/or too-short upper arms often create problems. If the scapula is at a steeper angle than desirable, for example, movement faults are often the result. A front assembly that is placed too far forward on the body, somewhat like the legs on a grand piano, will force the dog to stand over himself. The angulation

resulting from this forward placement will be steeper than desired and, consequently, can result in short, choppy, inefficient front movement. Short upper arms will not provide the return angulation toward the elbow that is required for correct reach.

Correctly placed legs are positioned behind the neck's junction with the body, thus placing the elbows directly below the withers and providing a good forechest. You can tell if the legs are correctly placed; you should be able to draw an imaginary straight line from the withers through the elbow to an ending point just behind the front foot.

The standard asks for a front that is "muscular, well coordinated with hindquarters, and capable of free movement." The canine shoulder assembly lies along the rib cage and is held in place by muscles and tendons—rather than the ball-and-socket joints found in human shoulders—and provides greater flexibility than a ball-and-socket assembly would permit. The strength and conditioning of these muscles and tendons (which move the scapulae back and forth, thus providing part of locomotion), affect their power and placement and, therefore, the dog's movement. The movement of the shoulder blades along the rib cage can be seen by simply watching the shoulder blades when the dog is gaiting, which demonstrates this flexibility quite clearly. Their optimum placement is critical for correct, balanced movement. To build the desired front, the shoulder blades need to be long and must lie back properly along the ribs. The position of the shoulder blades should not in any way approach the vertical.

The correct specific degree of shoulder layback has been the subject of much investigation over the years. Of course, the first issue is deciding just where one finds the exact points from which the measurements should be taken; all of these are measured

off a vertical line. Taking a measurement at a point a bit farther forward on the scapula or farther forward on the forearm assembly will, obviously, change the degree of angulation. Many judges and breeders measure front angulation by using their hands to feel for the top of the scapula (the withers) and then measuring from that point to the point of shoulder (the foremost junction of the scapula with the humerus, or upper arm). This is an easily determined shortcut to help us visualize the placement of the scapula. In ideal terms, this imprecise shortcut provides a visual angle approaching 45 degrees. This is probably where the basis of the 45-degree angle given as the ideal front angulation in a number of breed standards (though not in the Golden Retriever standard) comes from, and it is the most common visual method of checking the angulation on dogs. Others will measure from the rearmost point of the scapula rather than its highest point, creating a greater angle than actually exists. No matter where a person measures from, it must be consistent. At the same time, you must remember that these shortcut measurements do not reflect the actual physical angulation seen on x-rays.

From the 1970s, Rachel Page Elliott, who had long been intrigued by the reasons behind correct movement and had published a book on canine movement in 1971, continued her long-term research by investigating the actual physical angulation on a correctly moving dog. She used a new technique called *cineradiography* ("moving x-rays"). These moving pictures of the actual bones, muscles, and tendons and their interrelationships as the dog moves at a trot resulted in her revising her thinking, as they offered proof that in real, functional terms, the mythical 45-degree layback does not exist on a correctly built and good-moving dog.

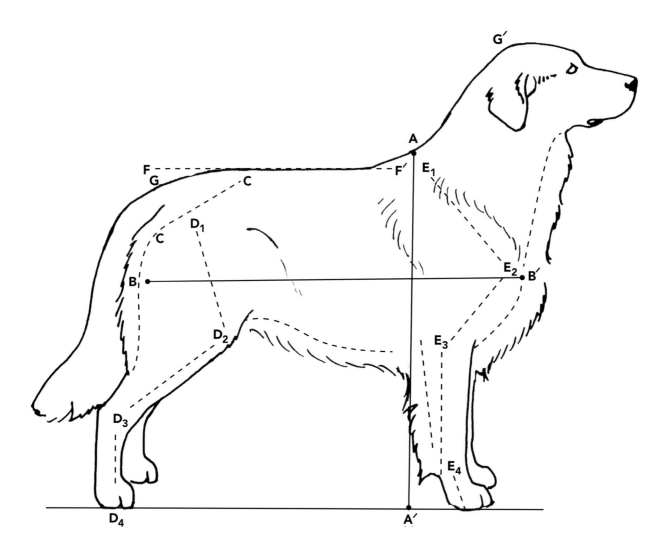

The results of this research were discussed in extensive worldwide lectures and appeared in Mrs. Elliott's well-known book *The New Dogsteps* (1983). She examined this subject further and more recently in *Dogsteps: A New Look* (2001). In these books, Mrs. Elliott describes just how a correctly-moving dog is constructed so that he can move properly. There is a raised spine along the center part of the scapula that serves as the separation point for the tendons and muscles that create movement. (This ridge is hidden by flesh and coat, making it difficult to see or feel, but it is obvious in x-rays.) The scapula itself lies along the ribs, reaching toward T2 (the second thoracic vertebra along the spine), and is held in

The points on the illustration on the left show the external landmarks for taking shoulder-lay-back measurements, while the illustration on the right shows the internal (functional) measuring points.

place by muscles and tendons attached along either side of this ridge.

This central spine on the scapula is the reference point from which Mrs. Elliott and her colleagues measured shoulder layback and angulation on the dog. Following this bony spine, they measured down the ridge of the scapula to the point on the top of the humerus located directly below the ridge. This contin-

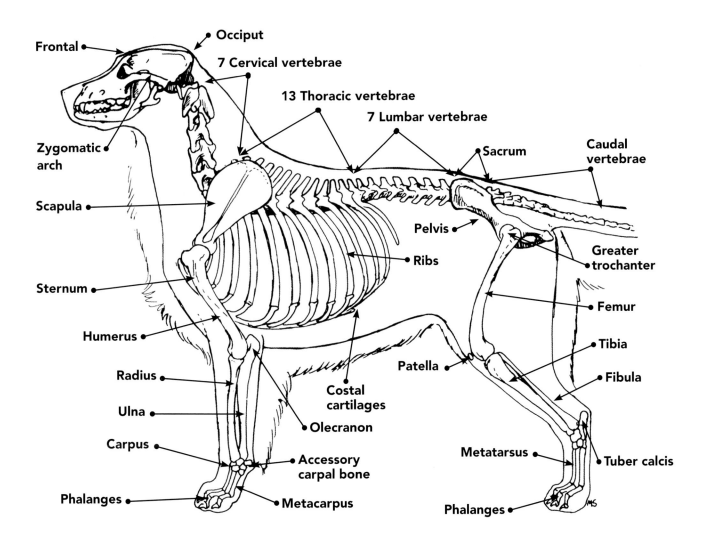

These illustrations show the actual front angulation based on the external and internal measuring points.

ued back to the rearmost tip of the elbow to determine the angulation of the forequarters. This study proved that the desired angulation was not 90 degrees but a more open angle of approximately 110 degrees. As dogs are living creatures, this measurement will vary slightly from dog to dog and breed to breed.

Further, backed by research done by Dr. Farish Jenkins of Harvard and Curtis Brown, among others, Mrs. Elliott's research revealed that the actual functioning layback angulation on a well-built, good-moving dog (as closely examined by cineradiography and ultra-slow-motion photography), is closer to 30 to 35 degrees (measured off the vertical) when measured along the spine of the scapula from the withers to the lower end of that ridgelike structure.

Regardless of the measuring points used, the upper tips of the shoulder blades should be located along the spine, directly above the elbows, and should be fairly close together. But there still should be some space between the two blades so that they can move freely. The shoulder blades have a good deal of mobility, which is influenced by their length and the shape of the rib cage, which in turn impact the position of the elbows and legs as the dog moves.

Well-balanced reach and drive is illustrated in this photo. Notice how close to the ground the feet are at full extension, showing little wasted motion.

Correct movement is a complex action that requires much study and understanding of canine anatomy. It is a study that continues today. For a full discussion on the correct structure required for good movement, I urge you to read Mrs. Elliott's *Dogsteps: A New Look* and to make use of the many illustrations of proper structure found in that book.

The upper arm begins at the base of the scapula and extends downward and toward the rear of the dog at a complementary angle equal to the angle of the scapula so that the elbows are placed directly under the withers. For the dog to move properly, the length of the upper arm needs to be approximately equal to or, at most, very slightly longer than the length of the scapula. Short upper arms, a very com-

mon fault in Goldens, negatively affect correct reach; if there is inadequate length of bone, the legs cannot reach as far forward of the body as desired. This results in short, choppy steps.

Front legs should be straight, with adequate bone. This does not mean that the Golden should have the heavy (meaning thick) bone desirable in massive breeds such as the Newfoundland. It does mean that thin legs (meaning those with fine bone) that look out of proportion to the body, therefore

appearing as though they might have difficulty holding the Golden up, are undesirable. The current fad of back-brushing the coat on the legs to make the hairs stand up and away from the bone (like a bristle brush) is wrong. This is done in an attempt to create the appearance of heavier leg bone, but might actually create the impression of too much bone, resulting in a coarse look. Elbows should point neither in nor out; rather, they should be parallel with the rib cage. Feet should point straight ahead.

The front pasterns, or wrists, should not be vertical but should slope slightly from the leg bones to the feet. This slight bend creates a kind of a shock absorber for the foot, cushioning the impact as the foot comes down and hits the ground, thus helping avoid a breakdown of the foot. Shock absorption is especially important for a dog who is expected to work on varying kinds of terrain, both hard and soft, as he does his job of retrieving game. Too much slope in the pastern, however, indicates a weakness of the wrist and is not desirable.

The medium-size feet require thick pads to protect the delicate bones from the shock of repeated impact as the dog moves across varied terrain. There should be good knuckling of the toes. Excess space between the toes—or splayed toes—is often accompanied by flat feet, which do not have the strength or resilience necessary for good endurance.

Hindquarters

Hindquarters—Broad and strongly muscled. Profile of croup slopes slightly, the pelvic bone slopes at a slightly greater angle (approximately 30 degrees from horizontal). In a natural stance, the femur joins the pelvis at approximately a 90-degree angle; stifles well bent, hocks well let down with short, strong rear pasterns. Feet as in front. Legs straight

UNDERSTANDING ANGULATION

It is important not to confuse the visual shortcut methods with functional measurements. For many of us, using our hands to measure provides a visual shortcut to checking front angulation. This works as long as we understand that this is strictly a visual aid and that it probably will not reflect the actual physical construction of the dog. Using this shortcut, from the front of the dog—measured from the point of shoulder to the withers—the scapula should rise up toward the rear at an angle extending well back along the ribs at what appears to be approximately a 40-degree angle. Thus the mythical 45-degree angle does not really occur even when using this visual method, though the apparent visual angulation will often be greater than the actual functional measurement.

when viewed from rear. Cowhocks, spread hocks, and sickle hocks to be faulted.

There are several issues that are worthy of mention in this section, but none more than the requirement for a "broad and strongly muscled" rear. When you place your hands on the buttocks of a Golden, the muscles should be hard and well defined. In the opening paragraph of the standard is the admonition that "dogs should be shown in hard working condition." The first place a judge will go to test for proper conditioning will be these rear muscles. Judges do not like soft, flabby muscles or small muscles. The

A midair leap into the water, powered by strong, muscular hindquarters.

dog gets much of his propulsion, on land and especially in the water, from the strength of his rear.

Note also that the croup is supposed to slope slightly, which places the tail at a downward angle so that it extends behind the dog rather than above the backline as in some other breeds. An upright tail, as seen in most terriers, for example, is undesirable in a Golden. As discussed earlier, correct placement allows the tail to act as a means of balance on land and as a rudder in the water.

The required rear angulation provides the necessary balance of reach and drive for correct movement. The rear legs should be in "a natural stance" when assessing rear angulation, not in the exaggerated stance often used by handlers in the show ring. Many smart judges will assess angulation when the

dog is "free stacked" (standing in a natural position without any assistance from the handler) rather than when the dog is standing for examination, artificially posed by the handler.

To determine whether your dog's rear legs are properly placed, draw an imaginary line from the buttocks to the floor. The rear pasterns should fall directly in that line. Be careful not to move the rear legs too far behind this line, or you will create an unbalanced look to your dog.

The standard asks for well-bent stifles (knees on the rear legs), which is part of proper angulation. The hock joints (the tops of the rear pasterns) should

be parallel with each other. They should never face in ("cowhocks") or out ("spread hocks"). In the parallel position, all of the energy of the rear legs is used to push against the ground to provide forward propulsion. If the hocks are pointing to either side, some of this energy is wasted in incorrect movement.

Good feet (round, compact, and well knuckled, with thick pads and tight toes) are necessary on all four feet. The feet, of course, must push against the ground for the dog to move forward and must cushion the dog's landing with each step to protect the organs from unnecessary jarring. Splayed feet cannot absorb the shock of landing nearly as well as properly constructed feet. Thus, splayed feet will break down quicker, causing the dog to become lame. Rear feet must face forward.

Coat

Coat—*Dense and water-repellent with good undercoat. Outer coat firm and resilient, neither coarse nor silky, lying close to body; may be straight or wavy. Untrimmed natural ruff, moderate feathering on back of forelegs and on underbody, heavier feather on front of neck, back of thighs and underside of tail. Coat on head, paws and front legs is short and even. Excessive length, open coats, and limp, soft coats are very undesirable. Feet may be trimmed and stray hairs neatened, but the natural appearance of coat or outline should not be altered by cutting or clipping.*

The coat plays many roles for the dog. The coat is the outer package, the icing on the cake, that helps make the Golden so attractive to the eye. But a correct coat, which allows the dog to perform his intended function, is crucial. The coat provides protection from the heat and cold; the undercoat

insulates the body while the outer coat protects the dog from dampness and the ravages of the environment. The standard is quite clear on the qualities of the required coat, and it is a serious mistake to try to change the coat to fit your own purposes. The coat is certainly one area in which "more is better" is not necessarily true. Remember, excessive coat is specifically faulted in the standard.

The standard asks for a coat that is "dense and water-repellent with good undercoat." The correct coat, therefore, is thick, slightly coarse, and firm to the touch, never soft and silky or, even worse, woolly. The top coat is designed to protect the dog's body. Pass your hand over a correct Golden coat, and you'll find that the guard hairs of the outer coat may feel somewhat stiff or coarse to the touch. This is correct. The coat should not be exceedingly soft and silky and must certainly not stand away from the body. It need not be straight; a slight wave is specifically mentioned as being correct in the standard.

The proper undercoat, the density of which will vary according to the season and climate, is softer and provides the layer that lies against the body to protect the skin and insulate the body from the cold. A lack of undercoat will rob the body of necessary heat in cold water and cold weather. The undercoat also provides a degree of protection from excessive warmth, much like how the insulation found in the attics of homes works to minimize heat loss in the winter and shield against excessive heat in the summer. Much of the undercoat will be shed in the heat of summer, however, so the required double coat may be difficult to find in the summer and year-round in warmer climates.

The coat needs to be brushed regularly—at least weekly—all the way down to the skin to remove loose, dead hair and allow air to reach the skin. As many

The damp coat of a Golden after a water retrieve shows its density and water-repellent properties.

Golden owners learn, the breed is susceptible to skin diseases, including "hot spots" that can result from incomplete brushing. The skin needs to breathe, and moisture must be able to evaporate to help prevent this itchy, moist eczema from plaguing the dog.

There is an unfortunate tendency today for owners and handlers to prepare their dogs for the ring by fluffing up the coat so that it stands on end instead of lying flat against the body as the standard requests. The use of various grooming products permits the skillful exhibitor to sculpt the coat to lie in the desired directions. Artfully done, this can create the visual impression of additional thickness of the leg bones or of correct shoulder layback and good length of neck. However, this "fluffed and puffed" coat is clearly contrary to the breed standard and should always be faulted by judges. It is certainly not the waterproof jacket that the standard desires.

Over the years, exhibitors have become more and more skillful with their grooming techniques, but these efforts also take a good deal of time. A dog who is kept on the grooming table while his handler spends an hour or more preparing him has to get tired and may not perform as well in the ring when it counts, which harms his chances of winning. Further, a coat that is constantly bathed will, over time, have its natural oils depleted and will not carry the healthy shine we all look for; the skin may become dried out as well. And, without question, a coat with too much grooming product in it will not have the firm texture that indicates the correct water-resistant properties required by the standard.

When I first started showing my own Goldens in the early 1970s, standard grooming practices were much simpler and much less time-consuming. Show dogs were trimmed and bathed at home. Ears were neatened and excess coat on the feet was removed

The author winning Group Two with Am./Can. Ch. Pepperhill Yankee O' Goldtrak in 1986, showing the less exaggerated grooming of years gone by.

to show the natural outlines. Tail feathering was trimmed a bit to avoid the impression of thinness or excessive length. Dogs were bathed after being trimmed. I can still distinctly remember how long it took to wet down the coat enough to apply shampoo—most of the water tended to roll off the coat like it would from a duck's feathers, just as the founding breeders intended.

In contrast to today, preparation at the show grounds was fairly quick. A coat conditioner such as Full Bloom might have been sprayed on the coat, and the coat would certainly have been brushed out— perhaps with some cornstarch or powder to remove any dirt or to separate the feathering a bit—but that

was usually the extent of it. You then had a well-rested dog who was ready to go into the ring.

The overall goal of today's excessive grooming, I suppose, is to fool the judge into thinking that the dog is better than he actually is. Most judges are not so easily fooled. The drawback of this kind of preparation (besides the time needed and the costs of equipment and products) is that it can backfire. Certainly, to many eyes, a dog looks better with every

hair in place and the sculpted appearance of correct structure. The question is, who is being fooled by this? Make sure that you don't fool yourself when it comes time to breed the dog.

There are pitfalls that seem to be overlooked in the zealous drive for the perfect silhouette on a dog, especially if these preparations are carried out simply because "everyone else is doing it." To begin with, not all dogs have the same problems, so not all dogs need the same "solutions." Fluffing up the body coat can have undesirable effects other than the obvious faulty open coat. For example, a coat standing away from the body tends to move more than a coat lying close to the body. As a result, dogs who tend to have a slight (and undesirable) rolling motion to the topline when moving will, if fluffed and puffed, display considerably more unwanted movement in the backline when gaiting. Because this rolling motion is already an issue for the breed, doing anything that makes it more obvious just doesn't make sense. Judges fault this rolling motion, as it usually indicates incorrect physical structure, so this grooming technique creates a bigger fault rather than an enhancement.

Color

Color—Rich, lustrous golden of various shades. Feathering may be lighter than rest of coat. With the exception of graying or whitening of face or body due to age, any white marking, other than a few white hairs on the chest, should be penalized according to its extent. Allowable light shadings are not to be confused with white markings. Predominant body color which is either extremely pale or extremely dark is undesirable. Some latitude should be given to the light puppy whose coloring shows promise of deepening with maturity. Any noticeable area of

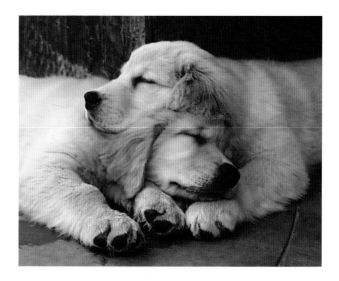

Look at the darker color on the puppies' ears, which is a better predictor of their overall coat color as adults.

black or other off-color hair is a serious fault.

The AKC breed standard calls for "Rich, lustrous golden of various shades." There will always be some personal preferences for one shade or another, but the overall color of the coat should fall within the acceptable range. Dogs that appear totally white or very light cream with no hint of gold in the coat, or dogs that appear to be dark red, as might be desired in an Irish Setter, fall outside the parameters of acceptable color, which permits a very wide range of shades.

Those new to the breed are often unaware that puppy coat color will tend to deepen as the dog matures, especially on lighter-colored dogs. Look before you fault. Young puppies tend to have darker coloring on their ears than anywhere else on the body. The color of the ears will almost always eventually blend with the color of the body coat as the dog matures. The coat will darken somewhat, with each succeeding coat shed until the ears and coat match. This process might take five years to finish. Because of this natural progression, youngsters should not be

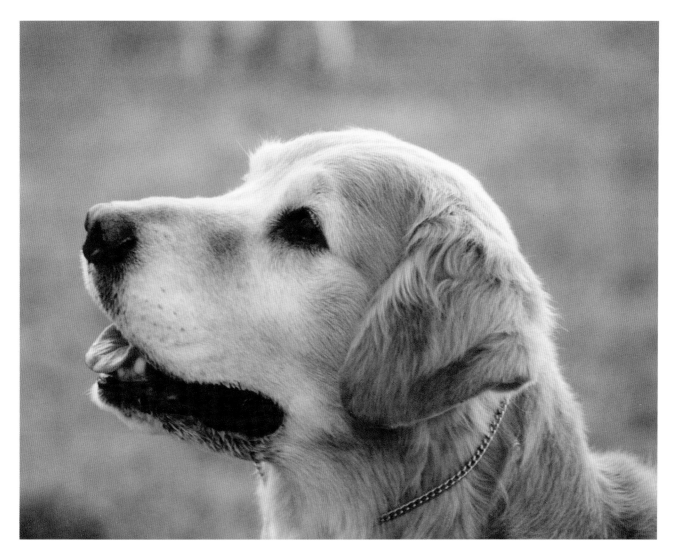

As Goldens age, they often gray around the muzzle, but this is not to be faulted.

penalized for being too light in color if they show the hint of darker color on their ears.

More importantly, color should probably be the last thing considered when evaluating a Golden Retriever. There are so many other facets of the dog that are much more important than color. Unless the color falls outside the accepted parameters, choosing a dog based simply on color is almost always a mistake. Those who judge the breed should pay particular attention to this statement. I have judged Goldens all over the world for more than twenty-five years, and in all of that time and with all of those dogs, there has never been a time when the winning dog was chosen based on color. I have never been in a position of judging two dogs that were so equal in quality that there was nothing but the color left as the deciding factor.

It is also important to remember that in many other countries, breed standards specifically mention cream as an acceptable color for a Golden Retriever. One of the bigger differences between the AKC breed standard and that of The Kennel Club in the United Kingdom is the section on color. (See Chapter 8.) This section in The Kennel Club standard reads, "Any shade of gold or cream, neither red

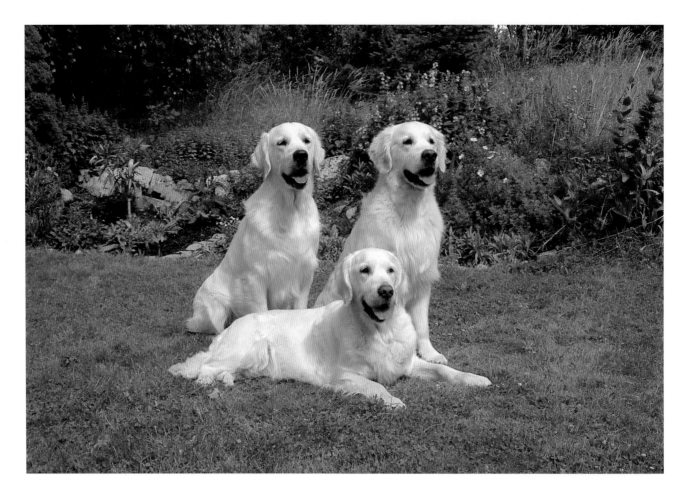

nor mahogany." Any countries following the rules of the Fédération Cynologique Internationale (FCI) The Kennel Club breed standard, so cream-colored Goldens are quite acceptable in most countries around the world. Dogs imported to the United States from other countries often have these lighter-colored coats.

People often ask which standard's color requirement is more historically accurate. That is hard to know. Most of the photographs and paintings we have of early Goldens show dogs that tend to be in the middle or darker range of acceptable color. At the same time, it is true that the breed is called a "Golden" Retriever, so it is probably correct to think that the cream color is a bit lighter than that of the original dogs. Some earlier authorities on the breed believe that the change made to the English breed

A trio from Sweden with the cream-colored coats allowed by the FCI.

standard in the mid-1930s was done to allow for the light shadings often seen on the feathering of Goldens and was not intended to permit a predominant body coat color of cream. Many others would disagree. Certainly there were some notable lines of Goldens in the United Kingdom in the 1940s and '50s in which the cream-colored coat was dominant. Because dogs of these lines were winning in the show ring, they were often used as sires by other breeders, perhaps resulting in many Goldens with cream-colored coats. In the end, what is important is not so much the shade of gold that your dog has but just how well he meets the requirements of the breed standard.

Gait

The second-to-last part of the standard deals with "Golden gait." Assessing gait requires the knowledgeable person to put together all of the parts of the dog that have been spelled out in previous sections of the standard. Correct gait is the result of correct type and structure; you cannot have one without the other.

Gait—When trotting, gait is free, powerful, and well coordinated, showing good reach. Viewed from any position, legs turn neither in nor out, nor do feet cross or interfere with each other. As speed increases, feet tend to converge toward center line of balance. It is recommended that dogs be shown on a loose lead to reflect true gait.

The discussion of correct gait in the Golden is a major topic. The Golden world's leading authority on correct movement was undoubtedly Rachel Page Elliott, whose editions of *Dogsteps* can be considered the bible for correct movement in the breed. The last version, *Dogsteps: A New Look* (2001), is an excellent and easy-to-understand explanation of correct gait that should be on your short list of books to purchase. Some of the drawings from this book appear in this chapter with the author's permission.

The correct gait of a Golden Retriever is balanced and well-coordinated, showing good reach and drive. Truly balanced movement is athletic and smooth. The effortless gait of the correctly structured dog is readily apparent to all who see it, and it makes the dog stand out from the crowd. When we see a dog like this move, several things become obvious quickly: there is no wasted motion; legs do not fly up in the air; the head is carried forward of the body, not above the back; the body moves forward with no roll or swaying of the backline; the feet touch the ground well forward and well behind the dog; and, at full extension, the feet rise only an inch or so above the spot where they touched the ground.

Correct reach and drive is determined by where the dog places his feet on the ground in each stride, not by how high in the air the feet fly when moving. Flying feet might attract the eye, but this type of movement is contrary to the requirements of the breed standard and is just wasted motion. Balance is the key.

Correct reach and drive, and correct movement in general, is dependent on proper structure. Good, balanced angulation is required for good movement. Note the position of the bones in the drawings. Study the sketches of the dogs standing on page 115 and note the differences in the position of the bones on both dogs. The dog with proper angulation stands better than the dog with poor angulation. The correctly angulated dog appears balanced as a result of proper placement of the forequarters, and his backline is level in comparison with the poorly constructed dog. He even has a better forechest than the poorly angulated dog. The correctly structured dog not only moves better, he looks better.

Good angulation permits a smooth, ground-covering stride that is well balanced. However, good conditioning, a sense of athleticism, and strong, flexible joints all contribute to good movement. Coordination is also a part of good movement. The dog needs to learn correct foot timing so that the action of the front legs coordinates with the equivalent action of the rear legs. At a trot, the legs on opposite sides of the body must work together so that as the right front leg moves forward, the left rear leg moves forward with it. The opposing legs must not interfere with each other on the return stride. The diagonal rhythm that is necessary for correct movement means that all four legs must work together

and have equal angulation in both front and rear quarters.

Even with correct structure, poor handling skills can make a good dog move poorly. Although the standard requests "a loose lead to reflect true gait," many handlers in the conformation ring use a very tightly held lead to hold the dog's head up higher. This is an unnatural position for the head in a retrieving breed—it should be carried forward of the body, not over the shoulders—and the tight lead also forces the dog to lift his legs higher as he seeks to avoid the pressure on his neck. Lifting or high-stepping is not the desired movement—we are seeking good forward reach that pulls the dog along. Legs that are lifted as high as halfway up the chest are not moving efficiently.

Good reach is determined by just how far forward of the body the dog places the foot on the ground. Any extra upward motion rather than extension forward before the foot touches the ground is energy wasted and does nothing to pull the body forward. Similarly, good drive is measured by how far behind the body the foot touches as it propels the dog forward. Any upward motion after the footfall is wasted energy. The desire here is for the dog to cover as much ground as possible with each stride, with the minimal possible energy expended in the effort. Think of it this way: if I have to move across a 30-foot field, I will expend less energy if it takes me ten strides to cover the distance rather than fourteen shorter strides. Over the course of a day of hunting, those extra four strides every 30 feet add up to a lot of wasted energy, and I will tire earlier. So, too, with the dog.

Folks not involved in conformation showing will often point out that the dog does his job well based on his desire to complete the task, not his structure. Dogs with poor structure, they will say, can be great

workers. In other words, a dog doesn't hunt on his legs, he hunts on his "heart"—his instinctual drive to retrieve. (See Ann Strathern's discussion on "heart" in Chapter 11.) This is, of course, quite true. The Golden's great desire to please will often override his physical limitations. However, think of how much longer the dog will last and how much less damage he will be doing to his body if he has correct conformation that allows him to do the bidding of his heart efficiently. This is also the case if the dog is working in obedience or agility, where jumping is required. As Sharon Bolton and Chris Miele so aptly point out in the chapters on obedience and agility, respectively, a correct body is just as necessary for a dog working in these pursuits as it is in the conformation ring—perhaps even more so.

There are many movement faults, all caused by less-than-ideal conformation. Dogs having unbalanced angulation will have to compensate for their lack of symmetry. This is often apparent in dogs who "crab" (move sideways like a crab) or prefer to pace rather than trot. The pace (where both legs on one side of the dog move together in the same direction rather than in opposite directions) eliminates faults such as overreaching (where the rear overruns the front, causing the legs to hit each other), crabbing, and other common movement faults. Dogs who are more comfortable pacing often have poorly constructed quarters or are suffering from pain for some reason. Dysplastic dogs or dogs with injured backs often prefer to pace, for example.

Elbows facing out or in rather than being parallel cause the front legs and feet to turn out or in—another example of inefficient movement. Hocks that are not parallel do not have the same strength to propel the dog forward as do those with correct placement. Dogs with straight fronts and rears (that is, lacking proper

These illustrations originally appeared in Rachel Page Elliott's *Dogsteps: A New Look*. The standing dog on the right displays good angulation, which "facilitates a smooth, ground-covering stride" as shown in the motion sequence below.

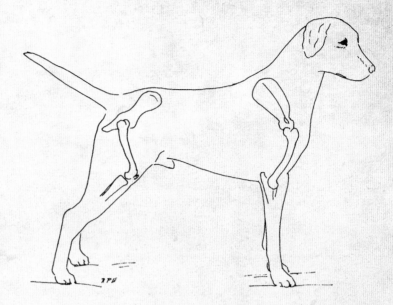

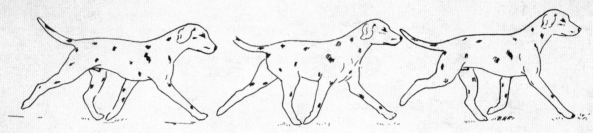

The standing dog on the right shows poor angulation, while the illustrations below show its effects. Poor angulation "shortens stride because the bones meeting at the shoulder joints and hips are steeply set, forming joints with wide open angles."

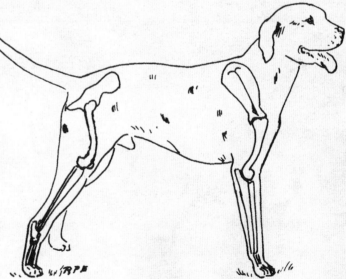

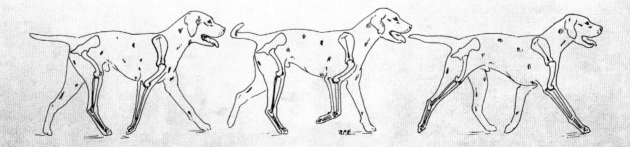

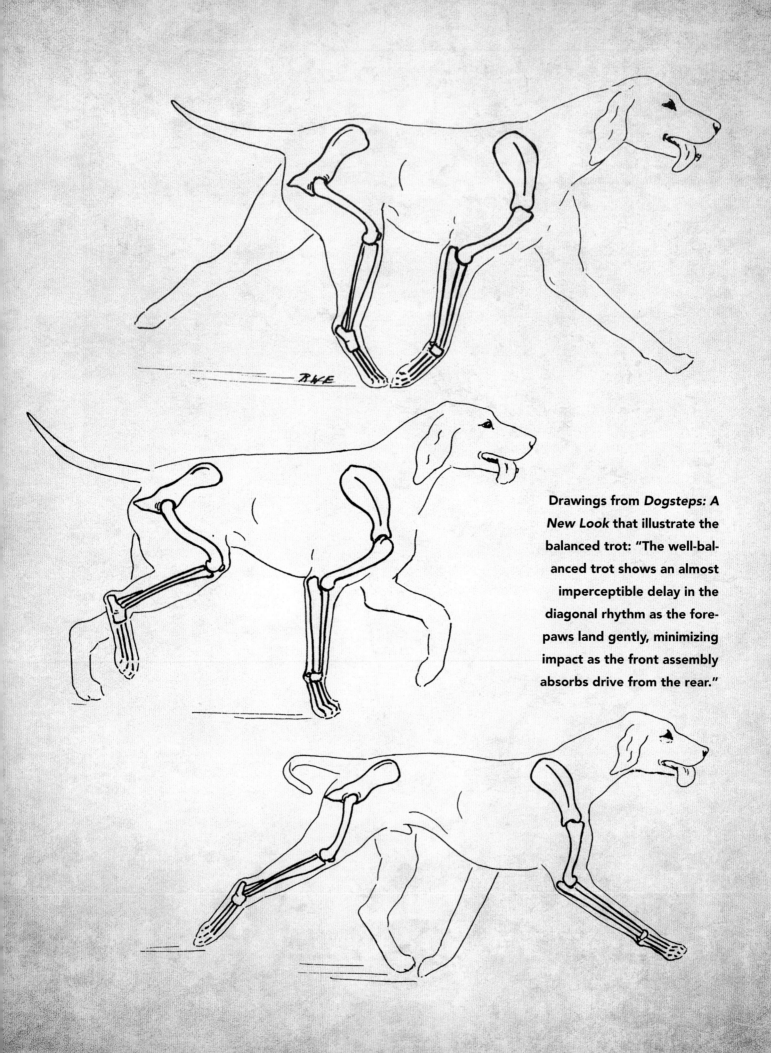

Drawings from *Dogsteps: A New Look* that illustrate the balanced trot: "The well-balanced trot shows an almost imperceptible delay in the diagonal rhythm as the forepaws land gently, minimizing impact as the front assembly absorbs drive from the rear."

angulation) simply require more steps to cover the same ground because they have neither the reach nor the drive of the well-angulated dog.

So how do breeders and judges assess the movement of individual dogs? The process involves watching the dog at a trot, because this is the speed that shows the gait the most clearly. Dogs are judged both from the side and coming and going (away from the observer and back toward the observer). Both views are necessary for a full evaluation. Watching a dog's side gait gives the trained observer the best overall picture of just how well the dog moves. From the side, you are able to see how all the parts fit together and work together in harmony. The dog's overall structure, balance, and coordination are best seen from the side. Remember that the standard states that the back should be "level both standing and moving." In the show ring, most judges put the most emphasis on side gait, as the desirable balanced silhouette is easy to see as the dog moves.

The Golden standard is rather specific regarding how movement should be judged: "It is recommended that dogs be shown on a loose lead to reflect true gait." Racing around the ring with the dogs on tight leads, which is the current fashion, is not desirable. All dogs should not be moved at the same speed. Different dogs look better at different speeds. Practice moving your dog at different speeds and ask someone to videotape him as you do this. You might be surprised by how different a dog can look at different speeds. When your dog moves at his best speed, you can often feel how smoothly he gaits through the lead.

Gaiting is not a race to see who can get around the ring the fastest, with the most legs flying high in the air. Often, dogs are moved too quickly for their construction, thus accentuating faults rather than showing off strengths. Remember, good movement

This dog is being moved too fast, and the feet are too far off the ground, wasting energy. The dog also is overreaching, as the rear leg is in front of the front leg underneath the dog.

An obviously unbalanced front and rear, with the rearmost leg very high in the air. This is inefficient and incorrect movement.

The dog's feet are somewhat high in the air, and there is a roach over the loin rather than the desired level topline.

Correct handling
at a proper pace
leads to smooth
gait, viewed
from the side,
front, and back.

is not determined by how fast the legs are moving, but by how much ground is covered with each stride. Faster is not necessarily better.

Conformation judges are sometimes asked, "Which is more important, type or gait?" I'm sure that you cannot separate the two, because you cannot have one without the other. A typey Golden has to be able to move to retain his type. However, it is certainly true that you can have a good-moving dog who is not a good Golden. Type, you will remember, is what makes a dog identifiable as a Golden Retriever. A yellow mixed-breed dog can be a good mover, but that doesn't make him a good Golden. In the conformation ring, many judges will first sort the dogs in a class based on how closely they conform to the standard, and then pick the best-moving dog out of those with good type as his winner. However, good movement should not overrule outstanding type.

Temperament

Temperament—Friendly, reliable and trustworthy. Quarrelsomeness or hostility towards other dogs or people in normal situations, or an unwarranted show of timidity or nervousness, is not in keeping with Golden Retriever character. Such actions should be penalized according to their significance.

The Golden's temperament is an essential aspect of the breed. It is one of the most important attractions of the breed and an index to the emotions of the Golden Retriever. Historically, the Golden was often lent to a friend or neighbor to retrieve his game when hunting. Gentlemen often hunted with friends, and these friends would bring their dogs along to assist in the day's work. The Golden needed to work harmoniously with these canine newcomers.

One of the points considered before breeding was (and still should be) the temperament of both prospective parents. The standard clearly states what type of temperament is desired. No breeder should consider breeding a Golden with a bad temperament any more than he would consider breeding a dog with a genetically based defect or disease. Good temperament is as vital a part of a correct Golden as any other aspect of the standard.

This ten-year-old dog is beautifully balanced and compact, shows the correct outline, is in excellent condition, and has a happy Golden Retriever expression. This is Am./Can. Ch. OTCH Highmark Mirasol Once A Knight, UDX3, TDX, JH, MX, MXJ, WC, VCX, the national specialty BOB in 2001 and 2002, shown here before winning BOS in 2008.

Official AKC Standard

for the Golden Retriever

General Appearance

A symmetrical, powerful, active dog, sound and well put together, not clumsy nor long in the leg, displaying a kindly expression and possessing a personality that is eager, alert and self-confident. Primarily a hunting dog, he should be shown in hard working condition. Overall appearance, balance, gait and purpose to be given more emphasis than any of his component parts. *Faults*—Any departure from the described ideal shall be considered faulty to the degree to which it interferes with the breed's purpose or is contrary to breed character.

Size, Proportion, Substance

Males 23–24 inches in height at withers; females 21½–22½ inches. Dogs up to one inch above or below standard size should be proportionately penalized. Deviation in height of more than one inch from the standard shall *disqualify*. Length from breastbone to point of buttocks slightly greater than height at withers in ratio of 12:11. Weight for dogs 65–75 pounds; bitches 55–65 pounds.

Head

Broad in skull, slightly arched laterally and longitudinally without prominence of frontal bones (forehead) or occipital bones. *Stop* well defined but not abrupt. *Foreface* deep and wide, nearly as long as skull. *Muzzle* straight in profile, blending smoothly and strongly into skull; when viewed in profile or from above, slightly deeper and wider at stop than at tip. No heaviness in flews. Removal of whiskers is permitted but not preferred. *Eyes* friendly and intelligent in expression, medium large with dark, close-fitting rims, set well apart and reasonably deep in sockets. Color preferably dark brown; medium brown acceptable. Slant eyes and narrow,

triangular eyes detract from correct expression and are to be faulted. No white or haw visible when looking straight ahead. Dogs showing evidence of functional abnormality of eyelids or eyelashes (such as, but not limited to, trichiasis, entropion, ectropion or distichiasis) are to be excused from the ring. *Ears* rather short with front edge attached well behind and just above the eye and falling close to cheek. When pulled forward, tip of ear should just cover the eye. Low, houndlike ear set to be faulted. *Nose* black or brownish black, though fading to a lighter shade in cold weather not serious. Pink nose or one seriously lacking in pigmentation to be faulted. *Teeth* scissors bite, in which the outer side of the lower incisors touches the inner side of the upper incisors. Undershot or overshot bite is a *disqualification*. Misalignment of teeth (irregular placement of incisors) or a level bite (incisors meet each other edge to edge) is undesirable, but not to be confused with undershot or overshot. Full dentition. Obvious gaps are serious faults.

Neck, Topline, Body

Neck medium long, merging gradually into well laid back shoulders, giving sturdy, muscular appearance. No throatiness. *Backline* strong and level from withers to slightly sloping croup, whether standing or moving. Sloping backline, roach or sway back, flat or steep croup to be faulted. *Body* well balanced, short coupled, deep through the chest. *Chest* between forelegs at least as wide as a man's closed hand including thumb, with well developed forechest. Brisket extends to elbow. *Ribs* long and well sprung but not barrel shaped, extending well towards hindquarters. *Loin* short, muscular, wide and deep, with very little tuck-up. Slabsidedness, narrow chest, lack of depth in brisket, excessive tuck-up to be faulted. *Tail* well set on, thick and muscular at

the base, following the natural line of the croup. Tail bones extend to, but not below, the point of hock. Carried with merry action, level or with some moderate upward curve; never curled over back nor between legs.

Forequarters

Muscular, well coordinated with hindquarters, and capable of free movement. *Shoulder blades* long and well laid back with upper tips fairly close together at withers. *Upper arms* appear about the same length as the blades, setting the elbows back beneath the upper tip of the blades, close to the ribs without looseness. *Legs*, viewed from the front, straight with good bone, but not to the point of coarseness. *Pasterns* short and strong, sloping slightly with no suggestion of weakness. Dewclaws on forelegs may be removed, but are normally left on. *Feet* medium size, round, compact and well knuckled, with thick pads. Excess hair may be trimmed to show natural size and contour. Splayed or hare feet to be faulted.

Hindquarters

Broad and strongly muscled. Profile of croup slopes slightly, the pelvic bone slopes at a slightly greater angle (approximately 30 degrees from horizontal). In a natural stance, the femur joins the pelvis at approximately a 90-degree angle; *stifles* well bent, *hocks* well let down with short, strong *rear pasterns*. *Feet* as in front. *Legs* straight when viewed from rear. Cowhocks, spread hocks, and sickle hocks to be faulted.

Coat

Dense and water-repellent with good undercoat. Outer coat firm and resilient, neither coarse nor silky, lying close to body; may be straight or wavy. Untrimmed natural ruff; moderate feathering on back of forelegs and on underbody; heavier feather on front of neck, back of thighs and underside of tail. Coat on head, paws and front of legs is short and even. Excessive length, open coats and limp, soft coats are very undesirable. Feet may be trimmed and stray hairs neatened, but the natural appearance of coat or outline should not be altered by cutting or clipping.

Color

Rich, lustrous golden of various shades. Feathering may be lighter than rest of coat. With the exception of graying or whitening of face or body due to age, any white marking, other than a few white hairs on the chest, should be penalized according to its extent. Allowable light shadings are not to be confused with white markings. Predominant body color which is either extremely pale or extremely dark is undesirable. Some latitude should be given to the light puppy whose coloring shows promise of deepening with maturity. Any noticeable area of black or other off-color hair is a serious fault.

Gait

When trotting, gait is free, smooth, powerful and well coordinated, showing good reach. Viewed from any position, legs turn neither in nor out, nor do feet cross or interfere with each other. As speed increases, feet tend to converge toward center line of balance. It is recommended that dogs be shown on a loose lead to reflect true gait.

Temperament

Friendly, reliable, and trustworthy. Quarrelsomeness or hostility towards other dogs or people in normal situations, or an unwarranted show of timidity or nervousness, is not in keeping with Golden Retriever character. Such actions should be penalized according to their significance.

Disqualifications

Deviation in height of more than one inch from standard either way.
Undershot or overshot bite.

Approved October 13, 1981
Reformatted August 18, 1990

Comparing the Breed Standards

here are different approaches to writing breed standards, and this can be especially evident when comparing breed standards for the same breed from different countries. The Golden Retriever was originally developed in the United Kingdom, but the great popularity of the breed throughout the world has led to somewhat divergent development of the breed in different countries.

Not surprisingly, the two most dominant breed standards used for Goldens are those of the American Kennel Club in the United States and The Kennel Club in the United Kingdom. Breed standards in other countries are usually largely or wholly based on one of these two standards.

At first glance, there is a big difference in the way the two standards are presented. However, when you closely examine the two standards section by section—using a common layout because the two do not discuss topics in the same order—these differences become much less dramatic. In this chapter, we will compare the two standards to increase our understanding of the Golden worldwide.

In the United States, each parent club owns the standard for its breed. The AKC parent club for the Golden Retriever is the Golden Retriever Club of America (GRCA). Any changes to the standard must be approved by a two-thirds majority of the GRCA membership. The AKC controls the format of breed

A champion in several European countries, Dewmist Leading Lady is a very typey English-style female and was 2008's Best Bitch at Crufts.

standards, and its Board of Directors must approve any changes requested by the GRCA and approved by the GRCA's membership. The AKC basically stays out of the business of writing standards, although it provides advice based on its extensive experience.

The American Kennel Club cannot require any parent club to change its breed standard if the membership of that club does not wish to make changes. When the AKC standards were reformatted in 1990 so that they all provided information in the same order, not all parent clubs complied. Some breeds' standards go back unchanged to the first half of the twentieth century.

In England, by contrast, breed standards are owned by The Kennel Club, not the parent clubs.

Ch. Toasty's Treasure Island was the top Sporting Dog in the United States in 2009 and is the top-winning Golden bitch of all time. Bred and owned by Pam and Jerry Oxenberg.

This means that The Kennel Club has full final control over all breed standards and any changes made to them. The parent club (the UK club is the Golden Retriever Club) may suggest changes, but it cannot enforce those changes if The Kennel Club disapproves. Similarly, if the club or its members disagree with an unrequested change made directly by The Kennel Club, they cannot overrule it. This is a significant difference.

As I said, for all practical purposes, these two Golden breed standards (the American and the

British) are used as the basis for judging the breed throughout the world. Countries whose national kennel clubs are members of, or affiliated with, the FCI must use the breed standard of the country of origin for each FCI-recognized breed, which means that they use the British standard for the Golden Retriever. In most other countries, the national kennel clubs use either the British or the AKC standard as the model for their own standards. In much of Asia, the AKC standard is used. In Europe, the British standard is followed. The Canadian standard is very similar to the American version.

Because the American and British Golden standards are by far the most influential, it is important for those who desire an understanding of the breed to appreciate the similarities and differences of both standards. Let's look at the two standards section by section and compare them. Throughout this chapter, we will list the corresponding sections of the two standards together, with the words of The Kennel Club preceding those of the AKC. As the two standards do not list sections in the same order, the order of the sections presented here follows that of the AKC standard for simplicity's sake. The words of the standards are presented in italics, with my comments following in regular type. To my knowledge, there were no changes to either standard being considered at the time of this writing.

General Appearance

Kennel Club Standard

Symmetrical, balanced, active, powerful, level mover; sound with kindly expression. Biddable, intelligent, and possessing natural working ability.

AKC Standard

A symmetrical, powerful, active dog, sound and well put together, not clumsy nor long in the leg,

displaying a kindly expression and possessing a personality that is eager, alert, and self-confident. Primarily a hunting dog, he should be shown in hard working condition. Overall appearance, balance, gait, and purpose to be given more emphasis than any of his component parts.

As you can see, some of the same words are used in both of the standards, and the meaning of these two sections are quite similar to each other. As is true in nearly every section of the standards, the American version is more descriptive and provides more interpretation and direction than the English version. Both provide an overview of the breed and the basic expectations for a correct Golden; further, the American Kennel Club's standard emphasizes the need to look at the whole dog, not just the parts.

Size

Kennel Club Standard

Height at withers: dogs: 56–61 centimeters (22–24 inches); bitches: 51–56 centimeters (20–22 inches).

AKC Standard

Males 23–24 inches in height at withers; females 21½–22½ inches. Dogs up to one inch above or below standard size should be proportionately penalized. Deviation in height of more than one inch from the standard shall disqualify.

This is one of the few sections in which there is a significant difference between the two standards. The English standard asks for a Golden that is somewhat smaller than required by the American standard, and the English version provides no leeway for over- or undersized dogs or bitches. Compared to the AKC standard, males can be an inch shorter at the withers under the English standard and bitches can be an even more significant 1½ inches smaller.

The English standard's requirements are perhaps more in keeping with the desired moderate-sized Golden Retriever. Note that the American standard penalizes dogs or bitches that are over or under the preferred size and then issues a disqualification for a deviation of more than one inch over or under the specified size range. On a side note, the English standard provides for no disqualifications at all, other than monorchidism (only one testicle descended into the scrotum, which is a disqualification in all breeds in the United Kingdom). The question of whether disqualifications are really helpful is certainly debatable.

Proportion and Substance

Kennel Club Standard

Short-coupled.

AKC Standard

Length from breastbone to point of buttocks slightly greater than height at withers in ratio of 12:11. Weight for dogs 65–75 pounds; bitches 55–65 pounds.

The American standard is much clearer as to what constitutes a "short-coupled" dog. By specifying the desired ratio of length to height, the preferred proportion of the dog is clearly spelled out. The Kennel Club standard's lack of attention to correct body proportion might be one reason dogs of English style generally have a tendency to be longer in body than their American counterparts. The AKC's desired weight range might not reflect the weight of the majority of Golden Retrievers, whether they live in the United States or anywhere in the world, but it is more in keeping with dogs that fall into The Kennel Club's height range and does serve as a clear statement of the desired moderation in the breed.

Head

Kennel Club Standard

Balanced and well chiselled, skull broad without coarseness; well set on neck, muzzle powerful, wide and deep. Length of foreface approximately equals length from well defined stop to occiput. Nose preferably black.

AKC Standard

Broad in skull, slightly arched laterally and longitudinally without prominence of frontal bones (forehead) or occipital bones. Stop well defined but not abrupt. Foreface deep and wide, nearly as long as skull. Muzzle straight in profile, blending smoothly and strongly into skull; when viewed in profile or from above, slightly deeper and wider at stop than at tip. No heaviness in flews. Removal of whiskers is permitted but not preferred. Pink nose or one seriously lacking in pigmentation to be faulted.

As previously mentioned, the head is an important index of any breed. Here again the English standard is less specific, perhaps preferring to leave more up to the breed knowledge of the reader, although it goes into more detail than previous sections. While the American standard provides more complete descriptions, its details do not conflict with the requirements of the English standard but, rather, amplify them. In fact, the different styles of headpiece that are predominantly associated with each of the two countries is not specified in either standard, providing an excellent example of the flexibility of interpretation built into both standards.

The differences between the typical English- and American-style head are most evident in the breadth of the skill, depth and width of muzzle, and amount of stop desired. In my opinion, the heads seen in Britain more closely conform to the requirements of either breed standard when compared to the head

LEFT: A very expressive English-style male head. Note the excellent pigmentation of the lips and nose and the correct placement of the ear. BELOW: BISS Ch. Toasty's Dust In The Wind II SDHF, OS, was Top Twenty owner-breeder-handled in the United States in 1998. "Kansas" has a very typey American-style male head.

style now more typically seen in the United States. To my eye, at least, there is less variation between heads in English-style dogs compared with the great variation seen in the American style. This wide divergence is something that American breeders need to address lest correct type be lost. The relative similarity found in the English dogs is commendable.

The variation in American dogs is a recent phenomenon. If you look at old photos of Goldens from both countries during the late 1800s through, say, the late 1940s or early 1950s, the heads are strikingly similar in comparison with those today. It was around the 1950s that a deviation of style started to become more evident in America, with a great change from the original style seen in the English dogs. The best American heads remained a bit more similar to the original style. However, by the early 1980s, there was a noticeable change in American heads, usually away from the English style. American heads developed less stop, less chiseling under the

eyes, and skulls that were less broad and generally more rounded. Heads in the United Kingdom during this time seemed to tend toward even broader skulls, higher ear sets, and more pronounced stops. Is one "better" or "more correct" than the other? That seems to depend on the eye of the beholder. Both styles should be acceptable to judges as long as they fall within the parameters of the breed standard.

Both standards ask for a nose that is dark. The KC standard asks for a black nose, and the AKC standard specifically faults a pink nose or one seriously lacking in pigmentation. In fact, prior to the 1981 revision, a pink (or "Dudley") nose was a disqualification. In any case, the nose should be large and dark with big, well-opened nostrils to allow for good scenting. The dark nose is part of the desired dark pigmentation on the lips, flews, and eye rims. The correct pigmentation adds to the overall beauty of the head.

Eyes

Kennel Club Standard

Dark brown, set well apart, dark rims.

AKC Standard

Friendly and intelligent in expression, medium large with dark, close-fitting rims, set well apart, and reasonably deep in sockets. Color preferably dark brown; medium brown acceptable. Slant eyes and narrow, triangular eyes detract from correct expression and are to be faulted. No white or haw visible when looking straight ahead. Dogs showing evidence of functional abnormality of eyelids or eyelashes (such as, but not limited to, trichiasis, entropion, ectropion or distichiasis) are to be excused from the ring.

Again, the American standard provides much more specific information about what is desirable and also takes pains to point out what is not correct.

The AKC standard places more emphasis on the correct expression for a Golden. Further, the AKC standard points out a group of potential eye-health issues and makes them especially important by calling for a dog with any of these functional problems to be excused from the ring—and thereby from competition. Certainly the eyes are important, and improperly shaped, colored, or placed eyes detract greatly from the desired soft expression of the Golden, which is so appealing to all who see him.

Ears

Kennel Club Standard

Moderate size, set on approximately level with eyes.

AKC Standard

Rather short with front edge attached well behind and just above the eye and falling close to cheek. When pulled forward, tip of ear should just cover the eye. Low, houndlike ear set to be faulted.

The desired size, shape, and set of the ears are directly dictated by the Golden's original function as a land and water retriever of game. Large, low-set ears are a decided detriment to a swimming dog, as they tend to allow water to enter the ear canals. Water in the ears can lead to discomfort or infection or can cause the dog to shake his head, possibly losing his grip on the bird in his mouth. Finally, because there is a Bloodhound cross in the breed's ancestral pedigree, and because large, low-set, long ears are functionally faulty, houndlike ears should be considered especially undesirable.

Mouth

Kennel Club Standard

Jaws strong, with a perfect, regular and complete scissor bite, i.e. upper teeth closely overlapping lower teeth and set square to the jaws.

A feminine English-style head. The "winter nose" does not detract from the lovely head.

AKC Standard

Teeth scissors bite, in which the outer side of the lower incisors touches the inner side of the upper incisors. Undershot or overshot bite is a disqualification. Misalignment of teeth (irregular placement of incisors) or a level bite (incisors meet each other edge to edge) is undesirable, but not to be confused with undershot or overshot. Full dentition. Obvious gaps are serious faults.

The desired structure of the mouth relates directly to the breed's function. Dogs lacking a good mouth may have increased difficulty holding game, especially birds that have been injured but not killed. A full complement of teeth is a great asset, as is a correct bite. Both standards directly address these

needs, again with the American version being more specific and pointing out potential flaws. The English standard, however, does not fault missing teeth nor does it call for full dentition, a somewhat surprising absence in view of the breed's function. Found here is the second disqualification in the American breed standard—a bad bite disqualifies a dog from show competition.

Neck

Kennel Club

Good length, clean and muscular.

AKC Standard

Medium long, merging gradually into well laid back shoulders, giving sturdy, muscular appearance. No throatiness.

Both standards are looking for the same kind of length. Note that "good length" does not mean an

especially long neck, but rather a neck long enough to allow the dog to easily pick up a bird from the ground or water without having to stoop to reach it. The English standard asks for a "clean" neck, which is very similar to the AKC's "no throatiness." Both standards require a muscular neck, needed to carry the bird to the handler.

Topline and Body

Kennel Club Standard

Balanced, short-coupled, deep through heart. Ribs deep, well sprung. Level topline.

AKC Standard

Backline strong and level from withers to slightly sloping croup, whether standing or moving. Sloping backline, roach or sway back, flat or steep croup to be faulted. Body well balanced, short coupled, deep through the chest. Chest between forelegs at least as wide as a man's closed hand including thumb, with well developed forechest. Brisket extends to elbow. Ribs long and well sprung but not barrel shaped, extending well towards hindquarters. Loin short, muscular, wide and deep, with very little tuck-up. Slabsidedness, narrow chest, lack of depth in brisket, excessive tuck-up to be faulted.

The Kennel Club standard is lacking in detail here, which may be a disservice to the breed in the long run. The importance of a correct, strong, and level backline cannot be questioned, yet far too many Goldens have an incorrect backline. The Kennel Club's misuse of the word *topline* is unfortunate. It is the *backline* that should be level on the Golden, with the necessary slope of the croup that permits the proper tail set so that the tail is carried behind the dog rather than high above the backline. Interestingly, the Kennel Club standard gives no guidance on the width of the chest nor does it mention the slope of the croup. Sadly, any indication of the desired body proportion is missing from the English standard.

Tail

Kennel Club Standard

Set on and carried level with back, reaching to hocks, without curl at tip.

AKC Standard

Well set on, thick, and muscular at the base, following the natural line of the croup. Tail bones extend to, but not below, the point of hock. Carried with merry action, level or with some moderate upward curve; never curled over back nor between legs.

There is a subtle difference between the two standards in this section. The AKC standard indicates that the tail can be carried "level or with some moderate upward curve," while the English standard clearly indicates that the tail is carried "level with the back, without curl at the tip." This means that the English-style dog should only carry his tail behind him, not with an upward curve—a requirement that is, perhaps, more ignored than followed. I find it curious that this statement is made but nothing is said regarding the angle of the croup, which plays a large role in tail set. In addition, the American standard points out that the correct retriever tail is "...thick and muscular at the base." A thin, ropy tail lacks the strength needed to act as a rudder and is therefore undesirable, a feature not mentioned at all in the English version of the standard.

Forequarters

Kennel Club Standard

Forelegs straight with good bone, shoulders well laid back, long in blade with upper arm of equal length placing legs well under body. Elbows close fitting.

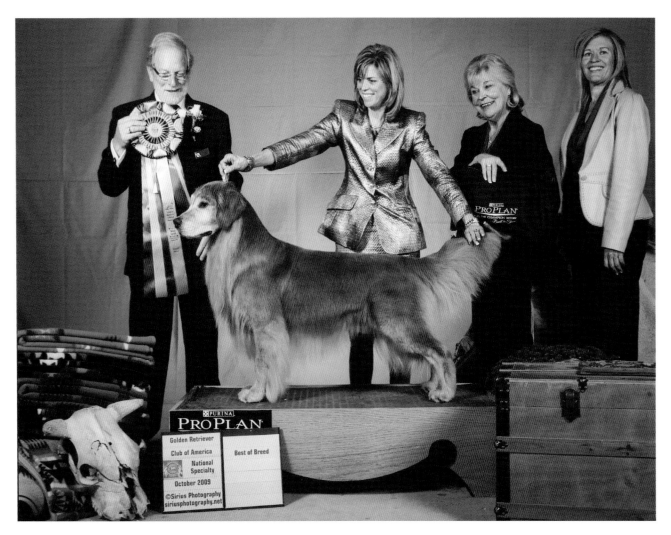

Best of Breed at the 2009 GRCA national specialty was Ch. Rush Hill's Run'n Amuck at Abelard OA, OAJ, AXP, AJP, NFP, owned by Tonya Struble and Deborah Blair-Muzzin. The author was the judge.

AKC Standard

Muscular, well coordinated with hindquarters, and capable of free movement. Shoulder blades long and well laid back with upper tips fairly close together at withers. Upper arms appear about the same length as the blades, setting the elbows back beneath the upper tip of the blades, close to the ribs without looseness. Legs, when viewed from the front, straight with good bone, but not to the point of coarseness.

Pasterns short and strong, sloping slightly with no suggestion of weakness. Dewclaws on forelegs may be removed, but are normally left on.

Perhaps the most difficult component of any dog to consistently produce correctly is the forequarters. As discussed in depth in the breed standard chapter, good forequarters are hard to acquire in a breeding program and can be easily lost. While the American standard goes into a good deal more detail, the requirements of both standards are virtually the same.

The English standard does not directly describe the desired construction of the pasterns. This is a shortcoming from my point of view, because correctly sloped pasterns function as shock absorbers, helping keep the dog from tiring prematurely when working.

Similarly, the subject of dewclaws is not addressed in The Kennel Club's standard.

Feet

Kennel Club Standard

Round and cat-like.

AKC Standard

Medium size, round, compact and well knuckled, with thick pads. Excess hair may be trimmed to show natural size and contour. Splayed or hare feet to be faulted.

This section is straightforward. Excess hair can, if groomed artfully, cover up bad feet. Splayed feet are weak feet, affecting the dog's ability to do his job over time.

Hindquarters

Kennel Club Standard

Loin and legs strong and muscular, good second thighs, well bent stifles. Hocks well let down, straight when viewed from rear, neither turning in nor out. Cowhocks highly undesirable.

AKC Standard

Broad and strongly muscled. Profile of croup slopes slightly, the pelvic bones slope at a slightly greater angle (approximately 30 degrees from horizontal). In a natural stance, the femur joins the pelvis at approximately a 90-degree angle; stifles well bent, hocks well let down with short, strong rear pasterns. Feet as in front. Legs straight when viewed from rear. Cowhocks, spread hocks, and sickle hocks to be faulted.

Because much of the dog's propulsion both on land and in water comes from the hindquarters, the importance of good, strong, well-muscled hindquarters cannot be overstated. Both standards require very similar structure, though, as usual, the American standard provides more detail. Note that the English standard calls cowhocks "highly undesirable," an even stronger condemnation than found in the AKC standard's "to be faulted" statement.

Coat

Kennel Club Standard

Flat or wavy with good feathering, dense water-resisting undercoat.

AKC Standard

Dense and water-repellent with good undercoat. Outer coat firm and resilient, neither coarse nor silky, lying close to the body; may be straight or wavy. Untrimmed natural ruff; moderate feathering on back of forelegs, and on underbody; heavier body feathering on front of neck, back of thighs and underside of tail. Coat on head, paws and front of legs is short and even. Excessive length, open coats, and limp, soft coats are very undesirable. Feet may be trimmed and stray hairs neatened, but the natural appearance of coat or outline should not be altered by cutting or clipping.

In both the KC and AKC standards, the requirement for a dense, water-resistant coat is quite clear and is obviously in line with the intended function of the breed as a retriever on land and in water. Unfortunately, this requirement is too often ignored by exhibitors and judges in the conformation ring. Grooming in the United Kingdom and in FCI countries is quite different from that seen in the United States. Overall, there is less "fluffing and puffing" of the coat and use of products to create a sculpted silhouette than seen in the United States.

The AKC standard clearly asks for an "untrimmed natural ruff." In the United Kingdom and FCI countries, the ruff is usually trimmed down almost completely from just above the forechest to the

In Europe and England, trimming the neck ruff is expected. Note the beautiful topline as the dog is being examined by the judge.

base of the jaw. This results in a very different look for the front of the Golden.

Despite the AKC standard's clear requirement that the "natural appearance of coat or outline should not be altered," excessive grooming is rampant in the show ring, especially in the United States, sometimes creating a look that is but a caricature of what is desired by the breed standard. All too often, a correct dense, water-repellent coat is fluffed out so that it becomes the open, limp coat that the AKC standard calls "very undesirable." Judges should be paying much more attention to this faulty coat. In the end, the British and FCI dogs appear much more natural than their American counterparts in the show ring.

Color

Kennel Club Standard

Any shade of gold or cream, neither red nor mahogany. A few white hairs on chest only, permissible.

AKC Standard

Rich, lustrous golden of various shades. Feathering may be lighter than rest of coat. With the exception of graying or whitening of face or body due to age, any white marking, other than a few white hairs on the chest, should be penalized according to its extent. Allowable light shadings are not to be confused with white markings. Predominant body color which is either extremely pale or extremely dark is undesirable. Some latitude should be given to the light puppy whose coloring shows promise of deepening with maturity. Any noticeable area of black or other off-color hair is a serious fault.

While much of the intent is the same here, there is a fairly significant difference in the allowable

colors. The English standard specifically permits a cream-colored Golden, but cream is not mentioned at all in the American standard. Many American fanciers and judges consider a cream-colored Golden too light in color and, therefore, undesirable.

The question of color has long been the subject of debate. One might remember that the breed was originally classified by The Kennel Club as "Retrievers—Yellow or Golden" clearly indicating that, at that time, cream-colored coats were not considered correct for the emerging breed. There have always been lighter and darker shadings to the Golden's coat, especially in the feathering, but I feel that the predominant color of the dog should carry at least some hint of a golden hue, not a biscuit or cream color.

The color of the Goldens seen winning in the show ring changes over time. In the United States, there have been periods, such as the 1960s and '70s, when darker-colored dogs seemed to have been favored. By the middle of the 1980s, lighter dogs seemed to have been more popular. More recently, the medium shades seem to be preferred. Certainly this cycle will continue to change over time. From a judge's point of view, color should be the very last thing considered when evaluating dogs as long as the color falls within the acceptable range of gold. There is, after all, so much more to the breed than its coat color.

Gait/Movement

Powerful with good drive. Straight and true in front and rear. Stride long and free with no sign of hackney action in front.
When trotting, gait is free, smooth, powerful and well coordinated, showing good reach. Viewed from any position, legs turn neither in nor out, nor do feet cross or interfere with each other. As speed increases, feet tend to converge toward center line of balance. It is recommended that dogs be shown on a loose lead to reflect true gait.

Remembering that the Golden Retriever is "primarily a hunting dog," this section is a critical part of what makes a good Golden. The English standard is short and simple, which leaves much to individual interpretation. Just what is "good drive"? Is good drive in the rear enough? After all, correct movement requires good reach, too. Those experienced in evaluating movement will always point toward balance and coordination as being very important parts of correct movement. Good drive needs to be balanced by good reach, or the dog will not move properly.

"Straight and true in front and rear" is from the English standard. Just how does one interpret that statement? Does it mean that the dog must move in a straight line (which is certainly a part of good movement—crabbing is nearly always an indication of faulty construction) or does it mean that the bones of the front legs need to be straight (also an expected part of correct Golden construction)? The third phrase gives an idea of the reach and drive desired and faults hackney gait, which is often the result of a short upper arm.

In my opinion, this section of The Kennel Club's standard would benefit from more complete guidance to the breeder and judge alike. The lack of specifics might be one of the reasons that, generally speaking, breeders who follow the English standard tend to put considerably less emphasis on correct movement than their American counterparts and, as a consequence, have dogs that often do not move

Two very typical English-style Goldens with the grooming and lighter coat color often seen on dogs in the United Kingdom and Europe.

as well as their best American counterparts. Correct type requires both correct structure and correct movement.

The AKC standard more clearly defines desired movement ("When trotting, gait is free, smooth, powerful and well coordinated, showing good reach.") and mentions correct construction as well ("Viewed from any position, legs turn neither in nor out, nor do feet cross or interfere with each other. As speed increases, feet tend to converge toward center line of balance."). Interestingly, the American standard mentions front reach but not rear drive, which is just as incomplete as the description given in the English standard.

Temperament

Kennel Club Standard

Kindly, friendly, and confident.

AKC Standard

Friendly, reliable, and trustworthy. Quarrelsomeness or hostility towards other dogs or people in normal situations, or an unwarranted show of timidity or nervousness, is not in keeping with Golden Retriever character. Such actions should be penalized according to their significance.

All too often ignored, the temperament section of the breed standard is of vital importance. In addition to his good looks, the Golden Retriever has a reputation as a sound, stable, easily-cared-for family pet, which draws many to the breed. That there are Goldens with bad temperament is, sadly, beyond question. Fortunately, specimens with bad temperaments are not widely found. Some breeders have the

unfortunate tendency to forgive atypical temperament in an otherwise good dog, and undesirable temperament is passed on from parent to offspring just like other characteristics are. Sound temperament is a hallmark of the breed. Therefore, Goldens with unacceptable temperaments should never be bred from.

The American standard spends more time discussing correct temperament and, just as importantly, details what bad temperament includes and directs evaluators to consider a bad temperament as faulty.

Faults

Kennel Club Standard

Any departure from the foregoing points should be considered a fault and the seriousness with which the fault should be regarded should be in exact proportion to its degree and its effect upon the health and welfare of the dog.

AKC Standard

Any departure from the described ideal shall be considered faulty to the degree to which it interferes with the breed's purpose or is contrary to breed character.

This is one of the few areas in which the English standard is longer than the AKC version. Both standards use similar words; however, The Kennel Club's standard, correctly in my opinion, adds concern about the "health and welfare of the dog." If the AKC standard is ever revised, it should include a similar phrase.

Typically, The Kennel Club's breed standards reserve statements regarding faults until the end of the standards, as is the case in the Golden standard. I feel that references to faults are clearer when made directly after describing the correct feature, but this

is not a critical requirement, just a stylistic point. The statement on faults in the AKC standard appears at the end of the General Appearance section at the beginning of the standard.

In conclusion, both the Kennel Club and the American Kennel Club versions of the Golden Retriever breed standard provide good, clear outlines of the desired traits for the breed. Although breed standards are written for those who are already familiar with the breed and with canine anatomy, not everyone who reads these documents has such knowledge. Many do not. With this in mind, it would seem that more detailed information would be useful to newcomers. The AKC version of the standard goes further in explaining to the uninitiated just what is desired in the correct Golden. There are sections of the American standard that the UK standard could usefully incorporate into its version, perhaps giving greater clarity to novices compared to the current version. At the same time, the brevity and preciseness of The Kennel Club standard could be usefully applied to some parts of the AKC standard that are, perhaps, a bit too detailed. Realistically, neither standard is of much use to the uninitiated person who has no background in dogs.

The English standard's format of leaving a description of faults to one sentence at the end of the document is interesting. Following this design permits a more positive standard, concentrating on the strong points of the dog being described and avoiding fault judging. However, it also relies on the reader's memory and interpretation of what is correct and not correct. The AKC standard's tendency to list faults within individual sections helps less experienced folks contrast the desirable with the undesirable, which can be a benefit, especially for

A beautiful Golden head on Ch. Pebwin XPDNC. Can you tell whether this is an American or an English dog? See the photo on page 149.

those trying to learn what makes a truly outstanding Golden Retriever.

No matter which version of the breed standard you prefer, all breeders must strive to meet the requirements of the standard. It does not matter if you are breeding primarily for the show ring, the obedience ring, the agility ring, field trials, or "just" for healthy companions—all breeders must follow the dictates of the breed standard, not their own personal preferences, especially when those preferences conflict with the standard.

Ignoring the standard or picking and choosing which parts of the standard to pay attention to and which to ignore is detrimental to the breed. It will eventually lead to the destruction of the Golden Retriever and, for that matter, purebred dogs as a whole. Each breeder has the profound responsibility of protecting the breed for future generations.

Going for the
Gold

The Versatile Golden Retriever

Perhaps the best reason to pick a purebred dog is that your choice will never be a surprise package. And which breed has become one of the most attractive and popular purebred packages in the world? As you've seen throughout this book, the Golden Retriever is popular worldwide as a companion dog, a hunter, a show dog, and a performance-event competitor, as

The intelligence and inquisitiveness of the breed is clearly evident in this very young puppy.

well as a service dog performing myriad functions in assistance of man. This is no accident, for the Golden Retriever is one of the most versatile of all breeds of dog.

Without a doubt, the Golden is one of the best breeds to own as a companion dog—a "pet." To be sure, the Golden Retriever is a good-looking dog, but it is his outstanding stable temperament and eagerness to please his owners, critical hallmarks of the breed, that are among the most important reasons for his great popularity. The Golden is typically a wonderful family member, eager to please and at his very best with children of nearly all ages (infants and toddlers might need some protection from the Golden's typical joie de vivre and the young pup's sharp

baby teeth). The Golden Retriever seems to have an inborn affinity for children, and many Goldens know innately when a child needs calm, quiet time or simply some one to cuddle up to. The Golden truly loves to be with people, and if the Golden's owner is not available, any person will do! The gentle nature of the breed is legendary.

Just what is it that makes this wonderful breed so appealing? *Adaptability* is the Golden's middle name. This is a breed that can do nearly everything. The Golden is commonly seen in print advertisements and on television, playing the role of a typical family pet. Goldens have been assisting the handicapped for many years. Golden Retriever guide dogs have long been known for helping the visually impaired. There are a number of organizations throughout the United States that raise and train Goldens for this kind of work.

More recently, Golden Retrievers have been trained to assist those with hearing difficulties as

Tracking is one of the lesser known areas of AKC competition, but Am./Can. Ch. Chuckanuts Brasstime TD, JH, NA, NAJ, VCX, WC, SDHF, OS, Can. TD, Can. JH, Can. WC, aka "Banjo," has tracking titles in the United States and Canada among his many achievements.

well as individuals with physical impairments. For example, Goldens have been trained to help those with balance and coordination issues; the individuals steady themselves by leaning on the dogs. Other Goldens have been trained to carry backpack-type pouches containing school books or other items for those unable to carry these things themselves. Goldens have been trained to open doors, turn on lights, open the refrigerator, and perform many other tasks to assist an owner with physical limitations.

The Golden Retriever's sensitivity and concern for people has led the breed to perform some pretty amazing feats for their owners. One Golden learned

THE TENACIOUS MR. BEAR

The trainability of the breed is one of its most attractive features for many newcomers. The typical Golden has a phenomenal eagerness to please those he loves. He is also an intelligent breed that can put his "smarts" to good use with proper direction from his owners. Left to his own devices, however, he can pick up bad habits.

Here's a great example of a Golden using his intelligence: one of my old Goldens, many years ago, was outside one afternoon with several other Goldens of mine. Inside, his favorite female was in isolation because she was in season and I did not want to breed her at that time. Old Mr. "Bear" (his registered name was Am./Can. Ch. Pepperhill's Basically Bear; he is shown above taking a Group placement) wanted very much to get to his lady friend. Knowing this, I had put a snap-bolt in the gate latch so it could not be opened. As I watched from inside the house, Bear would look around to see if anyone was looking and then bat at the gate latch to try to pop it open (something he had figured out how to do in the past). When that didn't work, he stood there, looking at the gate latch and trying to figure out why. Then he seemed to realize that the snap-bolt was in place, so he jumped up to push it with his paws. That didn't work either, so he tried to push it aside with his nose. I watched for at least ten minutes while he patiently tried many different ways to open that gate. Clearly a thinking dog, trying to work out the solution to a problem. I'm certain that if he had a thumb, he would have found a way to open that gate!

In the end, he did figure out how to get his way. Later that day, I brought Bear and the other dogs back into my kennel building (which was attached to my house). Knowing that Bear had a great nose and that his lady friend was eager to be bred—despite my wishes—I placed Bear at one end of the kennel building and the female at the other end, six runs away. Each of the inside runs had an outdoor run, each separated by fencing, and the dogs could go in and out as they wished. I went into the house to prepare the dogs' afternoon feeding. I was gone less than twenty minutes, and when I came back out, Bear was not to be seen in his run. Most Goldens are foodaholics, and Bear was no exception, but he was not there waiting for dinner. I stepped outside to see where he might have gone, and found him almost immediately. With a big smile of satisfaction on his face, there he was, in the run with his lady friend. He had dug through all six runs and bred to her while I was in the house. She had fourteen puppies nine weeks later.

to recognize imminent seizures before her epileptic owner was even aware that a seizure was coming on. This allowed the owner to take appropriate steps and medication to minimize the seizure before it even occurred. Another Golden learned to differentiate specific odors produced by certain types of cancer, thus providing an early warning system for a potentially deadly disease.

Some disabled kids are in wheelchairs because their bodies are unable to function normally or a disease has not allowed their bodies to develop adequate strength. Dogs can help. These dogs often carry saddlebags that the children can use to carry books and other items. Some children can use their dogs to steady themselves while walking with the use of special equipment. In doing his job, the Golden often becomes much more than just an assistant. He becomes a friend, companion, and confidant, sharing in the child's triumphs and easing the child's failures, never judging. A Golden always loves his person, no matter what happens.

In these cases, the Golden often serves another important and sometimes unexpected purpose: he helps the shy child meet people and make friends. The dog's happy, positive, and outgoing attitude attracts other children and helps the child establish relationships with his peers, resulting in greatly improved self-esteem.

The Golden's innate ability to be a nonjudgmental friend makes him an outstanding therapy dog. Many hospitals and senior citizens' facilities have Goldens visit patients on a regular basis. The trained dogs visit patients and are there to help in any way they can. For some patients, simply stroking a dog's soft fur is enough. The Golden is quite willing to lie, stand, or sit quietly while being petted. There are many stories told of reclusive people coming out of their shells and talking for the first time in a great while by talking to a therapy dog or sharing memories of their own former pets. The dog provides a common ground for people to share their experiences with others.

Many years ago, I was the director of an emergency diagnostic shelter for abused children. The children came into our care because of some sort of traumatic experience in their young lives required them to be placed in our short-term facility while Protective Services and our staff sought an appropriate long-term plan. Many of the children found it difficult to relate to adults or share their feelings at this most difficult time in their lives. I would often bring one of my Goldens to work each day. Many of the children would seek out the dog to pet or to play with, or just to sit with. The door to my office was always open, and often the Golden would come in and lie down next to my desk. Sometimes children would come in as well, often just to pet the dog, and this relaxed atmosphere became a non-threatening opportunity for the child to talk about what had happened to him. The presence of the Golden made it possible for a child who otherwise found it difficult to share his feelings to open up.

As friends, as helpers, or as both, Goldens are natural companions to children.

The Golden's a star in whatever endeavor he attempts.

The Goldens seemed to sense which children needed them to be active—by retrieving a thrown ball, for example—and which children needed them to just sit quietly by their side. The dogs were never specifically trained for this job; they just knew innately what would be the best thing for them to do. All of this was taxing on the dogs, however. By the end of the day, the dog who had accompanied me would be exhausted and quite ready to go home and sleep. As a result, I would usually rotate dogs so that the same one did not come every day.

The typical Golden's great desire to please his owners makes the breed very trainable for all sorts of jobs. You don't tend to think of a Golden as a police dog, but many serve that function very well. It would be almost impossible to train a Golden to be an attack dog, but there are many other jobs that a Golden can perform with great success. For example, one Golden (bred by a breeder who showed her dogs in the conformation ring) served as a bomb-detection dog at the Statue of Liberty in New York Harbor for a number of years. Others have been trained as narcotics-detection dogs and do their jobs quite well.

When New York City was attacked on September 11, 2001, both towers of the World Trade Center collapsed in a huge pile of rubble. Sadly, many people, including a significant number of policemen and New York Fire Department personnel, were inside the structures at the time. Specially trained search and rescue dogs were flown in to search for survivors; a number of them were Golden Retrievers. Many of the dogs at Ground Zero were trained by Pluis Davern, author of the search and rescue chapter in this book.

These search dogs served another function during that terrible time. The inability of the rescuers to find any survivors was very depressing for both the human workers and the search dogs. Many of the firefighters and other emergency responders would take breaks from their labors and decompress by petting the dogs. The dogs helped to lift the spirits of many during those awful days.

The world of the Golden Retriever is whatever world he finds himself in. This is a breed that loves everyone, a breed that never makes judgments about anyone. The Golden loves everyone equally—rich or poor, city dweller or farmer, adult or child—it makes no difference. Goldens do have basic needs, of course. They need room to run on a regular basis, proper food and nutrition, good routine veterinary care, regular grooming, and a warm, dry place to sleep. But above all, they need people. They want to be with you as much as possible. This is not a breed that does well if left to his own devices all the time. If you provide your Golden with the basics, understand his physical needs, and give him some of your time every day, he will be devoted to you forever. His eagerness to please you will make him quick to learn, and he will do his very best to make you happy as long as he understands what you expect of him. The Golden Retriever is very nearly the "perfect dog."

The Golden in the Conformation Ring

In the mind of the general public, a "dog show" is what members of the fancy sometimes formally call a "conformation" show, as compared to an agility, field, or obedience trial. Many people have seen dog shows on television. Not so long ago, the only regularly televised dog show in the United States was the annual Westminster Kennel Club show, held at

New York City's Madison Square Garden in early February. With the growth of cable television and its many channels, other dog shows are now regularly presented, such as the AKC Eukanuba show, often shown on Animal Planet or other cable networks. NBC shows highlights of the Kennel Club of Philadelphia's benched show right after the Macy's Thanksgiving Parade, drawing a very large audience. The increasing popularity of pet ownership has led to the development of a major industry around the world. For example, giant corporations such as Nestlé, Proctor and Gamble, Colgate-Palmolive, and Mars own, respectively, Purina, Iams/Eukanuba, Science Diet, and Pedigree and Royal Canin. Their products are marketed around the world. Government statistics in the first decade of the twenty-first century indicate that the pet market generates over $60 billion in the US economy every year.

Conformation shows are held in all parts of the globe, some sponsored by these large dog-food manufacturers. What was once primarily a hobby of relatively few in western Europe and North America has become a passion on every continent except Antarctica. Devoted Golden Retriever fanciers can be found from Sweden to Israel to South Africa to Australia to Japan, and just about everywhere in

Ch. Toasty's Hello Dolly SDHF demonstrates a lovely "free stack" in the Westminster Breed ring on her way to BOS. Learning to stand without having their feet placed by their handlers is an important part of show dogs' training.

between. There are now fanciers in Russia and China as well as in many other countries where the sport of showing dogs is just beginning to grow in popularity.

Dog shows worldwide follow somewhat different rules, but all have the same basic goals in common: to have knowledgeable judges evaluate the results of the breeding programs of dedicated breeders, with decisions based on the merits of the dogs as described in written standards of perfection for the breeds.

Your First Show Dog

If you do not yet own your first show dog and wish to get involved in the sport of dogs, you need to do some thinking and searching before you make the commitment of purchasing a dog. Because you are reading a book about Golden Retrievers, we can assume you have already decided which breed is the one for you. Next, you will need to decide whether you want a dog or a bitch. There are advantages and disadvantages to both sexes.

Both males and females need the same outgoing and confident temperament that should be present in any Golden Retriever to begin with. Both need to have correct conformation and must move well. Both need to enjoy being in the show ring. Unlike in the old days, today both sexes do well in Best of Breed and Group competition. Males do not come into season and thus do not tend to drop their coats with the same regularity as can be expected in bitches. This natural loss of coat can have an effect on a dog's show career.

You will want to purchase your dog from a breeder whose lines have already displayed a record of success in the conformation ring. The cost of a puppy will be approximately the same from most breeders and will represent only a small percentage of the total cost of showing and finishing a quality Golden. You want to start with the best dog you can find. As a bonus, the in-depth experience of the breeder from whom you choose to purchase your dog

The purple ropes and backdrop of "the Garden" are a dead giveaway that Ch. Highmark's Cowboy Coffee OS, SDHF is competing at the prestigious Westminster show.

has the potential to become an asset as valuable as, or even more valuable than, the dog you purchase. Once you have established a working relationship with a dedicated breeder, that person will always be available as a mentor and consultant as you learn the ropes of showing and beyond. Finding such a breeder is not easy, but in the long run it is more than worth the investment of time and money. You'll want to read through all of the chapters in this book to become an educated consumer who knows what questions to ask.

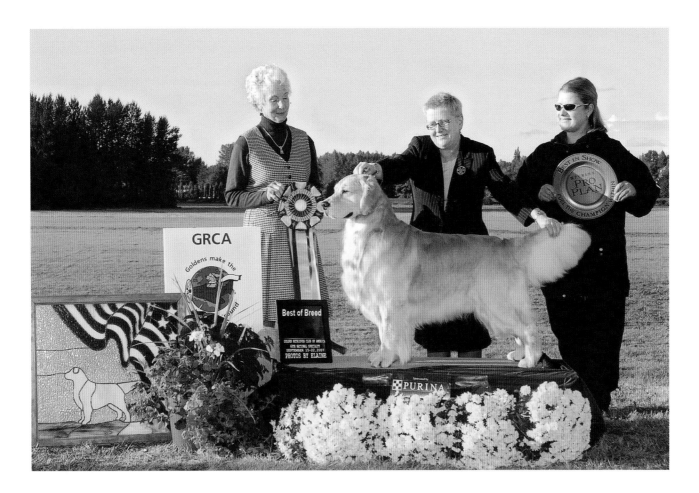

Ch. Pebwin XPDNC OS, SDHF is the 2007 GRCA national specialty Best of Breed and an influential stud dog.

Training and Conditioning

Show dogs are born, but they also need to be made into the kinds of dogs that will win at shows. First, to have a big winner, you will need a top-quality dog who loves being in the show ring. He must be confident and self-assured at all times, so he must be well socialized and must readily allow strangers to "go over" him. You need a confident dog who is not at all concerned with being in new places and among other dogs and people he does not know. As friendly as most Goldens are, they are not just born that way. The kind of confidence and outgoing temperament needed in a successful show dog comes from careful socialization that must begin with the very young puppy and continue throughout his lifetime.

Dogs should be taught to be confident and comfortable in new situations and with new people. A show dog needs to learn to stand still for examination and viewing by the judge and to stand in a position that shows off his best qualities. He must allow the handler to move his feet as needed to attain the best possible pose. He will be required to remain alert, with his tail wagging, and to stand still for a length of time. Show dogs also have to be taught how to gait properly and gracefully on lead on both indoor and outdoor surfaces. Owners and handlers need to allow puppies to be puppies and

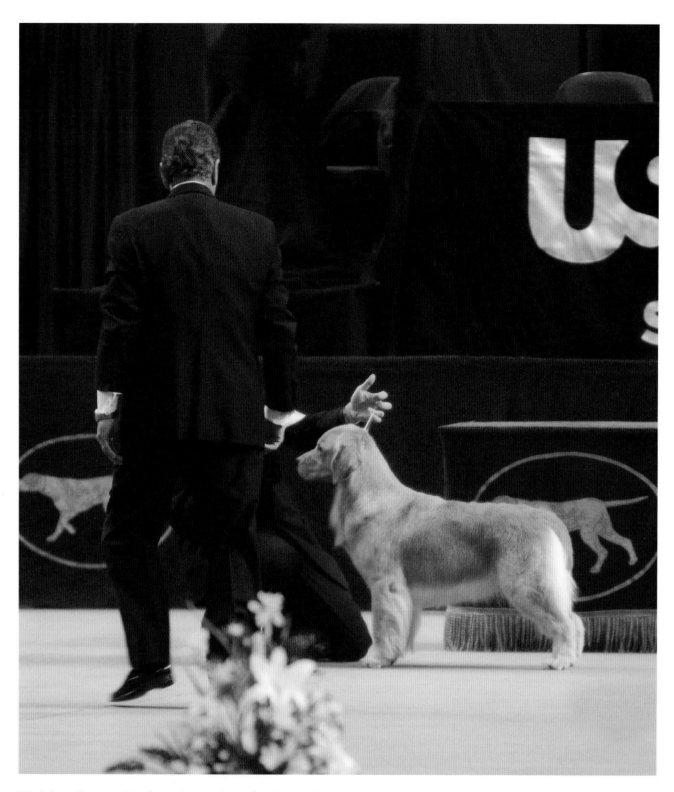

With handlers and judges dressed to the nines, the televised Group competition at Westminster is majestic and exciting. This is Ch. Toasty's Treasure Island, bred and owned by Pam and Jerry Oxenberg, representing the breed in the Sporting Group in 2008, a year in which she was also the top Golden and the national specialty BOB winner.

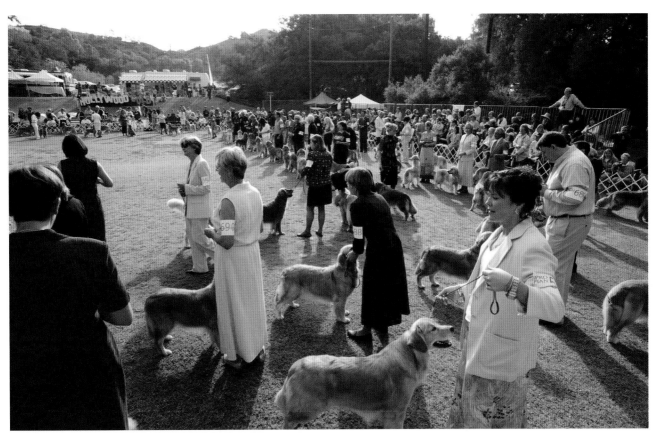

A class is checked into the ring at a Golden Retriever specialty.

should not have the same expectations for puppies to concentrate and stand in one place as they would with experienced adult dogs.

Handlers also need to hone their skills. Good handlers are made through preparation and practice. You need to prepare for showing your dog by practicing setting him up in the most favorable position. Using a full-length mirror and looking at your dog from the same position a judge will use will quickly help you see just how to stack your dog to his best advantage. Sometimes, simply moving the front feet a bit further under the dog or moving the rear feet just a bit forward of where you first thought they looked good can make a big positive (or negative!) difference. Watch successful handlers, both professionals and owner/handlers, for clues on how to best

stack your Golden. It is important to practice until you can stack your dog very quickly. If this is not your first dog, remember that not all dogs look their best in the same position. Find the right position for the dog you are showing now.

In the United States, and in many other countries, a good deal of a judge's emphasis is placed on just how well dogs gait. Different structures call for different gaiting techniques. Not all breeds look good moving fast; in fact, you might be surprised at just how many dogs do not look good scrambling around the ring at the fastest speed you can muster. Remember, good gait is determined first by the structure of your dog and second by his foot timing and just how well he uses his body and angulation when gaiting. A good Golden need not keep up with the setters in the Group to be moving well.

Ask someone knowledgeable about correct gait to watch your dog moving and tell you when he looks

ABOVE: At an outdoor dog show, areas for grooming and preparing for the ring are set up under tents.
BELOW: A typical handler's "setup" at an outdoor show.

his best. Remember just how fast you are moving at that point and use this knowledge in the ring. Move your dog at his best speed. Don't be pushed into moving faster just because everyone else is doing it. Good type combined with good gait is what determines the big winners.

Do your homework before you show. Don't leave your practicing until you are in the ring with the judge watching! Your dog's reputation and show record will be determined by how he looks in the ring. You want him to look his best at all times, both for the judge and for the spectators.

Preparing for the Ring

In addition to practicing, you will have to prepare your dog for the ring each time you show. Making your dog look his best will involve some grooming and trimming, but remember that the standard asks for a natural appearance: "...the natural appearance of coat or outline should not be altered by cutting or clipping." You do not want an excessively barbered appearance. Trimming techniques vary a bit from country to country, but all exhibitors seek to make their dogs look their best in the ring. Too many people simply copy what they see other exhibitors and handlers doing with their dogs without really understanding just why these things are being done. This will not work well for you in the long run. A particular grooming technique you've seen on a winning dog might be correct for the dog you are observing, but could be totally incorrect for your own dog.

Good grooming techniques require a thorough knowledge and understanding of correct structure and the requirements of the breed standard. The purpose of grooming is to make your dog look his best, minimizing his faults while emphasizing his strong points. For example, if your dog could use better shoulder layback, you want to make sure that the juncture of his neck to his backline curves a bit so that the neck flows smoothly into the backline with no lumps or bumps. Incorrect grooming here can make your dog look straight in front even if he has good angulation. The breed standard calls for a level backline from withers to slightly sloping croup. This means that you want to minimize any dips or bumps in the backline. Just how you groom will make a difference here. The same is true for other faults, such as too much loose skin under the jawline.

Coat preparation is always an issue and can sometimes be controversial. The breed standard clearly calls for a specific kind of coat on the Golden: "Dense and water-repellent with good undercoat. Outer coat firm and resilient, neither coarse nor silky, lying close to the body; may be straight or wavy...Excessive length, open coats, and limp, soft coats are very undesirable."

When preparing your Golden's coat for the show, keep the standard's section on coat in mind. The popular technique of puffing up the coat with grooming products and blowers invariably produces a coat that is soft and fluffy. Many judges, myself most certainly included, find this very objectionable and consider this carefully when deciding on the winners in a class. You don't want your dog to lose because of your grooming technique.

As I wandered around the grooming areas at a specialty show recently, I was amazed at the amount of time and care that was being invested in the preparation of the dogs for the show ring. There was actually a line of dogs at the bathing station. Seemingly hours were spent bathing dogs, blowing them

dry, and adding various products to allow for styling and enhancing the look of the dog. But to what end?

We can all agree that there is no such thing as a perfect dog—each dog has characteristics that could be improved to bring the dog closer to conformity with the breed standard. In the show ring, the judge's job is to find the dog who most closely conforms to the standard of perfection. A breeder's job is to improve the quality of his stock and the breed in general. The show ring is where breeders come to compare the results of their breeding programs. Lately, though, rather than improvement of the breed, it seems that winning for the sake of winning, no matter how, is the goal.

"Grooming in" correct structure appears to be the focus of many. Does the dog need more bone? Let's fluff up the hair on his legs so that it stands

The judge is making plenty of mental notes as he gets his first impression from the lineup of entrants.

away from the body and gives the appearance of substance. Got a dip in the topline? Fluff up the hair above the offending dip and add some product so it stays in place. Lacking good shoulder layback? Bring out the thinning shears and other grooming implements to create the illusion of proper layback. Big feet? Tightly trim all that hair around the feet to make them look smaller.

Despite AKC rules barring the addition of "foreign substances" to the coat or changing the dog by artificial means, a number of exhibitors seem to use as many tricks as they can to cover up faults. Lacking pigmentation? Add some color to the nose and

eye rims. Coat color showing some gray? Add some coloring to cover it up. The goal? Fool the judge into thinking that a dog has correct structure and color despite the fact that he doesn't. And what's wrong with a bit of gray anyway?

What many exhibitors seem to forget is that nearly every judge started out showing dogs—and, quite possibly, using many of the same tricks. With a coated breed, no judge is going to rely on his eyes alone to assess a dog. A good hands-on examination by the judge will quickly reveal if the dog has a short upper arm, is lacking in proper shoulder layback, or has other shortcomings.

So, what is the real problem? Grooming will not improve your dog or your breeding stock. While breeders and exhibitors are expending all of this energy to learn and apply new grooming techniques, they may well be fooling themselves, as well. Breeders need to know the strengths and weaknesses of their dogs by assessing them just as judges do. Energy should be concentrated on working toward real improvement in structure rather than the appearance of improvement. Careful breeding practices combined with pedigree study and an understanding of anatomy and genetics will lead to the real goal of improvement of the breed, not improved ways of fooling the judge—and yourself.

What Do Judges Look For?

So, just what do judges look for when they are standing in the center of the ring? While each judge interprets the standard a tad differently and may place a little different emphasis on various requirements in the standard, all seek the same thing: the dog in

RECOGNIZING PROBLEMS

Remember, to fix a problem, you first have to know that the problem is there. Only knowledge of the standard can tell you what is right and what is faulty. You want to do your best to make your dog conform to the requirements of the breed standard.

the ring that most closely conforms to their mental image of the "perfect Golden Retriever." Each judge will use slightly different ring procedures in helping them reach the goal of finding the best dog. There is no one correct way to judge dogs. Here, I will try to describe what I, as a judge, am looking for when it is my turn in the center of the ring.

First, I will bring all of the dogs in the class into the ring and have them set up. Here, I am looking for that all-important first impression. I look first at the silhouette of the dog, his overall outline. I'm searching for the dog with balance and harmony in a body that meets the type required in the standard. I'm looking at how the various parts of each dog's body embody correct type and how well those parts fit together. At this point, I might mentally single out several dogs as "possibilities" for further consideration, and I might also begin the process of discarding some entries as simply not meeting my requirements when compared to the other dogs in the ring. I have begun the process of mentally comparing dogs to one another, a process that will continue until I have placed the class. I am judging the dogs as they look on the day, not on their record or how they looked at other shows.

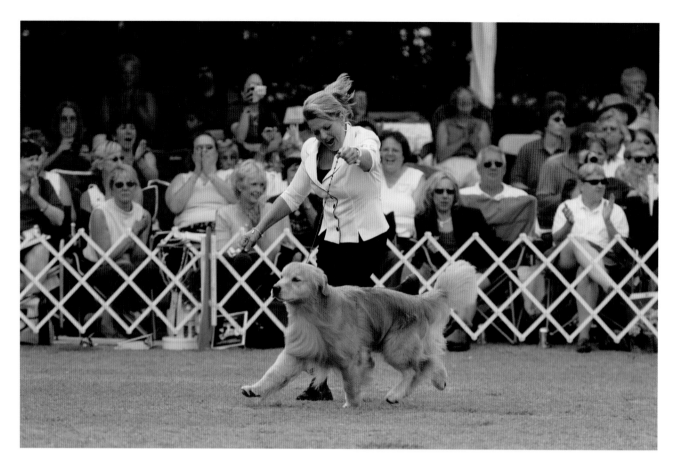

The judge assesses each dog's gait individually as well as in a group.

Next, I move the entire class together. I am looking at how the parts of the dogs fit together to make the whole. Do the dogs I initially liked standing still please my eye when moving? How are the toplines holding up on the moving dogs? Do the dogs move freely or is their gait restricted? Again, at this time, I am simply forming a first impression that will either be confirmed or denied as I examine each dog individually. Sometimes I am disappointed when going over a dog I liked initially. Other times, when examining a dog I didn't care for at first glance, I find many attributes I like and eventually place the dog, occasionally even in first place.

The mechanics of the individual examination are fairly simple. Here, each dog is carefully examined to see just how closely he conforms to the breed standard. I look at the dog's expression and check the elements of the head, such as bite, dentition, and ear size and placement, by eye and by hand. Next, I move on to the front assembly, checking angulation and layback, length of upper arm, bone, and size, as well as the legs and leg length, the toes, the pasterns, and the placement of the feet. Next, the forechest, topline, and depth and breadth of chest are checked, followed by the length of rib cage, the underline, and the loin. Finally, I check the rear assembly—the angulation; the angle of the croup; the position, length, and thickness of the tail; the rear pasterns; and the feet are all considered.

Now each dog is gaited individually, and significant attention is paid to how the dog moves,

especially when viewed from the side. For me, it is side gait that tells the most about the balance and correct gait of the individual dog, so typically I will have the dog first move in a triangle pattern and then down and back, allowing me to see how the parts of the body are used from all angles. I want to see a smooth, effortless, flowing gait. I pay attention to how the dog moves coming and going. Do the elbows move properly, or are they in or out? Does the rear move well, with the legs and feet moving in a straight line and hocks facing neither in nor out, not too close together or too far apart? In the end, though, it is the side gait with correct reach and drive and steady backline that I value most when watching a dog move.

Each dog is assessed individually and then mentally compared with the other dogs in the class. I make a mental note about just where each dog "fits" in line. Thus, the judging process is a constant mental evaluation of the dogs in comparison to the others. This is not a negative process. Rather, the strengths of each dog are compared and it is the typey dog with the greatest balance of strengths that emerges victorious, not the dog with the greatest weaknesses that loses.

This is not hard to understand if you remember that judging is the search for the perfect dog, and there is no such thing as the perfect dog. Given this fact, the evaluation process of judging is not looking for faults—every dog has some—but rather looking for strengths. If one were to judge by looking for faults, throwing out from consideration any dog with faults, then the winner is quite likely to be a dog with few faults, but also with few virtues. For, in this method of judging, one is not looking for the good, but just for the bad. Judging needs to be done from the standpoint of finding strengths. It is

GAITING

There is no part of a dog's examination that is more important than when the judge looks at the dog in motion from the side. It is in side gait that we can see the whole dog and can assess the overall balance and harmony of the animal. Many judges put their emphasis on correct side gait.

When evaluating a dog according to the breed standard, the first thing the judge does is determine how well the dog conforms to the standard (hence, conformation showing). For the dog to be outstanding, he must display all of the hallmarks of the breed. The head, type, proportion, conditioning, coat, and color all must meet the requirements of the breed standard. The wise judge chooses his winners from the dogs in the class that most closely conform to the standard. Once the judge makes his cuts, the dogs that remain in the class are evaluated on their balance, harmony, and gait.

Please refer to the section on gait in Chapter 7 if you have any questions regarding just what is considered correct gait in the Golden Retriever. Gaiting your dog correctly at his best speed can make the difference between winning and being an "also-ran."

a constant process of evaluation and comparison, weighing the relative strengths of a dog against those of the others in the class.

How Important Is Handling?

Handling is important. To a point. Good handling can help a dog win, and poor handling can make an otherwise good dog look much worse than he should. After all, you don't want to hide your dog's strengths from the judge! Handling is a skill learned from experience over time. Exhibitors can improve their skills by watching other successful handlers, by attending handling lessons offered by a local kennel club or privately by a skilled professional, or by seeking the help of an experienced friend in the fancy. No matter how you go about it, learning how to handle is a valuable skill learned only with practice and experience.

A question I often hear is, "Why do professional handlers win so often?" To begin, it is fairly obvious that a professional handler who doesn't win will quickly lose his clients and will not remain a professional handler for long! Therefore, professionals must constantly hone their skills to remain on top. They do this in many ways. First, because professionals have a lot of dogs to handle, they have a lot of practice. Second, to earn a living, professional handlers must go to shows—a lot of shows. Week in and week out, they are at the shows. They become familiar sight to exhibitors and judges alike. Good handlers build their reputations over time, be they professionals or amateurs.

In the United States, judges are expected to do their jobs at the rate of about twenty-five dogs per hour. This includes getting the dogs into the ring,

NOVICE HANDLERS

Do judges give novice handlers a break? For the most part, yes—when they can. I can remember doing a specialty years ago and coming across a beautiful bitch with a handler who clearly had never been in the ring before. The handler wore high heels (and I mean *high*) and didn't really know how to set up her bitch. The bitch was beautiful and caught my eye immediately. When it came time for the individual examination, the handler had the bitch looking more like a rocking horse than a show Golden. I finally stepped in and set up the bitch the way I wanted her to be, and I told the handler not to touch the legs until my examination was over. She was lovely. The bitch was then gaited and moved as well as I thought she would based on the physical exam. I told the handler to watch what the other handlers in the class were doing and to copy their work as much as possible. At the end of it all, this bitch won her class and was named Winners Bitch (and eventually Best of Winners and Best of Opposite Sex). Because it was a specialty show, I had some extra time and could work with the handler and her dog. At an all-breed show, where maintaining the schedule is important to the other judges and other rings, I don't think I would have been able to take the time.

Many well-known people get involved in the world of dog showing. Pepperhill's Price of His Toys, "Dash," was owned by Mary Tyler Moore and her husband, Dr. Robert Levine, and is pictured here winning Best Puppy in Breed at a Canadian show.

checking the judge's book, marking the judge's book, allowing time for organizing the ring, taking photos, and waiting for the late handler. In practical terms, it means that judges are allotted an average of two and a half minutes per dog, including all of the administrative work. This does not leave a lot of time to assess individual dogs.

Other countries have different rules, some requiring even faster judging. In Australia, for example, judges are expected to do about forty dogs an hour, or one and a half minutes per dog. Others allow more time. At FCI shows, which require individual critiques and ratings for each dog entered (dictated to a secretary in the ring and available to exhibitors after judging, with all this happening before the class is judged) more time is needed. The dogs are not compared to each other until the critiques are completed for every dog entered in that class. It is at this point that the dogs are compared to each other and the placements are made. Judges are normally limited to 100 dogs a day, or about twenty minutes per dog

because of the time needed to do the critiques. Considering all that must be accomplished with each dog, that's still not a lot of time.

All exhibitors, whether amateur or professional, need to focus on the small amount of time the judge has to examine each dog. Because time is limited, it becomes especially critical that the dog look as good as possible for the entire time that the judge is looking at him. This means a minimum of fumbling to get the dog into the right position. You want your dog to look his best, not show the judge all of the worst sides of your dog. This fact alone makes it clear why training and advance preparation is so important to winning. You need to know how to ready the dog for examination and get the job done as quickly and efficiently as possible.

If Joe Handler is known to often have good Goldens to show, and he always shows them well, it makes sense that judges will pay attention to Joe's dogs because they might well be the ones to consider. Joe has done his homework because he has to in order to win often. Owner/handlers have the same need to prepare and train their dogs in advance. It is not the judge's responsibility to set up your dog properly. It is human nature for the judge to like the dog who is well presented, because the handler is making the judge's job a little easier.

Take a hint from the best of the junior handlers. Yes, the juniors. If you have ever watched Junior Showmanship competition, you have probably marveled at the skills of the youngest generation of fanciers. Notice that the junior who wins often is the one who has made his dog (rather than himself) the focus of the judge's attention, and has done it quickly and smoothly. Remember, it is the dog who is being judged in the show ring (although in Junior Showmanship, the junior handler's presentation is being evaluated). The smart handler will strive to make the judge want to put his dog up because his dog is the best in the ring.

Baiting in the Ring

Why do people bait their dogs? It should be to hold their dogs' attention and keep them focused so that they look their best. I'm never sure that all exhibitors really know why they are doing it, but they bait because, after all, everyone else is doing it, so they should, too. Some people seem so concentrated on constantly feeding their dogs that they become oblivious to what the dogs actually look like while they blissfully feed away. Most Goldens are always hungry and can't wait to get to food. Often, a dog, in an attempt to get more food as quickly as possible, moves his legs into a very unflattering position. Rear legs are overstretched and hocks face each other. Front feet turn in or out, yet the handler hardly seems to notice as he stuffs more food in the dog's mouth.

Flinging the bait about the ring also seems a part of this exercise. Handlers throw bait around with abandon, and not all of them bother to pick up what they have thrown. I once had a handler in the next ring fling liver for his Great Dane directly into the path of the dogs gaiting in my ring! He did this several times, and I was finally forced to ask the steward in his ring to ask him to cease and desist. He apologized, but he wasn't even aware of what he was doing.

Sometimes a handler is so busy offering food that he does not notice that he is forcing the dog's head back toward the tail. This results in a dog's appearing short-necked or, worse, lacking proper shoulder layback. Having the dog stand with his head over the withers creates the appearance of a

The intent of baiting is to keep the dog looking alert and attentive, standing in a flattering position, in the show ring.

straight front. This is a common enough problem in dogs in general—so why exaggerate the fault? Others bait with such vigor that they actually encourage their dogs to lean backward, sometimes creating the appearance of weak backlines. Is this how you want to show your dog?

Now don't misunderstand. Baiting is not all bad. When done properly and skillfully, it can serve to enhance a dog's appearance. Used correctly, baiting can minimize certain faults and show off certain strengths. For example, a good alert expression is often desirable, and offering a morsel of food at the right moment will focus the dog's attention and provide the judge with a look at an alert and involved dog. A dog with a low ear set will at least partially hide this fault by holding his ears erect while seeking a bite to eat. It also might make his skull look broader.

Part of the judge's evaluation process for nearly any breed includes an examination of the head, expression, and bite. As the judge approaches, it often makes sense to offer the dog a bit of food to get that alert, intent look. However, if the dog is so focused on the food that he is constantly trying to get at the bait while he is being examined, making the judge's job more difficult, it does not make sense. And there is nothing pretty about looking at a dog's mouth as he is chewing the bit of liver that his handler gave him just before the mouth examination.

So, bait if you must. But do so with specific reasons in mind, and don't make baiting appear to be the primary focus of your time in the judge's eye.

Breeder-Judges or "All-Rounders"

There is an ongoing discussion among fanciers regarding the merits of breeder-judges compared to Group-level judges (though some breeder-judges also qualify as Group judges, they are still considered breeder-judges in this context). Those who prefer Group-level judges feel that they are more objective when judging because they don't concentrate on faults involving individual requirements of breed standards, which is a problem, they feel, with breeder-judges. Because Group-level judges are not breeders, those who prefer them feel that they give more importance to the overall dog rather than individual characteristics.

Those preferring breeder-judges feel that the increased breed knowledge and expertise of the

Four-time national specialty winner Ch. Sassafras Batterys Not Incld poses with the Best of Breed trophy.

breeder-judge leads to better evaluation of type and breed-specific requirements. Group judges, this faction believes, place so little emphasis on type that they spend most of their time looking at the generic qualities of the dog, such as gait, while ignoring the importance of breed-specific type.

Specialty shows in recent years, especially on the level of local Golden Retriever clubs, have tended to use Group-level judges more often than breeder-judges. Why this is true can only be the subject of supposition. Perhaps the feeling is that breeder-judges, who often know many of the exhibitors as rival breeders, might tend to allow personalities to get in the way of objective judging. Or perhaps the concern is that breeder-judges who are known to like certain styles within type might draw lower entries than Group-level judges. Or perhaps Group-level judges are thought to potentially be less political than breeder-judges—or the other way around!

Of course, both sides have some validity to their sentiments and some exaggeration, as well. In my view, both kinds of judging are necessary to maintain both the correct desired type and the functionality of the breed. If all judging were done by non-specialists, there would certainly be a tendency toward more generic dogs. If all judging were done by breed specialists, it is certainly possible that type would be emphasized at the expense of physical functionality. In truth, we really need both kinds of judges to officiate at our shows to maintain the quality of our dogs.

Experience Is the Best Teacher

In the end, dog shows should be fun as well as educational. By their very structure, dog shows are really a huge elimination contest. By the end of the day at a show, every dog entered has been defeated, with the sole exception of the Best in Show winner. In that sense, practically everyone is a loser and really none the worse for the experience.

Unfortunately, far too many people today seem to take their dogs' defeat at a show as a personal attack on them by the judge, rather than accepting the judge's opinion or admitting to themselves that the winner was a better dog. Rather than staying for the entire judging of the breed, many people seem to leave immediately after their dogs have lost. At an all-breed show, many do not stay to watch the complete entry in their breed, and few are still around to watch the Breed winner in the Group competition at the end of the day. The unfortunate result of leaving early is the loss of a great opportunity to learn more about what makes a good dog, what makes a good handler, and what other breeds should be like.

Handlers who are accustomed to the routine of dog showing might even get to kick back and relax a little.

Staying around for the entire show gives those who are really interested in learning many opportunities to talk to their fellow exhibitors and to learn more from those with more experience in their breed. This sharing of knowledge and skills, many of which apply to more than one breed, is how most successful exhibitors and certainly most successful breeders learn. Learning is, in fact, a continual process that begins at birth and ends only at death. No one ever learns all there is to know about any topic, especially one that is dealing with living things. Admitting what you don't know is the first step toward learning more.

Win or Lose

Good sportsmanship at shows is a must. It's easy to be a gracious winner; what is not as easy, but is equally as important, is to be a good loser. If you don't win, congratulate the winner. Remember, there will be another show the next day or the next week, thus other chances for your dog to win.

Be a good sport. If your dog doesn't win his class or doesn't go Winners, don't leave the ring in a huff or leave the show. Stay to watch the rest of the judging and learn. You'll learn more about your breed just by watching, and you will also have the opportunity to talk to other exhibitors and learn from them. Don't let your ego get in the way of having an enjoyable day with your dog. Going to the show is supposed to be fun!

Chapter Eleven

"Primarily a Hunting Dog..."

BY ANN STRATHERN

I admire Lord Tweedmouth's mindset and purpose when he designed his breeding program that established the Golden Retriever. He is reported to have been an avid sportsman and hunter, and he was interested in developing a superb yellow retriever that would be able to retrieve game from the rugged fields and waters of Scotland and England.

He developed a strain of retrievers that would do this job, which encompassed biddability in training, even temperament to work with other dogs, keen eyes and nose for marking and trailing game, and efficiency and extraordinary energy reserves that would allow day-long hunts. These retrievers met the job requirements of supplying meat for the table and providing companionship for the gamekeepers and their families. These wavy-coated yellow retrievers were also pleasant to the eye and assured this new breed of retriever admirers for many years to come.

Lord Tweedmouth's vision of this retriever breed and the qualities it was to possess are incorporated and delineated in the Golden Retriever breed standard, written by the Golden Retriever Club of America. You already know that the standard discusses and defines what a Golden Retriever is. It is divided into sections that describe every part of the dog, from the end of the nose to the tip of the tail and all parts in between. Breeders are responsible for maintaining the quality, type, and purpose of the breed. Any deviations, exaggerations, or excesses— any departures from the described "ideal" Golden Retriever—are detrimental to the original purpose of a nonslip retriever (whose function is to remain

A Dewmist puppy with the hunting instincts that are alive in the breed in dogs of any age.

quietly at your side and then seek and retrieve fallen game when ordered to do so).

Ideal type cannot be produced unless we understand the work for which Golden Retrievers were developed, and the relationship of the standard to the hunting dog has been and still is an avocation of mine. To define the form and function of the Golden Retriever, I will relate portions of my life with Goldens and examine how the breed standard translates in the field. And so unfolds my association with and love of the Golden Retriever since 1972.

Shortly after a move from San Diego, California, to Eugene, Oregon in 1971, we were excited to attend our first all-breed dog show. My husband was in search of a Labrador Retriever, while I was

The area around Guisachan as it appears today.

A typical stone wall found in Scotland.

Typical cover on the grounds of Guisachan.

The river at Tomich, the village that Lord Tweed-mouth and Guisachan called home. The ruins of the mansion still remain.

enamored of the Irish Setter. Much to our pleasant surprise, we stopped at a ring that had Golden Retrievers and found our blending of the body type and size that my husband was looking for and the color, temperament, and athleticism that I was looking for. We both found the Golden's general appearance to be stunning. To use some of the words found in the breed standard, a powerful, active dog, well put together with a kindly, eager expression and self-confidence is what we saw in each Golden that trotted around the ring to the applause of the bystanders.

Where, oh where, could we find this perfect compromise in our first canine companion? As luck would have it, Golden Retriever breeder Dan Browning was a few miles away, and we went to visit him. His litter of puppies was a few weeks away from going to their new homes, and we reserved a male. The only requirement was that we would field-train him and come out to sanctioned field trials held by the local retriever club. And so began a lifetime of training,

The Golden dives into everything he does with a splash.

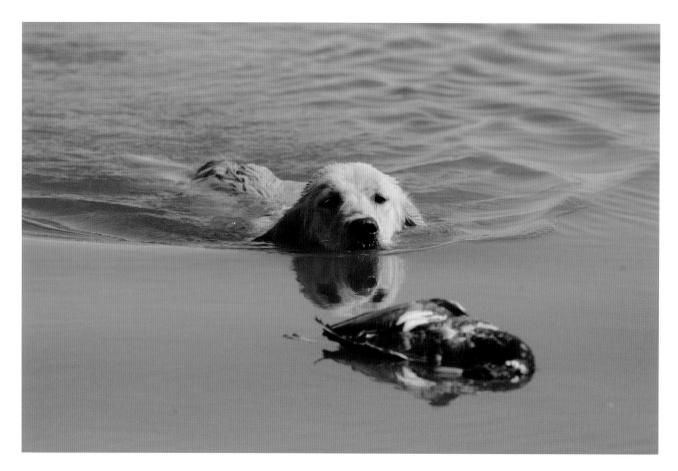

field testing, hunting with, and loving the Golden Retriever. Never having trained a dog for obedience, much less fieldwork, we had our work cut out for us!

Quick to learn and with his ancestors' natural hunting abilities, Duncan was the perfect first dog. Possessing the trainability inherent in the breed, he took honors in his obedience classes, much to the chagrin of a friend who suggested that I attend the classes with her and her Afghan Hound. Duncan displayed the enthusiasm and joy of learning and reveled in his new talents, helping to teach beginners' classes while demonstrating the more advanced Utility-level hand signals. His skills surpassed ours, and it seemed that he taught us more about retrievers than we taught him about retrieving.

Hunting on the Fern Ridge Reservoir with our Goldens was so peaceful. In the early morning before daybreak, we took our decoys out to cattail-covered

Notice the great swimming strength of this dog, as indicated by the bow-wave he creates.

high points and wedged our boat in to hide us and to keep us and the dogs up out of the water. On foggy mornings as dawn was breaking, we watched our first Golden listen intently. Duncan could not only hear the sound of the ducks' wings coming long before they broke through the fog but also would tell us from which direction they were coming by facing the sound. Occasionally, he would tremble with excitement, but patience was certainly one of his virtues, and obediently he would sit and wait.

Often, when shots were taken and no birds dropped, we would get a disapproving stare from our companion. Luckily, he did get lots of work, and he spent hours getting in and out of the boat with his bounty. His size and proportions allowed him

to effortlessly jump into the boat while holding on to his quarry. His coat was of the correct moderate length, and that was especially helpful on mornings when he had lots of retrieves. Because his coat did not carry a lot of water back in to the boat, there was no bailing water out of the bottom for fear of sinking! And, with his dense undercoat, he dried quickly with a couple of shakes, preventing the cold water and air from draining his reserves. His magnificent water entries and his enthusiasm for all tasks that were put in front of him will always be part of our memories. Duncan went on to become Qualified All-Age in field trials and a CDX (Companion Dog Excellent) with High in Trial placements in obedience. But, sadly, he died at the tender age of five when a foxtail seed he inhaled introduced a fungal infection into his lungs.

Often, his friend, a Cocker Spaniel named Honey, would accompany us during our hunts—and what a brave little dog she was. Going out to retrieve a goose, she would push it back to shore, grab its neck, and drag it as far as she could toward us. She was a good-sized Cocker, but she illustrated why a retriever's size was more efficient at bringing in the

Proper structure is important for making retrieves, especially heavy ones. This is a small female with a large bird.

bigger birds. A strong neck and front assembly was necessary to lift and bring those geese in, especially when they might still be kicking! A Golden's head, broad of skull with a well proportioned muzzle and good dentition to properly hold a wiggling bird—whether goose, duck, or pheasant—is critical so that a bird won't harm the dog with its spurs or beating wings. The dog's grip must be firm and well placed yet gentle so that the bird is "fit for the table." The well-defined stop allows the retriever to see over the bird in his grasp so that he can navigate back to the boat or the handler on shore.

Proper structure of the muzzle and skull is imperative to the primary functions of marking falls and carrying game. Further, with binocular vision, a Golden's field of vision overlaps when he is looking straight ahead. This overlap of fields increases the ability to better judge depth and therefore the distance between objects in the foreground and background. Eyes that are "set well apart and reasonably deep in [their] sockets" will have a greater field overlap. The accurate marking of fallen prey enables a dog to quickly go out, find, and return without disturbing too much ground or remaining in sight of new prey coming in. There are eye diseases that affect marking ability, but as breeders we are fortunate to have board-certified ophthalmologists that can check our dogs yearly until very old age and attest to their eyes' being free from cataracts, progressive retinal atrophy, and other eye abnormalities. Now we even have DNA testing that is available for prorgressive rod/cone deterioration (prcd), a form of PRA.

"Marking is of primary importance" is stated in the rules for AKC hunting tests. By having their dogs' eyes checked and tested well into the dogs' senior years, Golden breeders can keep those eyes free of disease and pass along this important feature to future generations. My Goldens are tested annually

until their death because of the potential of PRA to develop later in life. My current young Golden is the seventh generation that I have bred and benefits from seven generations of health clearances. Health screening deep into pedigrees ensures that the probability of inheriting diseases is very, very low.

If game is crippled and the dog must trail to find it, the structure of the muzzle and the desirable deep, wide foreface become a factor. Dogs are able to pick up odors in concentrations of one part per trillion. Scent is not turned off, so trailing/tracking a bird (or rabbit) entails the dog's ignoring other scent and honing in on the target scent by following his nose. The cavity in which the scent-sensing ethmoidal cells are located is 6 cubic inches in comparison to the human cavity of 1½ cubic inches. An organ called the Jacobson's organ, a type of chemoreceptor, in the nasal cavity allows tasting of air. Open, wide nostrils complete the pathway of scent.

A year after getting Duncan, we acquired another Golden, a female that was equally as talented and willing to learn the intricacies of obedience and the field. Maggie became my first Utility Dog (UD) Qualified All-Age Outstanding Dam (OD) with one litter.

On many sunny mornings, we found pure joy in looking for pheasant in the fields around the reser-

Maggie Happydaugh UD, the author's second Golden.

voir. We watched our dogs quarter naturally without ever being trained—one of them would actually point before being asked to flush the birds when we were within shooting distance. The action of her well-set-on tail would alert us to the hiding prey. The ease they showed while covering the ground made shorter work for us as we pursued our prey. Being well-balanced, short-coupled, and deep through the chest allowed room for lots of lung capacity and heart.

Their energy seemed boundless in the field, and they loved to come home and spread out in front of a fire while we cleaned up our dinner. These dogs were companions in the truest sense. They seemed to have split personalities. Indoors was a calm, quiet place, and outside they were ready for any adventure we drummed up. To this day, our expectations remain the same for all of our Goldens. The personality and temperament that Lord Tweedmouth orchestrated in his early breeding is essential in our multiple-dog household.

Quality of heart can be interpreted several ways. "Having heart" might mean sticking with a cripple through brambles, briars, or log-filled ponds; tracking a lost child or looking for victims in collapsed buildings or ponds; allowing a young child to grab onto your ears; or sitting quietly while an Alzheimer's patient strokes your head. Temperament, personality, prey drive, and the desire to please all play a part in having heart. However, none of these things can be accomplished without physically having a strong heart, and, unfortunately, our Goldens have a genetic potential to develop heart disease. As breeders, we can screen for the heart disease subaortic stenosis (SAS) to ensure strong hearts in our Goldens. All of my Goldens are checked by a board-certified cardiologist before they go to new homes at the age of eight weeks. They cannot be cleared at such

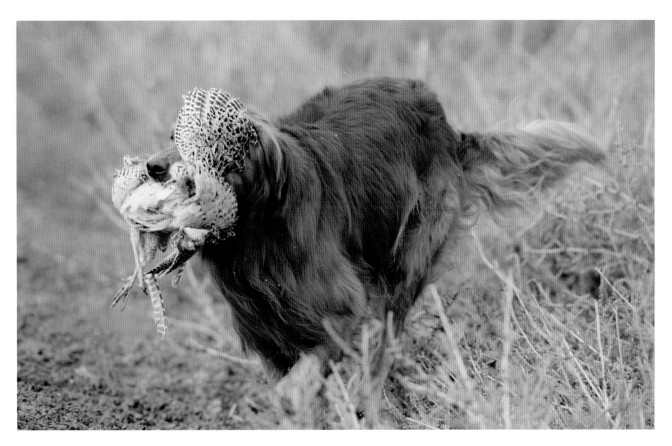

In field trials, dogs should show the same enthusiasm as if they were on an actual hunt.

a young age, but the cardiologist can assess their hearts and I can have peace of mind when I place the pups in the hands of their new owners.

Moving from quiet Eugene, Oregon, in 1977 to the hustle and bustle of Long Island, New York, was definitely a culture shock. Upon arriving on Long Island, we located a gentleman who introduced us to the large game farms on the far eastern end. These farms provided driven shoots and duck hunting and attracted hunters from all over the world. There were gamekeepers similar to those in England and Scotland, whose job was to handle the dogs that picked up the shot birds. The "pickup dogs" were a variety of breeds—German Wirehaired Pointers, Labradors, Weimaraners, Pointers, and Goldens. We joined the shoots, and our dogs would typically retrieve thirty

ducks in the morning in cold water, sometimes with skim ice, often going after cripples because, even though the guests were hunters, they were not always good shots.

After dining midday on delicious pheasant breast or duck, we would head out again for a driven pheasant shoot. Beaters would drive the pheasants toward the gunners, and the dogs would stay in a lineup until all of the birds were down. Then the dogs were sent into their areas to bring the birds back, making several retrieves and bringing both dead and cripples back to their handlers. Many dogs would be working at the same time, so they all had to have good temperaments so that no fights would ensue if they hunted too close to each other.

Another area would be selected to hunt and we would move on. Again, a typical day might be thirty or more retrieves on land. There were fields with brambles and densely wooded areas where marking

was impossible, so the dogs had to trail the birds. Our second male, Brother, was not only a great tracker but also lightning fast and would often bring me back a pheasant in the woods that had not been shot. The low branches would prevent the bird from getting a high enough jump to take off. After he was sent for another retrieve, I would release the bird to fly again another day, with Brother no wiser to my actions.

Stamina, muscle, and well-balanced front and back assembly were essential on the dogs for a long day of hunting and retrieving, sometimes under adverse conditions. We did not stop until the final whistle of the day sounded.

Effortless jumping in and out of boats, over logs in the water and fallen trees on land, and scaling hillsides covered with vines and heavy with brush all require good structure. Medium and large dogs of all breeds can be affected by hip dysplasia. This disease can cripple a dog and certainly shorten his life span unless surgical options are pursued. One of the earliest modern tools to help direct breeding programs was x-ray exams on the hips to view the conformation of the pelvis and femurs. When we got our first Goldens, the norm was to x-ray at one year of age. Later, it was determined that x-raying at two years of age, after the joints and bones had been allowed to mature, presented a more accurate indication of whether the dog had hip dysplasia or would have good hip conformation throughout his life with no arthritic changes. As discussed in a previous chapter, the Golden Retriever Club of America was a driving force in establishing the testing and standards for hip certification through the Orthopedic Foundation for Animals (OFA).

Our first Goldens' pedigrees had some of the earliest OFA certification numbers given, and hip certi-

fication through the OFA has always been part of my breeding program. I had the opportunity to have hip x-rays done on one of my dogs when she was fifteen years old and I had her in to remove a lipoma. When we developed her x-rays, I was amazed at how good they looked. Calling Dr. Corey, who was head of the OFA at the time, I asked if he would like to see a set of radiographs on a dog thirteen years after the originals were taken. He jumped at the chance, and when I got them back, he noted that he would still rate the hips as "good," just as they had been rated when she was two years old! Now we also have PennHIP as a resource to help breeders select the strong, powerful hindquarters that are needed in a hunting dog. Someday, there may be genetic testing as well.

The Golden standard states that "overall appearance, balance, gait, and purpose [is] to be given more consideration than any... component parts." Certainly, a dog has to be in "hard working condition" to sustain the type of activities required on a day's hunt. A smaller dog would not be able to keep up with the rigors of the day or be able to maintain body

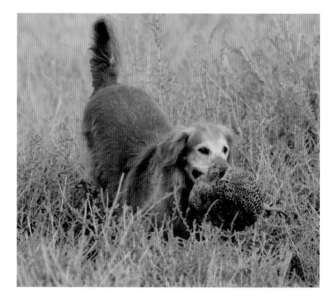

Some gray on the muzzle doesn't stop a Golden from doing what he was meant to do.

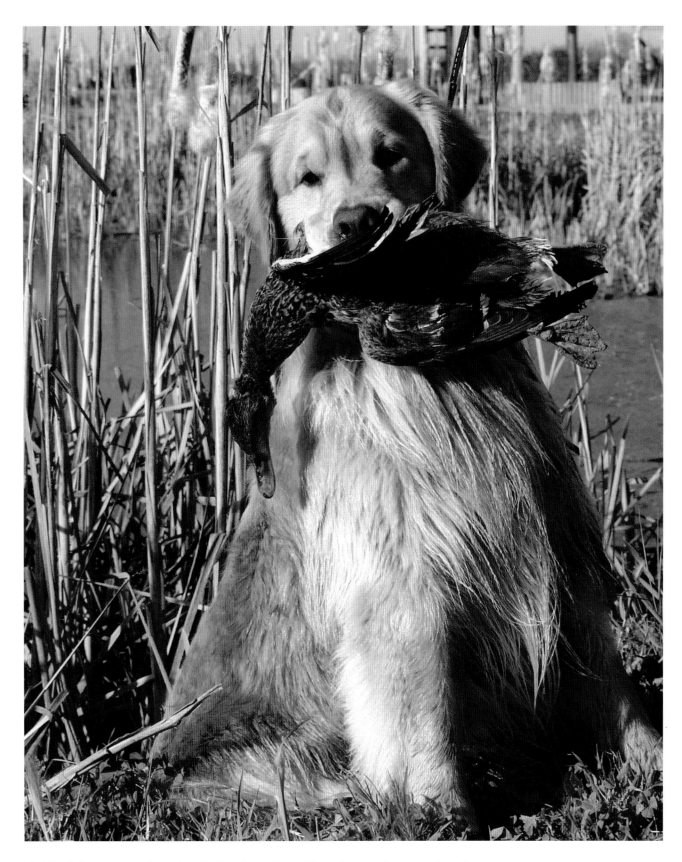

Field-trial success takes the dedication of a willing dog and a committed owner.

heat in frigid water or blowing winds. Well-sprung ribs allow the capacity for the oxygen exchange necessary to sustain long swims and chasing down cripples. A balanced front and back with good angulation is paramount to propel the dog over fences and logs, in and out of the water. A well-muscled neck, loin, and back propel the dog and contribute to the stamina he must possess for the type of hunting that is done in Scotland and in the United States.

AKC field trials, and subsequently hunting tests, were designed to challenge retrievers and help determine the relative merits of retrievers in the field. According to the *Regulations for AKC Hunting Tests for Retrievers*, AKC hunting tests "evaluate the abilities of retrievers in the field to determine their suitability and ability as hunting companions." Both trials and tests must "therefore, simulate as nearly as possible the conditions met in a true hunting situation." A stated objective of the Golden Retriever Club of America is to encourage members to "perfect, by selective breeding, Golden Retrievers that possess the appearance, soundness, temperament, natural ability, and personality that is reflected in the standard of the breed." Testing situations require different abilities than a day's hunt in the field or on water. In addition, according to the AKC hunting test regulations, "Retrievers shall perform equally well on the land and in the water, and shall be thoroughly tested on both…" There are short bursts of energy while the dogs are being judged and long waits in between series. Dogs must be able to rest and relax while listening to other dogs compete. The ability to be patient and wait until their turn comes keeps them from becoming stressed and worn out by the time they are on the line.

Hunt tests, by their nature, assess the abilities of a retriever on that particular day, under those particular conditions. The judges' responsibilities are to score the dogs in four different categories of their natural abilities: marking; style; perseverance/courage/hunting; and trainability, showing steadiness, control, response, and delivery. Natural abilities, from a breeder's standpoint, are of great importance, while abilities acquired through training are of lesser importance. However, a biddable, well-trained dog is evident in his carriage, enthusiasm, and demeanor on the line.

Judges evaluate the dogs using a numerical system with a defined set of abilities against an established standard, not by comparing the dogs to each other. The "bottom line" for most judges is to ask themselves, "Would I want to spend a day (at the level they are being tested) hunting with this dog?" If the answer is yes, then that dog will probably receive a qualifying score for the day.

Hunt tests have been a very useful tool in developing breeding programs that continue to incorporate the purpose of the Golden Retriever. By having their dogs tested against a standard and receiving qualifying scores and titles, a breeder can show that he is not only striving to produce an ideal type but also that he understands the work for which the dog must be perfectly suited.

Participating in field trials brings some different requirements for the Golden. Often, back in the 1970s, the West Coast trials—more so than those held in the East—seemed to simulate hunting conditions with multiple dogs walking up the field as if they were on a hunting trip and multiple dogs honoring, waiting patiently, while other dogs retrieved the birds. The shot birds were rarely over 250–300 yards away. We rarely saw a triple mark (three birds thrown in sequence) in the Derby (a field-trial class), and dogs back then seemed to do most of the work themselves. The handlers were there to help and guide. We were admonished by well-known trainers at that time

because we had taught our young dog (less than two years old) how to handle. The thought was that handling (teaching a young dog to respond to signals and casts to a bird he did not see fall) would ruin their marking (the natural ability to watch a bird down and go directly to it) if you started them too early.

My, how things have changed in the field-trial world! Now pups start their basic training by the time they have their permanent teeth, around six or seven months of age. They are started on basic obedience first and continue on to fetching, retrieving, and handling. By the time they are a year old, most retrievers will have finished "basics" and gone on to "transitional" training, transferring what they have learned "in the yard" to out in the field. By the time they are entering field trials at the Derby level (for retrievers under two years of age), they are running double marks at 200–300 yards, are taught not to "cheat" cover or water, and are well on their way with their blind retrieves. All of this requires a higher level of biddability, stamina, and trust. Most serious field-trial participants train four to seven days a week to keep their dogs sharp or teach new concepts. Additional stress and pressure comes with this type of rigorous training. The dogs need to be able to relax and rest and come out of their crates refreshed, ready to hit the long marks or face challenging blinds.

Field trials are not just for evaluating the natural retriever anymore. Training techniques and trainers have improved over the years, retriever breeders have been more selective in their breeding programs, and expectations have gone beyond the hunting dog and more toward an elite level of "retriever machines." To succeed in the field trial world, a Golden has to have great work ethic, great teamwork, and great faith in his handler.

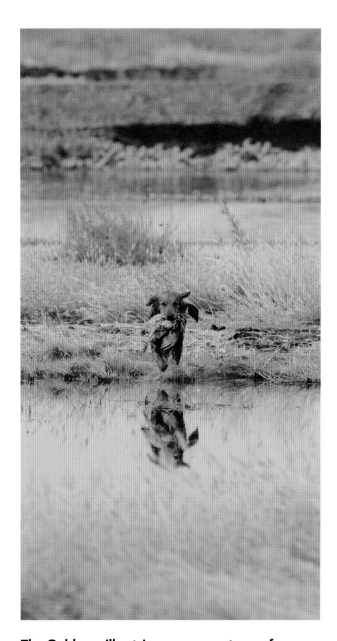

The Golden will retrieve over any type of terrain and through any type of cover, and water is never an obstacle.

Field trials are not for the weak of heart. It takes years of training to reach a competitive level with any retriever. The demands of today's field trials have brought a challenge to today's breeders to develop the Golden to be competitive in rigorous tests while maintaining the attractive, biddable, self-confident working gundog who was developed in the 1800s.

Chapter Twelve

The Golden in Obedience

BY SHARON BOLTON

O bedience trials are an excellent form of canine competition, and are actually the venues where most people are introduced to the sport of dogs. Many people are acquainted with the sport of obedience through purchasing a pet and starting in obedience classes, which leads to a new and wonderful world of competition not previously known to them.

Obedience is an easy place to start in the world of competitive dog sport. It requires the least amount of equipment—a dog, a lead and collar, and a few toys and treats for motivation and you're ready to go. Spacewise, all you need is a driveway and a backyard, and you can even train some exercises in the house. Even for upper-level training, you need little equipment when compared to other aspects of competition. It is definitely the simplest in terms of special needs for training. It is just you and your dog—with you explaining the details of what you want to your canine companion.

Structure and Obedience

Competition in all aspects of the dog game has become very extreme, and obedience competition is no exception. The conformation dogs have become more extreme in coat and bone, the field dogs are asked to do longer and more complicated retrieves, and the obedience dogs are asked for more absolute precision. Unfortunately, the obedience world has gravitated to genetically selecting for what they primarily see as the mental capabilities to almost total exclusion of any other traits, including structure.

Obedience competitors are generally looking for high-energy dogs with strong focus; however, little consideration is usually given to the aspects of

Among the many titles of Ch. Highmark Mirasol Once A Knight is the lofty OTCH—Obedience Trial Champion. He's shown here winning the Group under the author.

structure. Part of this is because most people enter the dog sport through obedience and were never in a situation to learn about structure and its impact on how a dog moves, sits, stands, and jumps. Obedience competitors see breed-ring competition with its own set of extremes, which can include dogs with overdone coats, with overdone bodies, and who are heavy on their feet. This aspect of the conformation ring has made it more difficult for the performance

competitor to see how "structure" might affect their dogs. The top-winning obedience dogs often have a kinetic energy and are very light of bone and body, but many are lacking other qualities, including good front and rear angulation, soundness coming and going, and overall balance. A strong head with good pigmentation has become a rare find in bloodlines bred primarily for obedience. Unbeknownst to many competitors, most of these traits have an impact on a dog's working capabilities.

As trainers and breeders have selected for increasing amounts of energy and focus, they have continued to sacrifice correct structure. Some competitors feel that if a dog is sound enough to obtain an Obedience Trial Champion (OTCH) title, he must be a sound dog. Generally, for a dog to obtain an OTCH, he must possess an exceptional amount of desire to please. Is it possible that we have selected for so much desire to please that these dogs are willing to perform even though, structurally, it may be difficult or even painful? Typically, limitations in any being or process come from its weakest trait. For many obedience competition lines, structure has become the weak point.

As all venues of competition have become so narrowly focused, it has become necessary to breed selectively to be truly competitive. However, so often we see people breeding to stud dogs or purchasing dogs because of win records and not because of specific traits. We need to learn to breed entire dogs, not just pieces of dogs. As competitors often focus only on the traits they feel are necessary to win, they lose sight of the entire package and forget that this wonderful mind has to have a structurally sound body with which to perform.

The Golden Retriever was originally bred to be a gentleman's hunting dog. We know from exploring the breed standard that the Golden was not established to be an overdone show dog, nor was he to be a wiry, small-bodied dog. Whatever we do to further refine our goals is a natural progression of competition, but the minimal requirements when selecting and breeding Golden Retrievers should be those of a well-built, moderate, and athletic dog. As guardians of the Golden Retriever, it is our responsibility to preserve and promote our breed as it was intended. Otherwise, the result is a designer-type dog who no longer truly represents the Golden Retriever.

It is also in our own best interest as obedience competitors/breeders to select for sound structure. Our obedience dogs must not only have all of the necessary mental traits to be successful, but they must also be athletes. A dog of sound structure will be able to more readily withstand the physical demands of training. In the top levels of obedience competition, dogs are asked to heel in perfect position, have tight and compact sits, and jump and land fluidly. They not only have to perform with this type of precision but also endure the rigors of training. Poor structure will lead to aches and pains that the dog might not be readily able to convey to the trainer. Structural defects can be misinterpreted by a handler as unwillingness to perform.

Structure involves what is known as the musculoskeletal system. The skeletal system involves the framework of the bone structure. The axial skeleton consists of the spine, ribs, and head. The skeleton consists of the bones of the shoulder and front legs along with the pelvis and back legs. The muscles act not only to support the various bones and joints but also are the locomotion of the system. It is by the contraction of some muscles and the lengthening of other muscles that joints are moved. The muscles work in an agonist/antagonist relationship. For every

Proper structure makes it easier to succeed in obedience. Ch. Pepperhill's Travelin' Bear CDX, Can. CD was a winner in conformation a well as obedience in two countries.

group of muscles that moves a leg forward, there is a corresponding group of muscles that moves a leg backwards. Along with these, there are muscles that stabilize the legs toward the center line with their antagonists that prevent them from diverging too far away from the center line. The muscles also allow for turning by variations in contractile strength for a given movement. Most movements result from coordinated movement at several neighboring joints. However, the way they move can be quite different from dog to dog. Variations in the specific joints, the length of various bones, and where muscles attach will all determine the exact mechanism of specific movements.

The musculoskeletal system is a miraculous piece of mechanics. However, with poor structure, it can also be wrought with problems. The system needs to be in balance with itself to support and propel the entire structure most efficiently. This is why show dogs are evaluated both standing and moving. While the dog is standing, it is easiest for the judge to actually put his hands on the various bones and determine the length and angles. However, until the dog is evaluated in motion, we cannot tell how the muscular system is going to propel the various bones and joints. The judge is determining how the muscular system works in concert with the skeletal system when a dog is on the move. How the system works as a whole is the crucial point. For our performance dogs, efficiency and coordination of movement is imperative for peak performance with decreased risk of injury. So how does structure actually impact our performance competitors? Let's start with the most basic exercises.

The *Stand*

We always tell our obedience students that the *stand* exercise should be an easy thirty points. You should never lose points on the *stand for exam*, but it is interesting as an instructor to note how easily the *stand* comes for some dogs and how it seems to be more difficult for others. Obviously, as with all exercises, some issues are due to poor handling, how the dog is introduced to the exercise, and whether the dog understands the command. However, poor structure is often at the root of a poor *stand*.

Watch dogs stand. Some seem to stand very naturally and squarely, while others shift position and seem to have their weight over either their front or rear assembly. In show circles, you will hear comments such as "he's a natural stacker." Often, such comments are concerning dogs that always seem to stop and stand in a very natural foursquare stance. This natural foursquare stance is not a matter of training, but a result of a dog's being so structurally in balance that all four feet are squarely under him and supporting him equally.

When preparing a dog for a *stand*, the exercise comes much more readily if he has a natural foursquare stance. As you move the dog forward to stand, or merely ask him to rise his rear quarters to stand, a balanced dog will naturally stop in a foursquare stance. Once he has learned to stay while standing, he is much more likely to hold that position because he is basically comfortable in the *stand* position. However, for those dogs that are out of balance and tend to stand in a fairly unnatural position, the *stand* becomes a much more complicated exercise. Can they be taught to do the *stand*? Of course; Goldens are smart dogs. Does this add complication to the exercise? Most definitely.

Instead of the dog who naturally stops in a foursquare stance, we have a dog standing in an uncomfortable position. Unless the handler trains

This Golden demonstrates a correct tight *sit* position at the handler's left side.

the dog to either stay in this uncomfortable position or to "square up," the stand exercise will potentially be a point deduction as the dog eventually moves to try to get himself into a balanced position that doesn't actually exist for his structure. Certainly, for a good trainer, this is a fairly easy problem to overcome, but if you didn't have to deal with this problem, you'd have more time to work on other exercises.

The *Sit*

On the surface, the *sit* seems like the most basic of exercises. Any dog can sit, and many of us have taught our puppies to sit by eight weeks of age. But let us not forget that obedience trials are usually won or lost on heeling, fronts, and finishes. All of those components involve the *sit*.

Oftentimes, we see the "puppy sit." This is the *sit* in which a dog tends to sit with his back legs sprawled out, unable to keep his rear legs underneath him while in the sit position. This type of *sit* varies from the dog's actually sitting on his pelvis instead of his metatarsus to the dog's merely having his rear feet splayed away from his body while sitting. These loose *sits*, whether extreme or minimal, are generally due to weak adductor muscles of the rear legs. The adductors are not strong enough to keep the rear legs tucked underneath the dog.

How many times have we seen trainers continually trying to teach tight *sits* with a dog? With persistence, a dog can be taught to use and thus strengthen his genetically weaker adductors; however, if you have a structurally sound *sit*, this is not necessary, and you can spend your training time on other exercises. A dog with a balanced and strong rear will have the physical capability for a quick, tight *sit*.

We also see the dog who tends to what is known as "East/West" in the front. The East/West front is when the front feet angle away from each other instead of facing straight forward. It can result from long pasterns, weak musculature, weak ligaments in the carpal joints, or a combination of any of these. There is really no training that can be done for dogs that tend to be weak in the pasterns. An East/West front can also be due to a "pinched" front, in which the elbows are pinched in due to poor spring of rib. In this instance, the pasterns are of sound structure, but the elbows rotate inward due to a lack of chest so that the legs are twisted to the point that the feet face outward.

The ramification of the East/West *sit* in competition, whether from a weakness in the pasterns or being pinched at the elbows, is that the dog never appears to have a perfectly straight, tight *sit*. This dog invariably tends to have *sits* that appear to be "off" even though he is as straight as he is physically able to be. The East/West front also affects other exercises in competition. We will address the pasterns further in relation to jumping.

Heeling

For the top competitors, precise heeling is imperative and is probably the exercise that takes the longest to perfect. It is usually started by teaching the pup to move with his head looking up and with his attention on the handler. In proper heeling, more focus is placed on whole body position, not just head position. For most, it isn't truly polished until around three years of age. There are certainly some dog/handler teams that accomplish this earlier, but for most, it is a long process. Good heeling is essential to a top handler and is how a runoff (the winner of a tie score) is determined.

The American Kennel Club's obedience regulations state: "Heel position: The heel position as used in these Regulations, whether the dog is sitting, standing, lying down, or moving at heel, means that the dog shall be straight in line with the direction in which the handler is facing, at the handler's left side, and as close as practicable to the handler's left leg without crowding, permitting the handler freedom of motion at all times. The area from the dog's head to shoulder shall be in line with the handler's left hip."

The dog shall be straight in line with the direction in which the hander is facing. So what does this truly mean? The dog's spine, which goes from the front end of the dog to the back end of the dog, should be perpendicular to the handler's hips and shoulders. In simpler terms, the dog's rear assembly should neither flare out from nor be tucked behind the handler. I believe that this is the most difficult part of heeling to convey to the dog, but part of that difficulty deals with the structure of the dog.

When evaluating a dog for structure, we do what is commonly called the "down and back." This is where we view the dog moving straight away from us and coming directly toward us. We are evaluating multiple things at this time, many of which greatly affect an obedience dog. The aspect that mostly affects the heeling exercise is how squarely a dog goes away. There is a term called "crabbing" that compares movement to how a crab moves, with its rear end not in line with its front end. You can also see this in an automobile with poor alignment. Just as poor alignment is not good for the mechanics of an automobile, moving out of alignment is not good for the biomechanics of a dog. Not only is it hard on the dog's mechanics but it will also cause the dog to lose points in the obedience ring.

With attention on the handler, this Golden is heeling in the proper position and showing very correct gait.

The trained eye quickly recognizes crabbing, but it is a trait that even a less experienced eye can easily identify with a little bit of practice. Crabbing has various causes. The most common cause is too much rear angulation for the amount of front angulation. In this instance, the dog's front and rear angulation are out of balance, and the dog has more drive in the rear than he has reach in the front. This makes the rear end overdrive the front end. There are multiple ways that a dog can compensate for this defect, and crabbing is one of them. Crabbing pushes the rear end out of the way of the front end so the front and back feet do not interfere with each other when they meet in the center. It is very difficult to train a dog to move "straight in line with the direction the han-

dler is facing" when, structurally, he is not built to do so. With intense training, a dog can learn a different compensatory foot placement while heeling, but this is unnatural for the dog, will make him more prone to injury, and takes an extensive amount of time.

Some dogs will tend to flare their rears out for other reasons, such as a shorter neck and/or lack of shoulder layback. It is harder for a shorter-necked dog to comfortably keep his neck and head positioned for focused heeling and at the same time keep his rear and front end in line with each other. However, not all dogs who flare their hindquarters have structural defects. It is natural for a dog to want to flare out in the rear when being taught focused heeling. With most dogs, it has to be addressed in training at some point in time and is usually why we start *moving attention* (moving with head up, focused and watching the handler) with young dogs going in left circles. The left circles tend to push the rear toward the handler. But it is not efficient to try to train for both structural defects of crabbing and the natural tendency of the hindquarters to flare due to the sport.

Our AKC obedience rules state: "The area from the dog's head to shoulder shall be even with the left hip." For most dogs, this position is determined mostly by training issues and governed little directly by structure. However, we do see extremes in heeling movement from the side, many of which are not correct movements for the Golden Retriever and make a dog increasingly prone to injury. The type of movement specified in the Golden Retriever breed standard ("free, smooth, powerful, and well-coordinated, showing good reach") allows for the most efficient gait with little wasted energy. It is a generally accepted principle that movement is most efficient when the feet stay close to the ground. Dogs

that either kick up in the rear or lift their front legs high off the ground are inefficient and can be more injury-prone.

Unfortunately, oftentimes in the obedience ring—particularly in the upper-level classes—we see dogs that move with an extremely high-stepping hackneylike gait. This gait is usually caused by a short and upright scapula. Along with this, the dog will often have more rear angulation than front angulation. In this instance, the dog's front and rear angles are out of balance, and the two bones that make up the shoulder assembly, the scapula and the humerus, are out of balance with each other. The truly concerning part is that some handlers feel that this hackney gait looks flashy and they train for this incorrect movement intentionally. The more out-of-balance the dog is, the easier it is to obtain the hackney gait. This is worrisome because it encourages people to either consciously or unconsciously breed for incorrect fronts so they can more readily obtain this incorrect movement.

A portion of the hackney gait is trained into the dog; however, it would be very difficult to train a reasonably balanced dog to heel with this extreme gait. There are no bonus points for this type of movement, and there are many top-winning obedience dogs that do not have this incorrect gait, but there are certainly enough competition obedience dogs that possess some degree of the hackneylike gait to give newcomers to the sport the false impression that the hackney gait is not only correct but also something to strive for.

In heeling, the dog is scored on correct positioning. Some handlers will say that flashy movement gives them an edge in runoffs; however, most runoffs are won by fast, straight sits and perfect heeling position. There is also some concern about the long-

Hackney gait, in which the front legs are lifted high off the ground, is incorrect.

term effects on the dog's biomechanics and the instability caused to the musculoskeletal system by this type of movement.

The Golden's "heeling picture" should represent a free, fluid, powerfully-moving dog without wasted motion and with alertness and eagerness. A beautifully heeling team is lovely to watch; it is an outreaching, ground-covering gait with flawless attention.

Jumps

As jumps will be extensively discussed in the agility chapter, I will only briefly discuss a few issues here. Jumps can be either the easiest exercises to teach or the hardest. Dogs with poor timing, which is generally the result of some structural imbalance, will inherently have a harder time jumping. Poorly balanced dogs have to be in the perfect position at the perfect time to propel themselves over a jump. Out-of-balance dogs are less able to make adjustments in their stride length as they approach a jump. We certainly don't see as many jumping refusals as we

did when the jump height was one and a half times the height of the shoulder instead of the same as the height at the withers, as it is now.

The problems with a high jump come from three major areas. First, we have the timing issue, which refers to how a dog collects himself right before he jumps. Does he have the correct proportions to appropriately get his feet into the optimum position without the feet interfering with each other? This is an important coordination between the front and rear assemblies. We often see dogs who stutter-step, and we occasionally see dogs who are so out of balance that they have to go over a jump from a static position.

The second major area involves the pushoff; an important factor to consider is the strength and stability of the rear quarters. The rear is the primary push to get the dog over the jump. A dog requires the proper angle, the proper length of femur and tibia, and balanced muscle mass to be an effortless jumper. A poor or weak rear is not going to have the power to propel a dog adequately, particularly if the dog has to compensate for any other structural problems, such as poor foot timing between the front and rear assemblies.

So we must evaluate how well and how cleanly the dog uses his rear. Once again, we will evaluate the dog as he moves away from the judge. This is done in the same manner as when we were watching to see if the dog was crabbing, but now we will look at the rear leg movement. This time we are evaluating if the hocks, more correctly called the *metatarsi*, move fairly parallel with each other and fairly perpendicular to the ground. When we see hocks that are twisting and bowing in various directions, we know that this is not a clean, powerful rear. Can a dog still adequately propel himself over a jump even

with a poorly structured rear? If everything is going well, probably. But under a stressful situation at a show or if he's become concerned about an exercise for some reason, maybe he will be a little more likely to refuse that jump if he doesn't have a good drive from the rear assembly.

Finally, we have the landing gear, which is primarily the front legs and front shoulder assembly. We briefly made reference to the pastern in the sit section. With the sit, the pasterns have a fairly passive role; however, in jumping, the pasterns play a much more active role. The pasterns are the first joints to respond by absorbing shock. If the pasterns are too straight, they will not have adequate flex to help take up shock, but if they are weak and a dog is "down in the pasterns," the pasterns will not adequately soften the landing and will not have the proper recoil after the jump. The impact moves up to the elbows and finally to the shoulders.

Once again, if the dog does not have enough length or angle in the front shoulder assembly, he will have hard landings. With today's lower jump heights, this is not as big of a consequence as it once was; however, I do contend that one of the reasons for such a big push to lower jump heights was poor front-assembly structure in obedience dogs. If there was better landing gear in the front end, there would be fewer injuries. When a dog is not sound enough to be an athlete, and he is being asked to be one, injuries will occur.

One major structural piece not yet discussed is the middle piece. The middle piece basically includes the thoracic spine, with the rib attachments, and the lumbar spine, which is usually considered the loin. The body of the dog is the drive train. The power from the rear is driven through the body to the front end. Poor musculature, excess length

The *heel on leash and figure eight,* shown here, is done at the Novice level of AKC obedience, while the same exercise is done off leash at the Open level of competition.

in loin, or short ribs can a lead to weakness in the middle piece, which can lead to poor sits, problems with heel position, poor jumping, and rapid fatigue.

Working Ability

There are many different factors that make up the Golden Retriever's working ability, which is the primary focus of what most performance breeders try to breed for. But let's keep in mind that "working ability" covers a very large spectrum of traits. Ideally, for a dog to have good working ability, he must possess stamina, intelligence, desire to please, and focus.

Stamina

Stamina in your performance dog is an exceptionally important trait. However, this is an area that is significantly overlooked and mislabeled in the performance world. There are many different factors that comprise a dog's stamina.

First, we need to look at structure and review all the aspects we have discussed so far. If a dog is poorly constructed, he will have to expend more energy to produce the same amount of work as his well-structured counterpart. Poor balance in angulation, out-of-balance musculature, and therefore poor foot timing will all cause a dog to tire more easily. If the body pieces are not working in concert with each other but are working against each other, a dog will have the tendency to quit much earlier.

In the *long sit*, the handlers leave their dogs in the *sit* position; the dogs must remain seated for a specified amount of time (depending on the level of competition) until the handlers return.

We also need to evaluate for appropriate depth of chest to make sure that the Golden has enough room to accommodate his heart and lungs. The deep chest described in the standard gives room for adequate heart and lung volume, which is a part of this equation of stamina.

For our dogs to be able to work at whatever athletic endeavor we ask of them, they need to have the appropriate heart and lung capacity to do it well. However, there is another aspect of stamina that is rarely discussed but physiologically is an important factor for all athletes. This is called the *VO2 max*, the maximum amount of oxygen that an individual's body can process. An elite athlete's VO2 max is constantly monitored. It does improve with conditioning, but there are wide variances in inherent VO2 max levels. There are references to the VO2 max of sled dogs being monitored for team selection and training status.

In obedience training and competition, the VO2 max is probably less of an issue than in field or agility

competition, but on a long training day, a dog with a better ability to use oxygen will last longer. I don't think having all of our dogs tested for their VO2 max is necessary, but it is an interesting concept. I do think it would be appropriate to at least ask yourself, "Is my dog not working as well because he is physically fatigued with poor stamina or because he has an overall lower energy level and drive?" A dog with a good energy level and good drive but poor stamina will start off strong but will quickly fatigue.

Energy level and stamina are certainly closely related, but for this discussion I will consider energy level as related to the mental drive to move, as opposed to stamina, which is related to the physical capability for prolonged movement. Energy can be defined as "liveliness and forcefulness." For a dog to perform the tasks asked of him, he must possess the drive to do so. Some dogs become mentally fatigued or bored with work very quickly. They would be just as happy sitting by the fireplace, chewing on a toy. This obviously is not what we want for an obedience

Exhibitors get their dogs into position and prepare to leave their dogs for the *stand* exercise.

competitor or a Golden Retriever in general. This is a dog who should enjoy working. However, when the day is done, a Golden should enjoy relaxing with his family. Many people call this the ability to have an "on/off" switch. Balance not only applies to structure but also to energy level and drive.

Intelligence

Intelligence is probably the single attribute that most everyone who aspires to compete in performance events would want in a competitor. There are definitely some breeds that seem smarter than other breeds, but individuals within a breed also have varying levels of intelligence. The *Encarta Dictionary* defines intelligence as "the ability to learn facts and skills and apply them…" The intelligent dog should be able to apply his skills. There are certainly some dogs that learn fairly quickly but are more rote learners. They learn from repetition

and don't seem to be problem-solvers. On the other hand, there are problem-solver dogs who, when presented with a problem, will experiment to find the best solution. Such a dog tends to take more responsibility for his actions. Our standard certainly doesn't address the different types of learners, but the problem-solvers are undoubtedly more equipped to handle the tasks asked of our breed.

Desire to Please

The desire to please is, for many trainers, at the top of the list of necessary traits for obedience competitors. A dog who does not have the innate desire to please is just difficult to work with. There are actually many breeds that are "intelligent," but if they have no desire to please, they will be the most difficult dogs to train. A very intelligent dog with no desire to please is really only in business for himself. This personality type spends all of his intelligence on how to get out of what he doesn't want to do. However, there is no greater pleasure than training a dog who is truly in the game, trying to figure out what you want and so pleased with himself every time you are pleased.

Focus

Focus is a valuable trait when training a dog. It's not directly discussed in our breed standard, but as a retriever, the Golden needs to have a strong sense of focus for memory of multiple downed birds. For obedience competition, it is easier to train a dog who can focus on the tasks at hand than to deal with a dog who is hard to "keep in the classroom." However, we need to avoid the obsessive and compulsive behaviors that we see in some dogs, as these are not desirable traits. Once again, the word *balance* comes to mind.

Temperament

Temperament is the prevailing or dominant quality of mind that characterizes the general attitude of a dog. Most people see temperament as whether or not dogs "play well with others" of both the two- and four-legged kind. It is the temperament of the Golden that has endeared the breed to the world. Generally, our breed holds true to the standard, but certainly we do see some poor temperaments. The standard states: "Friendly, reliable, and trustworthy. Quarrelsomeness or hostility towards other dogs or people in normal situations or an unwarranted show of timidity or nervousness is not in keeping with Golden Retriever character."

For the most part, we can "control" a dog while in a training situation and on lead. There are those exceptions—dogs that demonstrate temperament issues while on lead or in a controlled situation. When, even in a training situation, a dog is a potential threat to other dogs or people, this is a significant temperament issue. This dog obviously should not be bred, and his pedigree needs to be closely evaluated. If there is concern about a dog's being aggressive to other dogs in the long stay exercises or toward a person during the stand for exam, this would be considered a significant temperament problem. However there are much more subtle situations than blatant aggression that need to be evaluated. How dogs respond toward people, other dogs, and new situations when in a non-training environment is critical.

First, let's look at crated dogs. All too often, we see dogs that are crate-aggressive. These are the dogs that do not let another person or dog get close to the crate without aggressive displays such as bared teeth, growling, or even ferocious barking.

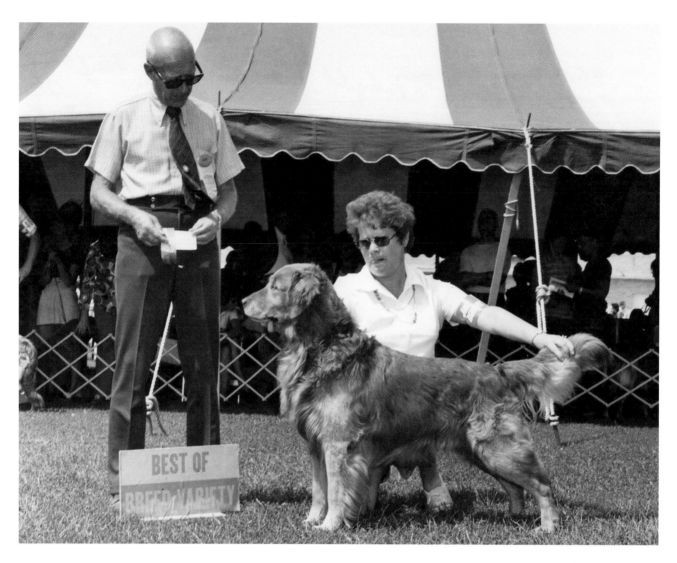

National specialty winner Ch. Malagold Beckwith Big Buff CD, OS, SHF.

Owners of such dogs will often keep their dogs crated away from others or keep the crates covered to prevent outbursts. Even though, for the most part, handlers are able to manage this situation, it is still a problem, and a dog who behaves in this manner is certainly not in keeping with the breed standard.

Next, we need to evaluate how well dogs get along when running loose together. There are some dogs that might get in a rare tussle, particularly when hormones are active. Even though these outbursts are quite upsetting at the time, in the grand scheme of temperament, the sporadic scuffle is not cause for alarm. However, when you routinely have to go to significant lengths to make sure that certain

dogs aren't together, you have to at least acknowledge the problem. When you have a dog who can't run loose with any dog, there is a definite problem. There are certainly many variations in between that need to be evaluated. Don't be too eager to overlook these issues, as that's how they become significant problems in a breed.

The other area of temperament, which is the most important, is how a dog interacts with people. Fortunately, this is a problem we don't often see in the breed. But any time you see a Golden Retriever

that is people-aggressive, whether it is true aggression or "fear biting," it is very disconcerting.

We see aggression in two primary scenarios. First, there is the dog who becomes aggressive for no apparent reason. This is clear-cut as very poor temperament and easy to evaluate as such.

The second scenario, which is more complex to evaluate, is the dog who responds to a correction by coming back at the handler in an aggressive manner. Some people contend that if a dog is corrected too hard or unfairly, he has the right to become aggressive. However, that is not what the innate reaction of the Golden Retriever should be. A dog whose reaction is to become aggressive when hurt is a potentially unsafe dog. A dog whose reaction to something unpleasant is to fight back is a dog who could become dangerous. We are now dealing with a threshold. Once we accept the idea that people-aggression is acceptable in certain circumstances, we have then accepted that aggression is acceptable. If a dog's foot gets stepped on, is it acceptable for him to become aggressive? If a child falls on the dog, is it acceptable for him to become aggressive? If we, as champions of the Golden, ever accept that any level of aggression is permissible, we will ruin the temperament of the breed. The gut instinct of the Golden Retriever to pain cannot be aggression.

The subtlest aspect of the Golden Retriever/human relationship that needs to be evaluated is what has been "covered up" with good training. The more accomplished the trainer, the more difficult it is to identify underlying potential temperament issues in a well-trained dog. A good trainer will identify small issues with a puppy and address them at an early age, before these issues even have the potential to become problems. Let me share with you a good example on this topic.

When my youngest daughter was four years old, we had a five-month-old puppy that I was raising. This was a multipurpose-type puppy with a very strong retrieve drive. One morning, they were playing with each other. The child had the ball and the puppy wanted it. The child wouldn't let her have it, and the puppy was chasing her around the house. The next thing I knew, the puppy had knocked her down. My daughter's being knocked down was not an issue for me in that situation; however, the puppy was standing over her and growling. The alpha bitch (me) was not at all happy about this, and the five-month-old puppy saw her life flash in front of her eyes. I'll just leave it at that. I never again saw one bit of aggression from that puppy toward either people or other dogs. But I never forgot about that incident. She was bred to a male with a pedigree known to be very sweet and docile.

I share this because this experience raises many questions. Was this just a puppy growing up and treating the child like a "littermate"? Was that the potential beginning of a serious problem—one that the puppy learned quite abruptly had fairly severe ramifications? If someone else had raised that puppy, would she have ended up people-aggressive/dominant? Or was it just a dog and kid playing, and I overreacted? Would stepping in and simply calling the puppy away so the child could get up have been adequate? I don't have answers to those questions, but it is still important to ask them.

Competitor and Companion

Those of us active in any area of the sport of dogs spend many hours of our lives with our dogs, and we spend many of those hours in training. The sounder,

Obedience practice can be done in your own backyard. "Barney" works on retrieving a dumbbell.

both structurally and mentally, your companion is, the more time you can spend on forward progress instead of spending time addressing handicaps.

Spend time becoming familiar with structure. Don't feel that because you compete in performance events, structure doesn't affect you. Performance is why we should be striving for sound structure. In the conformation ring, sound structure has become an end, but the entire purpose of identifying dogs with sound structure is to guide us to which dogs have the physical capabilities to perform.

Become a student of the breed standard, sound structure, and mental aptitude. Spend time outside the conformation ring and try to learn to evaluate various traits. Talk to those experienced in conformation. Watch videos of dog movement. Look at dogs in the obedience rings and try to deter-

mine potential physical weaknesses. Think about drive, stamina, and temperament, and try to discern the different qualities. And then, when you are ready to either breed or purchase your next competitor, you will be much more prepared for the journey.

Avoid the trap of merely purchasing a puppy just because he has "Great OTCH Whoever" in his pedigree. Before you obtain your next companion, you need to ask yourself and your potential breeder several questions. Find out about the structure of the sire and dam; if one has a particular weakness, it would be much better if the weak point in one were

a strength in the other. If both the sire and dam have weak rears, we have a fairly good chance of getting puppies with weak rears. Inquire about both structural and mental aspects of the dogs. If you don't feel comfortable evaluating the pups, and your breeder seems poorly equipped, ask someone more knowledgeable about structure to assist in evaluating the puppies. Find out as much about training and temperament issues as you can.

Generally, structure is initially evaluated at approximately seven weeks of age, but ten to twelve weeks is considered the most reliable age for accurate structural evaluation. Because temperament testing is most reliable at seven weeks, and performance competitors are anxious to obtain their puppies at that critical time, most performance litters will be evaluated for both temperament and structure at seven weeks of age. Most serious structural defects will be evident at this time. Overall coordination and balance, or lack thereof, is usually quite obvious by seven weeks, as well. Without overall balance and coordination, you are asking for years of problems to overcome.

Are the pups clean coming and going? Do they crab at seven weeks or are they throwing their front or rear legs in an inefficient manner? How tight are their sits? Are their pasterns strong for good shock absorption, without being too straight and rigid? Can the puppies go over a 4-inch jump easily? If they are in balance, coordinated, and fairly clean on both ends at seven weeks, the odds that they will be sound at two years are much better.

But try as we might, there are no perfect dogs. There will be some structural weaknesses in your next puppy. It is your responsibility to your dog to evaluate his weaknesses so you can most appropriately train and strengthen those areas. A more educated eye will be better equipped to recognize potential weaknesses and help your athlete better deal with them.

The Golden Retriever has so much to offer. The standard describes a beautiful and friendly dog with sound structure and a desire to please. There is certainly room for some variation while remaining within the standard, but when breeding and selecting dogs, we need to understand that our standard was written to exemplify a certain dog—the Golden Retriever. We have a wonderful breed with many glowing attributes, but it is the responsibility of those who breed, own, and judge our lovely Goldens to keep the breed as intended. The Golden Retriever is not a Border Collie in a yellow coat. It is a Golden Retriever with specific traits, temperament, structure, and breed type.

Chapter Thirteen

Agility and the Golden Retriever

BY CHRISTINE MIELE

The dog approaches the start line, tail wagging in anticipation. The handler takes off the leash and, with a pat on the dog's head, leaves the dog to get into position. The dog's ears are alert with expectation of the next fifty seconds of sheer joy.

The dog/handler team is ready to compete in agility, one of the newer events in the dog sport, and one that has caught on like wildfire. While this activity was developed for the herding breeds—in particular, working Collies—in the United Kingdom, it has gained popularity as a competitive sport for both purebred and mixed-breed dogs. In 1994, the American Kennel Club entered the agility arena, adopting a modified version of England's Kennel Club rules.

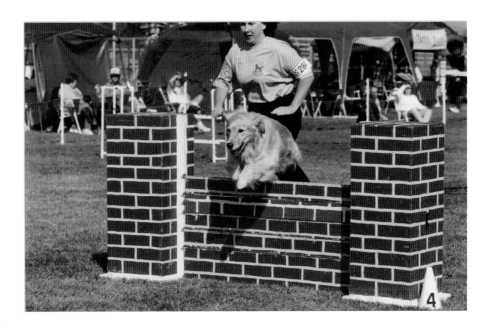

Correct structure will allow a dog to easily handle the jumping that agility requires.

The original agility trials in the United States had about thirty competitors per event. Today, there are over 800,000 entries in AKC agility each year, and there are several other successful agility associations, such as the USDAA (United States Dog Agility Association, Inc.), the NADAC (North American Dog Agility Conference), and the NCDA (National Conference for Dog Agility), also with large followings. In 2006, Golden Retrievers earned 2006 AKC agility titles, making them the fourth most popular breed for agility and the only non-herding breed in the top five. In 2007, there were 19,641 qualifying scores among Golden Retrievers as entries continued to rise. The trend continued in 2008, with 18,884 qualifying scores and 1,251 agility titles earned by Goldens.

The lure of agility is similar to that of golf. There is a course and there are obstacles to overcome, and no matter how well you do, you never quite perfect it. The sport is in the training, testing, retraining, and competing. It is interesting that over a century after the breeding of the first Golden Retrievers and other sporting breeds created to enhance the newly found free time of the gentry, we have a new competition designed to afford the dog owner the enjoyment of playing games with their dogs.

Agility competitions are timed events requiring the successful performance of an obstacle course. There are two key skills necessary to compete in agility: speed and control. Originally this was called

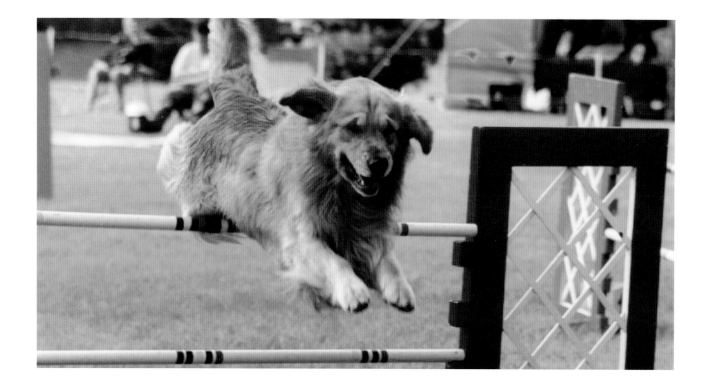

"freestyle" agility, describing how the dog and handler worked as a team, flowing from side to side as the course determined. Many of the early agility competitors crossed over from the obedience arena, and they had very well-trained dogs that would do anything their handlers asked of them in heel position. So the early agility competitions at Crufts Dog Show in England in the late 1970s had many handlers racing around the outside of the course with their dogs always on their left. Today, no one would even think of approaching an agility course in that manner. We have Belgian crosses, front and rear crosses, even a blind cross. There are half-pivots and reverse-flow pivots, and we have a complete lexicon of agility terms.

In agility competitions today, there are three types of courses: standard, jumpers, and games. The standard course consists of jumps, tunnels, and contact obstacles in a numbered sequence that can test many skills. A typical test will require the dog-and-handler team to change sides, also sometimes

In addition to having athletic ability and heart, many Goldens just plain enjoy the fast pace and challenges of the agility course.

referred to as lead changes, at least three times; perform a difficult jump sequence with possible off-course options; and complete a fast-paced open sequence where the dog is able to get in front of the handler and take verbal direction at speed. The jumpers course has jumps, tunnels, weave poles, and all of the challenges of a standard course, but at a much faster pace. The games course tests strategy and the ability to navigate a course using your strengths as a team.

What is it about the Golden that enables the breed to excel at this sport? The courage, intelligence, and stamina of a dog who can hunt over rugged terrain and vegetation and be calm enough to be a companion to the family represent the temperament and heart that make the Golden Retriever a wonderful agility dog.

Many people feel that if you breed an agility champion (called a MACH dog, an acronym for Master Agility Champion) to an agility champion, you will set agility "type" and beget more agility champions. This is faulty logic. As long ago as 1933, Mrs. Charlesworth, in *The Book Of The Golden Retriever*, wrote, "Mating a Champion to a Champion to Breed a Champion. This way madness lies, and not only that, but the ruin of the breed."

Once you start breeding for a smaller, light-boned, streamlined speed demon, you have severely compromised the very essence of the breed. The Golden will never have the speed of the Border Collie and will not be able to turn on the forehand the way the Border Collie does. The Golden's body structure doesn't permit him to slither over a jump. The Golden's shoulder structure doesn't allow the shoulder blades to accept the sliding stop that the much lighter Border Collie can execute.

Perhaps the conformation extremes aren't nearly as offensive as the temperament extremes. The frenzied and frothing demeanor sometimes seen in the agility ring should be very foreign to the Golden Retriever, and any attempt at introducing these traits should be firmly discouraged. I am seeing more and more "agility" Goldens nipping at their handlers, drooling incessantly on course, and being reckless with their bodies. These are not Golden Retriever characteristics. The Golden Retriever will never be a Border Collie, and it is incorrect to use that comparison as a compliment or a goal.

Not all successful agility dogs have an "over-the-top" temperament. Other than the extremes, there is a lot of misunderstanding about the temperament of agility dogs. People sometimes see the dogs working and crying with excitement in anticipation of their reward for being fast and accurate. Once done with

his work on the course, the typical Golden will lie quietly at the feet of his handler and be a perfect loving companion.

Many times, someone will say that he has the perfect agility dog in his litter. It is the dog who is busy, doesn't want to settle, doesn't sleep as much as the others, is a pest, and so on. But a good agility dog has to be quiet, has to like to take direction, is tremendously focused, and has a work ethic. A busy dog is not necessarily a good agility dog. The true Golden temperament of the dog who works well in the field and then lies quietly by the hearth with the family is the ideal working temperament.

While the sport of agility was not developed for retrievers, they do possess qualities that make them ideal partners. Intelligence, trainability, and a willingness to please are the hallmarks of the Golden Retriever's temperament. Goldens are bred to work with people, and they willingly accept that teamwork in agility. They have the stamina to withstand rigorous activity and are very patient with their handlers. The physical dexterity that makes the Golden an ideal dog for upland game is the same quality exercised on the agility field. The advantage of the Golden with proper conformation in agility is that of the short-coupled dog with strong loins, a muscular neck designed for carrying game, and sound feet and pasterns for easily navigating uneven terrain. The strength of back supported by a proper frame, a correct layback of shoulder, and properly functioning elbows and pasterns contribute to a dog who can jump with ease from any angle and land ready to go on to the next obstacle.

A very encouraging trend in agility is the realization of the importance of proper conformation. Many people started with pet Goldens, selected for companionship rather than for their agility. But as these people

become more involved in the sport, they start to pay attention to structure. This is good news. This will put added pressure on breeders to produce good specimens of the breed that are sound in body and mind.

Monica Percival, editor of *Clean Run* magazine and longtime agility competitor states, "I retired two dogs because of shoulder injuries—neither of them was ever asked to stop on a contact, nor jumped at excessive heights, nor started very early in agility training. Both dogs were straight in the front and had lousy shoulder layback and were impossible to 'build up' in the front. Agility or physics?"

The characteristic agility dog is very similar to the field dog. We train them to think on their own, use their intelligence, and work at our bidding. Just as a field dog with some structural faults will be able to achieve a certain level of success, the same can be said of the agility dog. It doesn't take a perfect specimen to perform the tasks required for the beginning agility titles. Goldens in agility often overcome structural deficiencies and run on heart more than physical ability. They work to try to please us as their primary goal even though they may be hurting or unsure of themselves. But dogs that are going to enjoy long and injury-free careers will do best if they conform to the breed standard.

The ratio of weight to bone is a part of the breed standard that was given very careful thought. Many dogs were measured before these measurements were incorporated into our breed standard. Think for a moment about these numbers: a height of 23–24 inches and a weight of 65–75 pounds for male dogs, and a height of 21½–22½ inches and a weight of 55–65 pounds for females. This indicates a dog who is strong and powerful with a fair amount of bone density. By comparison, the Border Collie is a medium-boned dog with a height of 19–22 inches

for males and 18–21 inches for females. The Border Collie standard goes on to say that, in the case of bone, lighter bone is preferable to too much bone. The average adult male agility Border Collie weighs between 32–42 pounds. In many breeds, Goldens included, there is a dichotomy between what is seen in performance dogs and exhibits in the conformation ring. The Border Collie standard includes an excellent statement that we could certainly take to heart: "Excess body weight is not to be mistaken for muscle or substance."

You would think that because the Golden has more substance, it would be more prone to injury. In reality, the statistics do not bear this out. Dr. Peter van Dongen of the Netherlands has written about the injuries to agility dogs. Research done in the Netherlands has found that it is not the height of the jump but the speed of the dog over the jump that is a factor in injury. In addition, the researchers found that "It is the speed, rather than the weight of the dog, which mainly increases the kinetic energy when landing after a jump. Double the speed leads to a fourfold increase in kinetic energy! Most injuries occur at landing, rather than when taking off, as the time during which the stresses occur is shorter, and they all work on the front legs only." To read Dr. van Dongen's article, visit www.agilitynet.com/health/jumpingheightinagility.html.

Just as the speed of the jump is more important than the height, the landing is more critical than the takeoff. You can show a dog with moderate hip dysplasia in agility, but you would find it extremely difficult, if not impossible, to show a dog with elbow dysplasia. A dog with a slipped hock or torn ligaments also will not be competitive, and recent studies at the University of Wisconsin by Dr. Peter Muir indicate that there might be a genetic component

to these injuries long thought to be caused by accident.

For a moment, let's talk about the landing over a jump with the dog continuing in stride to another obstacle about 20 feet away in a straight line. What do we see in a dog with impaired front assembly? A dog without shoulder layback is at a serious disadvantage. The dog with a totally straight front assembly, in which the elbows, ears, point of shoulder, and front pasterns are in a direct line, suffers the most jarring landing. Landing thus becomes a chain reaction. The elbows are the shock absorbers. If there is no return of elbow, the shock of landing transfers up to the point of the shoulder. If the dog has a short upper arm and a straight shoulder, that percussion travels farther, ultimately to the dog's neck.

If a dog has straight pasterns, or is knuckled over in front, this chain reaction starts even earlier in the landing sequence. Picture the dog with no prosternum to further help the ribs and lungs in landing over a jump. These dogs can be seen every weekend. They require an extra hop or shuffling of the feet on landing in order to collect themselves to move forward. They are not capable of landing in stride.

Sound structure also comes into play for the proper takeoff for a jump. The uncomfortable dog hesitates in front of a jump or stutter-steps before takeoff. Again, there are multiple factors at work. It is safe to say that if your dog is not an enthusiastic jumper, there is something wrong. An easy way to diagnose this is with a video and a good-quality stop-motion playback. You should be able to stop the video on any frame, and the dog should look

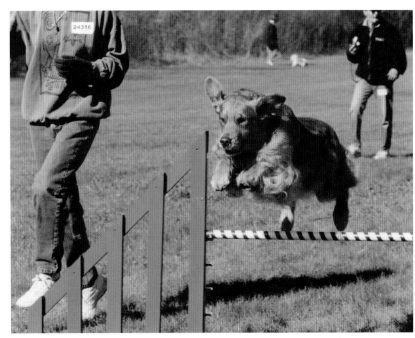

Correct conformation allows correct positioning of the dog's body when going over a jump, thus helping to avoid injury.

balanced on his feet. There should be no feeling that the dog is going to tip over and no excess movement of skin, hair, head, or feet. This trick also applies to dogs in the conformation ring or in the field. A truly talented field dog has breathtaking balanced movement, no excess motion, and a center of gravity well established under the dog.

In addition to having to make short steps before a jump in order to get into position, the dog with the short upper arm will find it difficult to establish a proper takeoff for a jump. He will often have problems with spread jumps because he can't get his neck and head into position to stretch them out correctly over the triple or double jumps. Contrast that with the balanced Golden that can easily execute a change of direction while in the air over a jump.

Now let's add a turn on the landing. A dog with good, sound feet, nicely rounded and tight with well-formed pads, has an advantage. A dog who is

knuckled over in the front pasterns will be unable to absorb the shock of that landing. That twist when the dog turns will travel up the legs to the elbows.

The work of Dr. Chris Zink has also indicated that head and shoulder position is directly linked to the performance of the dog on the contact obstacles. Dr. Zink also points out the importance of the dewclaw in agility. Many competitors want the dewclaws removed in their puppies, but this is a tremendous disadvantage to the agility dog. The agility dog actively uses his dewclaws on the equipment to help with balance and turns.

In addition to the front assembly, the length of back can also create many problems for the agility dog. The trend of the long and low Golden Retriever, meaning one with an extended length of back and who is also short on leg, leading to the "settery" extreme side movement that is so often rewarded in the conformation ring, is very undesirable for the agility dog. The dog with the short rib cage and 12 inches of unsupported loin will very often drop bars with his back legs when going over a jump. It is very tiring and difficult for those dogs to have an efficient trajectory over a jump.

When you view conformation videos of truly fine dogs, you will notice that their heads and toplines remain steady as they trot. I can't help but think of the demonstrations at horse shows with the Icelandic horses. The trainers would race across the show arena on horseback with glasses of champagne. The signature tolt gait of these horses was so smooth that not a single drop of their drinks would spill. So, too, is the well-constructed agility dog. When an agility dog is built correctly, it is easy for him to focus on the next obstacle; he has plenty of time to see it clearly because his body is not bouncing up and down as he trots or gallops to the next obstacle.

The correct dog will have smooth, effortless movement without his feet flipping up off the ground and without his hair flying around in the air. If you see excessive movement of the dog's coat, it is a definite indication that one part of the body is working harder than it should. Extreme movement that draws your eye to a specific part of the body is an indication of lack of balance and an illustration of a conformation fault. A balanced dog gives the impression of barely moving the air as he moves from one obstacle to the other.

Another common fault is that of a midback roll or a roll over the shoulders. The excuse for this is often that the dog has not yet grown into his skin, but this is a real fault that can cause the dog difficulty on the obstacles. Imagine the added stress for the dog on the dog walk, a 12-inch-wide ramp that leads to a 4-foot-high horizontal board.

Many agility dogs have exceptional toplines. This is due in part to the amount of exercise they receive, and it is an essential component of a sound, successful agility dog. Performance on all of the contact obstacles—the dog walk, teeter, and A-frame—requires a sound back, strength, and balance.

All dogs with structural deficiencies are forced into some form of compensatory behavior when maneuvering the agility obstacles. In reviewing hundreds of videos, I consistently see dogs with their ears back before jumping, looks of discomfort on their faces, and narrowed eyes. Contrast that with the well-structured dog who happily goes over a jump with a big Golden Retriever smile. A well-put-together dog knows the exhilaration of the ultimate team, the rare feeling of everything going exactly the way you trained for it, and the perfect communication and choreography between dog and handler at full speed.

AKC Novice Standard Course

AKC Open Standard Course

AKC Excellent Standard Course

AKC Open FAST Course

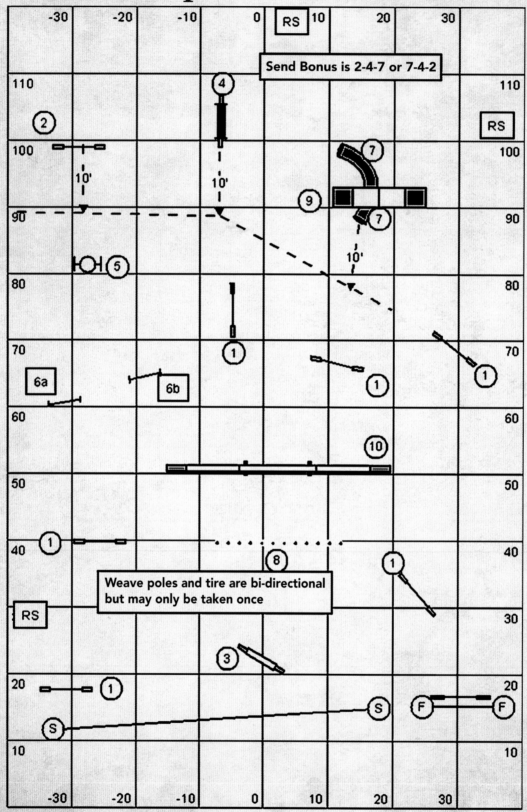

AKC Novice Jumpers with Weave Course

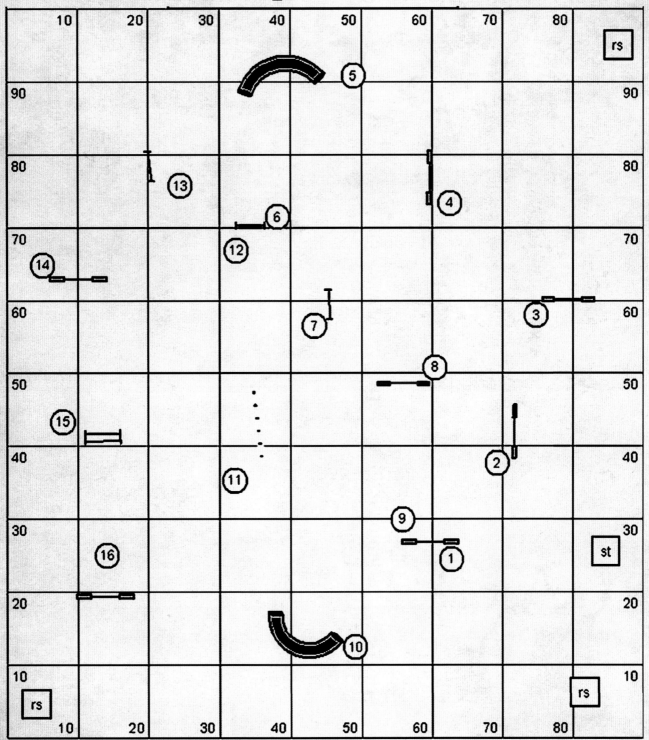

The Search and Rescue Golden

BY PLUIS DAVERN

O f all of the venues open to working dogs, the area of disaster search and rescue has to be one of the most, if not *the* most, challenging. It incorporates a tremendous amount of handler control and an inordinately high level of independent thinking and action on the part of the dog. This dichotomy dictates a canine candidate with a great desire to

Proud trainers and a new team celebrate their graduation. This dog was rescued from a shelter.

please, an equally great desire to "do," and the physical strength and stamina to carry out the mission.

The Golden Retriever described by the breed standard is a symmetrical, powerful, and active dog used to find and retrieve game for his master. To do this well, he not only needs the prescribed physical traits and attributes but also must embody the temperament of wanting to please his master. It is this willingness that makes him go out time and time again at the handler's behest and direction to locate game that he has not seen fall. To this end, the Golden Retriever has all the makings of a superlative search and rescue dog.

In all fairness, just as in the human realm, where there are many fine athletes who can be described as "weekend warriors" and a small number who are true Olympians in their chosen sport, not every Golden has the necessary qualifications to the degree needed for this particular job. To properly carry out the function of search and rescue, a Golden must have the basic conformation as spelled out in the breed standard and maintain his physical integrity year after year under the challenging training and conditions that the task demands.

And what is the task of a disaster search and rescue K9? To find live victims in the aftermath of a

natural or manmade disaster, the search dog must be able to locate, by air-scenting, the presence of live human scent in rubble of all types, such as concrete, wood, plaster, green waste, or any combinations thereof. Having ascertained as closely as possible the source of the scent, the dog must then indicate the find to his handler, who may be out of sight and far away, by barking at that very spot. The dog must maintain that "alert" until the handler can approach the location, reward the K9, and mark the position of the find for the rescue teams to come and extricate the victim.

So what do we look for when testing a new recruit? Over the years, we have learned that the desire to retrieve alone may not be enough for a successful

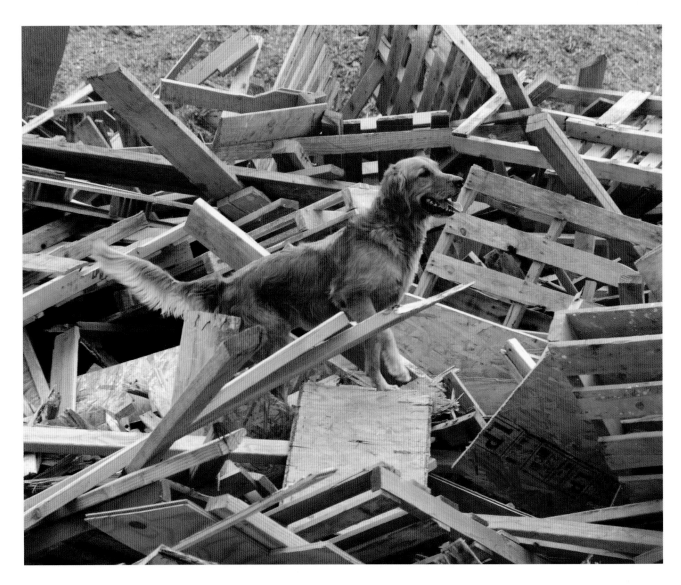

search dog; he must live to retrieve. This separates the "play drive" dogs from the "prey drive" dogs and ensures that challenging terrain and adverse situations will not compromise a dog's desire to search for a buried victim.

Switching a dog from finding and retrieving game to searching for and indicating the presence of human scent, which is often buried many feet under rubble or debris, is the least difficult part of the whole training regimen. As with drug and arson dogs and those that do Utility-level obedience work, it is simply a question of teaching scent discrimination. Once the dog understands what it is that you want

While searching for a victim, Baxter awaits a command from his human partner. Search dogs must be able to maintain their balance in very precarious conditions.

him to locate (a "victim" who has a toy to play tug of war with), it then becomes a matter of providing him with many alternatives that will teach him what you do *not* want him to find. During this procedure, many potentially interesting diversions are introduced, such as rodents, cats, birds, and food, all hidden in the rubble and taught to be ignored by the searching dog.

However, it does take skilled training to duplicate the excitement that a cackling pheasant, quacking duck, or gunshots heralding a mark initiates in the mind of a Golden and transfer this excitement to finding unseen quarry in all sorts of demanding situations, with just a tug toy as a reward. The process can take from six to ten months until the dog is thoroughly proficient and confident at this task.

Again, it is the inherent desire to be with, and work for, his handler that makes the Golden so admirably suited for this type of training. The rewards of playing tug of war with a person and being showered with vociferous praise and delight after

A newly formed SAR team plays at graduation. This type of bonding helps solidify the necessary working relationship between the SAR dog and his human partner.

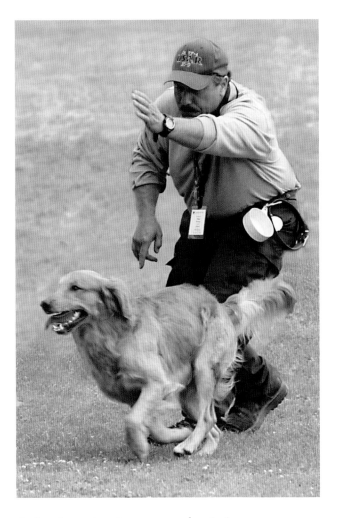

A dog is sent out on a search mission.

a successful find is the frosting on the cake for any good search and rescue dog.

After initially teaching the new candidate to bark at the sight of the tug toy, the training continues with a pretend victim running away and hiding in a barrel with a closed lid that has holes drilled into it. The canine who recognizes that the victim has the much-desired toy will chase the runaway, but the dog then has to indicate by barking that he can smell the victim even when the victim is not visible. The barrel allows the human scent to emanate from a relatively small and isolated area, therefore making it very concentrated. As soon as the dog barks at the scent,

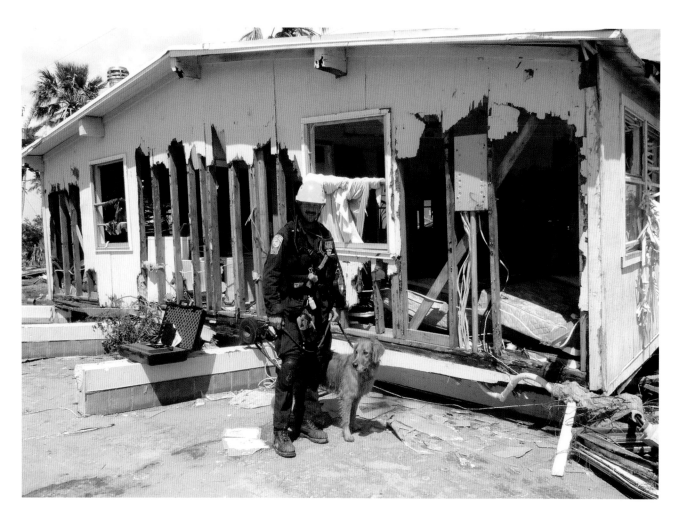

the lid is opened by the victim, who then gives the dog the toy and proceeds to tug with him.

Once the dog understands this concept, the victim goes and hides in a barrel placed in a different location without any visual stimulation, and the K9 is sent on his first real, albeit short, search. The barrel is then moved to a rubble site with different levels of difficulty of footing, and the same process starts all over again. Finally, the victim is buried in the rubble itself and the dog is rewarded for an alert by either the victim or the handler, recognizing that in the real world a true victim of a disaster would, of course, not have a toy in their possession. The transfer of the victim to a hole in the rubble brings with it another level of difficulty because the scent source is now more diffused. Scent percolates

Search dogs are trained to handle different types of disaster situations from the damage caused by a hurricane to the aftermath of a mudslide.

through many nooks and crannies in the debris, and the search dog has to determine where the greatest density of scent originates from and alert at that very location. This expedites the rapid extrication of the victim.

It is at this stage that those recruits who are totally driven to retrieve show their mettle by not hesitating to search, no matter how inhospitable the terrain might be. If a dog has concerns about where his feet have to go, he cannot concentrate on using his nose to air-scent for a buried person. Those dogs with footing issues are moved to other agencies that

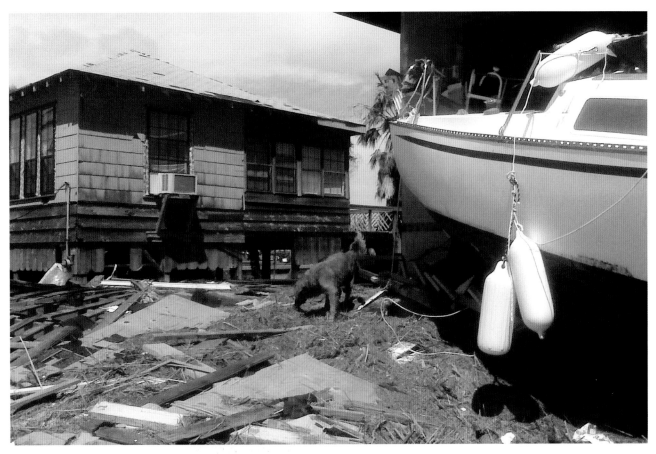

ABOVE: Damage from rising water may create many unusual scents, but the dog must focus only on the human scent. RIGHT: Search dogs must become accustomed to many different kinds of surfaces and footing.

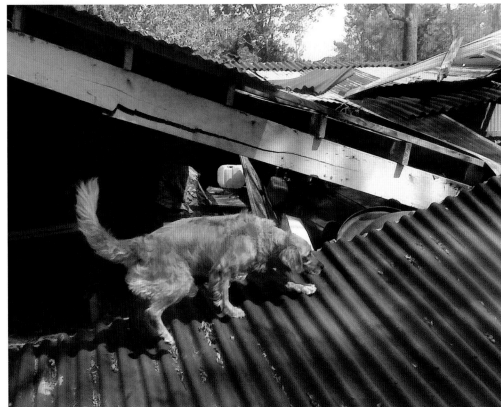

also require dogs with keen noses and good drive but whose work is conducted in more forgiving environments.

It becomes evident very rapidly at this point that the recruits are starting to face the physical demands with which they will have to deal for the rest of their working lives. In order to meet these challenges, their conformation must be sound and in keeping with the standard. A moderate dog will last longer, will be less stressed, and will not have to overcome his conformation with "heart" to maintain his working ability. A heavily boned and coated specimen, while perhaps willing and initially able to search, will break down more rapidly and subsequently have a far shorter working life. Given the approximate time (a year and a half) and cost (over $15,000) to produce a disaster search and rescue dog, it becomes imperative for the K9 to have every structural advantage to perform his job.

A poor front, lacking angulation and with little or no shock-absorbing qualities, will show its weakness rapidly, as the dog has to negotiate the ups and downs of demolished structures with their precarious voids and challenging ascents. The same is true of the dog's rear assembly. If the rear does not match the front, it creates great difficulties for the search dog in maneuvering and coordinating his foot timing

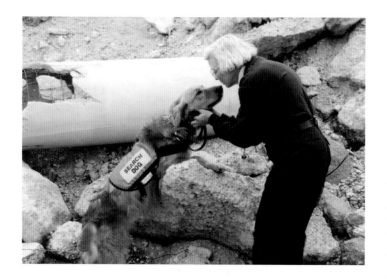

Wilma Melville, founder of the Search Dog Foundation, with a search dog.

over these types of surfaces. Again, the dog who will move most efficiently and will be able to work for longer periods of time is the one that most closely matches the standard. The emphasis in the standard on a strong, muscular, and powerful structure surely indicates the high priority that function was assigned in designing the Golden Retriever's form. He is always "primarily a hunting dog."

As the training searches continue at ever higher levels, the candidates also receive basic obedience, agility, and whistle training. The latter is of paramount importance in enabling the handler to communicate with his out-of-sight K9 partner over long distances and among the distractions of a disaster search site, with its noisy rubble-moving machinery, generators, and people doing various jobs. The ability to stop and direct the working dog at a distance not only means more efficient coverage of the area in question but also aids in keeping the K9 safe from potentially hazardous conditions.

The need for obedience training evidences itself during deployments in which the teams have to negotiate through debris, noise, and moving machinery. There must also be a complete trust that the canine will remain in a given place away from the handler while the handler is being briefed by the search-team managers and assigned tasks. In

certain instances, parts of collapsed material, including layers of mud in landslide disasters, have to be moved and stabilized before the dog can be sent to work. This necessitates an obedient, self-controlled demeanor on the part of the dog waiting to be deployed; this is not easy for the high-drive personalities that excel at searching.

Unlike in agility trials, which have become very popular, agility for a search dog is not about speed— it's about safety. Rubble must be negotiated confidently and methodically, with the possibility of aftershocks, shifting debris, and collapsing material always in the offing. It is imperative that the working dog maintain his equilibrium, both mental and physical, under these conditions and be able to "ride out" moving material; if he leaps off, he risks getting impaled by rebar, being cut by glass shards, or otherwise sustaining injury.

Keeping in mind that search K9s are irreplaceable resources. It requires a tremendous amount of training to convince these fearless creature to work at a reasonable tempo because the very essence of these remarkable dogs is drive and desire. These traits become especially apparent when a dog is asked to climb a ladder up to a second-story window or negotiate narrow planks elevated across voids in the rubble.

Here again, the correct temperament for the breed lends itself to a successful outcome. The Golden Retriever's responsiveness to his handler enables the two of them to truly work as a team, whether walking on rubble, being harnessed and airlifted to a site, or crawling in the dark through the basement of a collapsed structure. The ability to search a site in proximity to another dog without hostility or nervousness also requires the necessary temperament described in the Golden Retriever standard.

Having attained a high level in obedience and agility and being able to locate and indicate the whereabouts of multiple buried sources of live human scent, the search dog and his handler are ready to test. Upon the successful completion of the FEMA-administered evaluation, the dog-and-handler search team is deemed deployable.

Training, however, goes on for the working life of the dog. Ever more challenging search scenarios in all types of weather and in both nighttime and daytime conditions are presented to dog/handler teams so that they maintain their mission-ready status for any type of disaster.

The final result is a remarkable, uniquely honed tool who, together with his handler, can aid in saving human lives, provide comfort to the bereft, and fulfill his intended function as both a working retriever and family companion. For more information on the Search Dog Foundation, visit its Web site at www.searchdogfoundation.org.

More
Precious

than Gold

Chapter Fifteen

The Art and Science of Breeding Goldens

To breed or not to breed? Every Golden owner must, at some point, address this question. Those who choose not to breed—congratulations! The best thing you can do for your mature Golden is to spay her or neuter him.

A three-day-old pup, cuddled up and warm next to Mom.

There is no question that spayed and neutered dogs tend to live healthier lives. A reduction in the incidence of cancer is only one of the benefits of removing the reproductive organs. In addition, spaying a bitch eliminates the question of what to do with her when she is in season. Neutered male dogs have less of an inclination to wander and, once the testosterone has worked its way out of their bodies, tend to be calmer. Neutering a dog with aggressive tendencies will often decrease this atypical behavior. There is a propensity for altered dogs to have a bit of a slower metabolism, so after spaying or neutering, it may become necessary to switch your Golden's food to a "light" formula or to decrease the amount of food that you feed your dog.

Some thought should be given to allowing a bitch to have one heat cycle or a male to reach nine to ten months of age before spaying or neutering so that he or she receives a dose of adult hormones, thus allowing him or her to reach physical and mental maturity before removing the then-unnecessary hormones

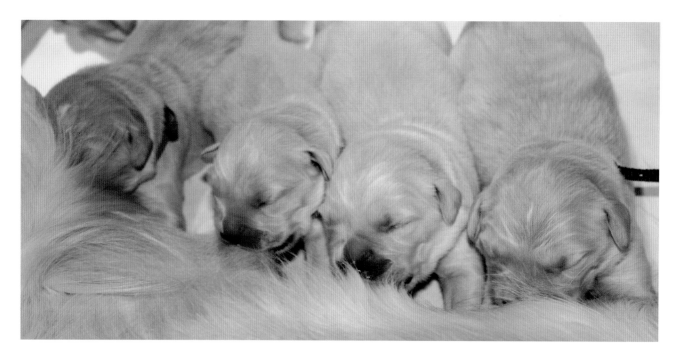

ABOVE AND BELOW: At three days old, puppies spend most of their time eating or sleeping, snuggled up with Mom or their littermates. They require their mother's body heat because they cannot yet regulate their own body temperatures.

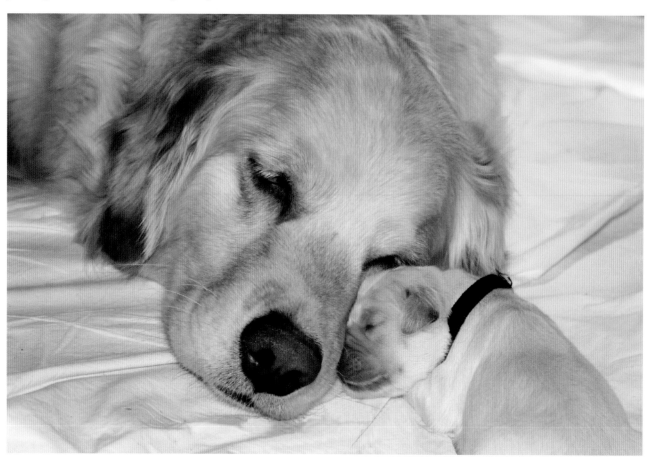

from the body. If you are considering competing with your dog, be aware that spayed and neutered dogs are eligible for all AKC events other than the conformation ring.

If you think that you do want to breed your Golden, you will first have to consider many factors before reaching a final decision. Breeding is not something that should be undertaken lightly or solely to allow children to see the "miracle of birth." Producing a litter of puppies carries with it great responsibilities as well as the potential for a lot of fun. Those truly devoted to the breed probably already follow many of the steps outlined in this chapter. Nonetheless, a review of the best breeding practices is always beneficial.

Once your decision to breed has been made, one of the first issues that must be addressed is the health status of your dog or bitch. As we have already learned, all dogs are subject to various diseases, but our purebreds have specific breed-related health issues of which we must be aware. One of the greatest responsibilities of a breeder is to make healthy pups available to those who can provide good homes and wish to purchase them from the breeder. Animal-rights activists have used breed-specific health issues extensively against all breeders, reputable or not. We must do everything we can to avoid giving them any ammunition to use against us. This means paying attention to health issues; working to produce healthy, well-adjusted pups; being responsible dog owners ourselves; and making donations to health-related research projects funded by knowledgeable organizations.

If you are reading this chapter, you probably have already made a decision to breed your bitch. Before actually taking the last step and proceeding with the mating, be absolutely certain that you

want to produce a litter and do all of the work that is involved in raising healthy, well-socialized puppies. Once the mating has taken place, it is too late for second thoughts. Please be sure that you have thought through all of the factors and possibilities associated with having a litter before it's too late.

Sure, having a litter of bright, cute puppies can be fun, but don't fool yourself. Breeding is a lot of work, even presuming that everything goes well and there are no medical complications with the dam or the pups. You need to provide a clean, dry environment for the growing puppies, and as they grow older, you will need to devote considerable time to socializing them. In addition to whelping the litter, feeding and cleaning up after eight to ten puppies quickly becomes a daunting job that has to be done practically around the clock for at least seven or eight weeks. The cleanup becomes particularly important when the dam stops assisting with the process, usually after the pups are weaned, beginning at three to four weeks.

Proper socialization of a litter is a critical and time-consuming necessity, and providing early veterinary care and vaccinations is also essential. Of course, this assumes that all goes well with the pups and their dam. We are dealing with nature, so this is not always the case. Serious medical issues associated with pregnancy, whelping, and nursing can, at the least, be expensive, and in the most serious cases, can lead to the death of the dam or one or more puppies. The emotional stress of dealing with the death of the dam can be extremely difficult for you and your family. It doesn't happen often, but it can happen.

There are plenty of other things that can go wrong. For example, newborn puppies cannot eliminate waste from their bodies on their own; they need the stimulation of their mother's licking to

move their bowels or urinate. If the dam refuses to wash her puppies or is unable to do so, you will need to provide this stimulation so the puppies remain healthy; this is done by using a towel to simulate the mother's licking around the genital area and rectum. Be certain that you are prepared for the possibility of problems with the dam and litter as well as for the joy of raising new puppies.

Despite what many seem to think, having a litter isn't a sure moneymaker—not if you want to be an ethical breeder. The ethical breeder will get health clearances on at least the hips, elbows, eyes, and hearts of the potential parents. Conscientious breeders will check into the health history of not only the parents but also the grandparents and great-grandparents of the proposed litter for medical issues such as cancer. If many dogs in the family died of cancer at a young age, it is quite likely that the puppies produced by your dog or bitch will pass on the genes responsible for this predisposition to the disease.

All of this preliminary testing can cost hundreds, even thousands, of dollars. What will you do if your potential stud dog or brood bitch turns out to

Once the litter is weaned, you must provide them with good nutrition for proper growth and health.

be affected by one of these medical issues? Having invested a good deal of time and money into this process, are you prepared to abandon the mating? Someone breeding strictly for profit will not even bother with health tests, and certainly wouldn't care about their results. What will you do in the unfortunate situation in which your dog does not pass?

Not all diseases are the same. For example, some say that because juvenile cataracts do not appear to have a long-term effect on the vision of the dog, perhaps it is permissible to breed an affected dog. Others will point out that if we ignore its presence, this problem could develop into something more serious in the future. Hip dysplasia is not a life-threatening illness. Indeed, mild forms of the disease might never have a clinical effect on the dog, meaning that the dog will show no outward signs of lameness. Should a dog with a "borderline" hip rating be bred anyway? These are the kinds of ethical questions that you will have to consider and answer for yourself if you become a serious breeder.

But let us be positive and assume that all goes well with the preliminary testing and you've decided to go ahead and breed. What steps can you take as you attempt to produce the best possible healthy puppies that conform to the breed standard and have the temperament and instincts to allow them to excel in your chosen area of the sport or be fabulous companions? Here are some things for you to consider as you approach breeding your dog or bitch.

History First

In years past, there were a number of large kennels that were devoted to successful breeding programs in one or more breeds. Often owned by individuals of considerable wealth, such kennels employed

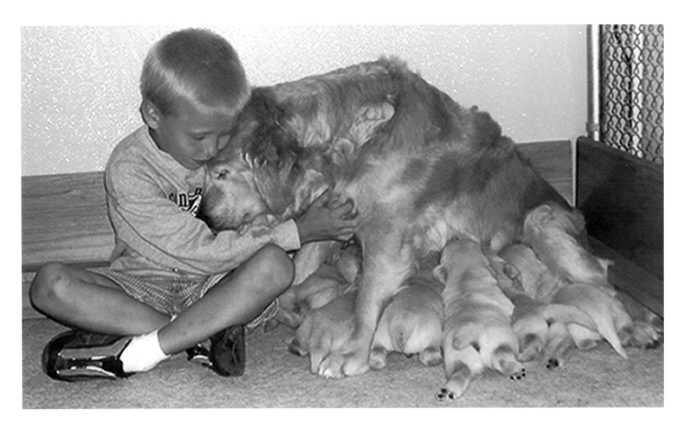

Taking care of a litter takes a lot out of a mom. She needs plenty of love, too.

knowledgeable and experienced "dog men" to assist the owners in establishing and maintaining extensive and successful breeding programs. These kennels would house as many as fifty dogs or more, usually in special buildings made to accommodate show dogs. After careful consideration of which individuals were worthy of breeding, the kennels would whelp a significant number of litters per year, keeping the best from the litters and selling the rest of the puppies as pets or show dogs.

Careful use of pedigree knowledge combined with the practical knowledge and experience gained from dealing with different bloodlines helped careful kennel managers develop a strain of winning dogs. A large breeding program also made allowances for the occasional unexpected results of a mating, which can occur despite the best planning. Should the

unexpected happen, and a planned breeding did not produce the quality puppies that were anticipated, or if the bitch died while in whelp, it would not inflict long-term damage on the kennel's breeding program because there would be other dogs and bitches available to work toward the same breeding goals.

Breeders were willing to experiment with different combinations of bloodlines to reach their goals. Over time, the successful kennels developed recognizable styles of dogs well within the parameters of correct type. As a result, judges and serious fanciers could identify dogs they saw in the ring as coming from specific kennels.

This also meant that individual kennels developed lines that were particularly strong in the specific characteristics most valued by the kennels' owners and managers. Thus, one kennel might consistently produce dogs with superior heads, while another excelled in good toplines or excellent movement. As the breeders selected for the specific

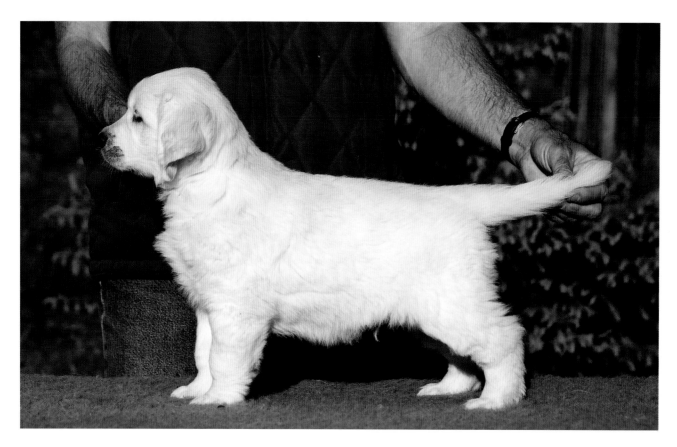

A puppy by Ch. Jazzman's Da Capo out of Ch. Dewmist Silky Rainbow, bred by Henric Fryckstrand of Kennel Dewmist in Sweden, established in 1968.

traits that most concerned them, they often made dogs of their kennel genetically dominant for these characteristics.

The benefits of this were great. If a kennel wanted to improve the shoulder layback on their dogs, for example, they would seek out a sire from a kennel known to have dogs that throw good shoulders. Breeding decisions could, to some degree, be based on the known strengths of a particular bloodline. Possessing this knowledge, gained over time and with experience, meant that a breeder could look at pedigrees and count on the probable results of a mating based on the strengths of a stud dog from a kennel known for a specific quality.

Large kennels such as these were found around the world. By the 1960s, as laws became more restrictive and society's interests and expectations changed, such kennels became increasingly rare. By the 1980s, with a few notable exceptions in some breeds, the

big breeding kennels had largely disappeared. Along with these great breeding kennels, the dog fancy also had lost much of the depth of knowledge that these kennel owners and managers possessed and, more recently, the long-term dedication to a breed seen in these key breeders. Today, many people come into and go out of breeds in five years or less, never fully developing their interest. As a result, much of the institutional knowledge about the breeds is lost as the old-timers pass away with no one to replace them.

When I first became involved with Goldens in the late 1960s, there were still some dominant longtime breeders in the breed. There were still identifiable lines that formed the foundation stock from

which many of our best-known dogs today evolved. Influential kennels of the time included names such as Cragmount, Tigathoe, Lorelei, Stilrovin, High Farms, Featherquest, and Golden Pine, among others. Their collective influence on the future development of the breed is incalculable (see Chapter 1 for more details on these breeders).

A combination of bloodlines from top kennels on the East Coast resulted in a number of important dogs. In the late 1970s, two very closely related dogs, who were the most heavily used stud dogs at the time, together created the more "modern" look of the Golden Retriever that we see today. Their pedigrees combined a number of influential bloodlines from the 1930s to the early 1960s. They were Ch. Misty Morn's Sunset CD, TD, WC and Ch. Cummings Gold-Rush Charlie. Both were sired by Ch. Sunset's Happy Duke (Ch. Cragmount's Peter ex Glen Willow's Happy Talk). Ch. Misty Morn's Sunset ("Sammy") was out of Amber Lady of Tercor Farm (Ch. Cragmount's Double Eagle ex Ch. Cragmount's Golden Wallis) while Ch. Cummings Gold-Rush Charlie was out of Ch. Cummings Golden Princess (Ch. Cragmount's Double Eagle ex Cragmount's Easy Lady). As you can see, these two dogs have the same sire, and their mothers were half-sisters—both are out of Ch. Cragmount's Double Eagle—making Sammy and Charlie very closely related. This quick look at their pedigrees shows that several of the top large breeding kennels of earlier years contributed to the gene pool that these dogs represent. Sammy and Charlie had great influence on the future of the breed; some of it has been very beneficial and some, over time, has proved to be less so.

While the owners of the earlier large breeding kennels certainly liked to win, they wanted to win with top-quality dogs that reflected the results of

TOP BREEDERS' BIG SECRETS

There are three big secrets that top-winning breeders rely on to succeed. The first is a complete and thorough understanding of the breed, its history, its standard, and all of the standard's requirements. The second is the ability to admire the strong points of others' dogs and, when appropriate, to make use of other breeders' knowledge and perhaps of their dogs' bloodlines. The third is a good working knowledge of their own dogs' ancestors' strengths and weaknesses; in other words, good *pedigree knowledge*.

The Golden Retriever was originated to perform specific functions and to have a certain look. The standard puts these requirements into words. Those who consider themselves serious breeders—no matter what purpose their dogs serve—must understand the history of the breed and its purpose so as to maintain in their dogs the requirements of the standard. They should never exaggerate or ignore aspects of the standard that in any way change the essence of the breed in the puppies they produce.

their own efforts as breeders. They didn't just want to own winners; they wanted winners that they bred themselves. Most shows of the day were benched, meaning that exhibitors were at the show all day.

Benching-area discussion at shows then was not about who was winning, but was more focused on which dogs were *producing* the winners. Much of the debate at shows, while waiting for judging or while the dogs were benched, centered on just what characteristics made the best dog, where this dog had inherited these characteristics, and how one might reach the elusive goal of breeding the "perfect" Golden. The merits of various dogs as sires and dams, and just how well they produced, were always the subject of much discussion. This shared knowledge was invaluable as the basis for future breeding plans.

By the middle of the 1980s, things had changed. Large breeding kennels had mostly disappeared, perhaps the result of changes in zoning laws—making it more difficult to have large numbers of dogs in most suburban settings—combined with changing attitudes toward breeding dogs in general, as well as increasing costs of maintaining large kennels. The emphasis on showing in conformation, perhaps mirroring American society in general, went from breeding the best possible dog who was winning to just owning a winner.

Fortunately for future Golden fanciers, some dedicated breeders remain around the world, and they continue to strive to improve the breed while still following the dictates of the breed standard. It is these breeders, those who struggle to improve the breed—not change it to meet the fashion of what is winning in the ring at a particular time—who hold the future quality of the breed in their hands. These are the individuals who are content to breed the specialty winner, the Best in Show dog, or the MACH-, OTCH-, or FC-titled Golden who is perhaps owned by someone else. These people realize that, while it is fun to win, the future of the breed lies with the breeders, not the owners of winners.

Mentors

So, how do the great breeders reach that lofty position? What secrets have they learned over the years, and how can we benefit from their knowledge and what they have to teach us? By far, the best way to find out is to earn the support of a top longtime breeder as a mentor.

To go beyond a general understanding of a breed, to learn the finer points of type and style that differentiate the novice from the expert, and to learn about the strengths and weakness of dogs in pedigrees, one benefits greatly from the advice of a breed mentor. *Webster's Dictionary* defines a mentor as "a wise and trusted counselor or teacher." For those of us involved with dogs, a mentor is one who, over a period of many years as a breeder and exhibitor, has learned the nuances of correct type and structure so well that these elements have become second nature. At the same time, a successful mentor has the ability to communicate his knowledge in a meaningful and unbiased manner. Someone with five or ten years of breed experience is just beginning the process of understanding the essence of his breed, not yet reaching the apex of knowledge. True learning is a neverending process. At the same time, a good mentor knows that the ethics of the dog world apply equally to the novice and the expert.

All dog breeds were developed over time to perform specific functions, and a breed does not develop overnight. A thorough knowledge of its history and purpose is essential to understanding the core of any breed. The kind of knowledge that is gained through years of going over hundreds of dogs, often including several of the pillars of the breed, can only be gleaned from a mentor with decades of experience. The personalized, in-depth pedigree information

This sequence shows how a promising pup matures into a valuable show dog and stud. ABOVE, LEFT: Future Ch. Highmark's Cowboy Coffee OS, SDHF ("Starbuck"), bred by Linda Willard and Vicki Havely and owned by Linda Willard, at five and a half weeks of age. ABOVE, RIGHT: Linda holds three-and-a-half-month-old Starbuck. RIGHT: Starbuck, stacked at six months old.

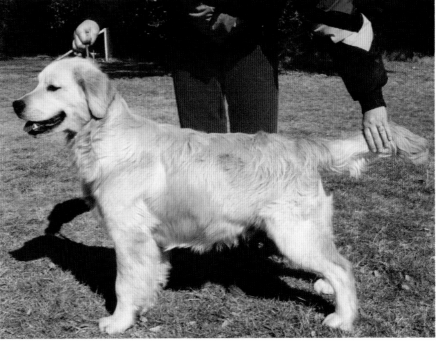

such a person will have developed through actually examining dogs in a pedigree is an invaluable tool for any breeder seriously concerned with maintaining the essential elements of the Golden Retriever while breeding winning dogs.

Seeking Positives

New judges are often cautioned to avoid "fault judging," the practice of making decisions based primarily on dogs' faults rather than their virtues. Breeders, too, should remember the importance of looking for the positive aspects of their dogs, not just the negatives. All dogs, of course, have faults. An unsure judge can easily eliminate outstanding typey dogs from consideration. Tail carried a bit high? Out you go. Coat a bit dark? Sorry, you're eliminated. The real problem with this sort of evaluation is that, in the end, the judge might find a dog with minimal faults, but all too often with minimal virtues as well. The best judging occurs when knowledgeable judges seek the dog with the greatest overall breed-specific strengths, perhaps in spite of a few areas that could be improved.

The same concepts hold true for exhibitors and especially for breeders. Good breeders pay attention to genetic health issues. Good breeders study the breed standard and consider its requirements carefully when making breeding decisions. Good breeders, unfortunately, sometimes forget to avoid the trap of making judgments based on faults when deciding which dog to breed to which bitch.

It is often a mistake to concentrate only on eliminating a fault when planning a litter. Let's say we want to improve angulation on the prospective puppies. Our brood bitch is a bit lacking in front angulation, so we want to correct this in her puppies.

How do we accomplish this goal? Breed to a dog with a good front, of course. So we'll take our bitch, Ch. I'm So Cute, to that stud dog with the wonderful front, Ch. Handsome. He has great angulation, after all. But what about the rest of the dog? Is he a good example of breed type? Is he balanced? Can he move correctly for a Golden? Even if our "plan" works, would we get a good Golden or just a generic yellow dog with a good Golden front? Remember, mixed-breed dogs can move well, too. Correct type must always be considered.

With today's grooming tools and skills, it seems possible to cover faults, or minimize them, but to what end? A beautiful, flowing, long coat that can be sculpted into the desired outline of an outstanding Golden does not make the dog beneath the coat correct. Most competent judges will see through the artistry and find the dog beneath. And even if you've fooled the judge, are you fooling yourself as well?

Good breeders need to concentrate on those aspects of their bloodlines requiring improvement by basing decisions on the breed standard and the overall balance and type of their dogs—not on what happens to be winning today. For example, flashy movement with a high foot action in front and a rear with a lot of "kick" might appeal to some, but it is not good, efficient Golden movement. Shorter legs create the need for faster-moving legs to cover the same ground, which some consider desirable, but those short legs are contrary to what is desired in the breed standard. While a lot of straight coat might be pretty to some, the breed standard considers excess coat and open coat very faulty. Yes, these are characteristics that might help some dogs win under less knowledgeable judges, but are these incorrect features something you want to breed into your line despite the mandates of the breed standard?

A shot of Starbuck at eleven months old, showing the head and forequarters.

Standing outside the conformation ring today—or inside it, for that matter—it is not at all unusual to look around and realize that there is a very wide variation of styles represented in the class. While there is—and should be—some allowance for differences in styles in established lines, the overall appearance of all dogs in the ring should scream "Golden Retriever."

As custodians of our breed, we need to recognize both the positives and the negatives. We must understand that the primary goal is to look at the overall dog, not its individual pieces. A good head on a long body does not make a good Golden. A good body on legs that are too short does not make a good Golden. Breeders must recognize that consistency of type is important, especially in a breed as popular as the Golden Retriever, or the breed will truly become a generic yellow show dog.

Remember that honestly evaluating your own dogs, seeing not only their strengths but also their weaknesses, is essential to breeding good dogs. "Kennel blindness," the unfortunate tendency of a breeder to see only positives in his own dogs while ignoring the areas that need improvement, is the breeder's worst enemy. Don't allow your ego to interfere with your breeding plans; a need to feel superior is very likely to lead you to frustration and disaster over time. To succeed, you need to acknowledge that all dogs have faults, even yours. It's your job to acknowledge the faults and do what you can to eliminate them from your breeding program as you proceed in your quest for the perfect dog.

Two useful hints for you to remember: first, never breed a dog and a bitch who have faults in common, for that will only serve to ensure that their puppies will have the same faults. Second, when making decisions about which dog to breed to which bitch, always try to choose dogs of similar type to maintain and strengthen those characteristics that you like.

Pedigree Knowledge

An often overlooked but extremely important part of breeding technique is pedigree knowledge. Good breeding practices do not mean just breeding to the current winner. All master breeders who have developed identifiable lines have accomplished their goals through the utilization of pedigree knowledge. Good pedigree knowledge permits the breeder to choose the dogs that, when bred, will have the greatest possibility of producing pups that meet the breeder's expectations. Pedigree knowledge is probably the single most important resource that a top breeder can have.

Breeding dogs is not like mixing paint. It's just not that easy. If it were, there would be no skill to it. If I take a can of white paint and mix it with a can of red paint, I will always get a bucket of pink paint. Living things do not conform to rigid expectations. The results of a breeding will never be a consistent mixture of the available genes and cannot be predicted with any certainty. If I breed a red dog to a white bitch, I will not get a litter of pink puppies. Instead I will get a litter of white puppies with red splotches, red puppies with white splotches, all-white puppies, all-red puppies, and everything in between. What's more, if I repeat the breeding, the puppies of the second litter probably will not be the same as those that came from the first litter.

If someone, for some strange reason, decides to breed his Golden Retriever male to a Poodle bitch,

ABOVE: Five-year-old Starbuck and Linda in the ring at the 2000 GRCA national specialty. RIGHT: Still going strong at age eleven, Starbuck was Best Veteran in Sweepstakes at the 2006 GRCA national specialty.

The Stud Dog Class at national specialties can be very competitive. Pictured here is the third consecutive win for Ch. Pepperhill's Basically Bear (LEFT), shown with his get Ch. Pepperhill Yankee O' Goldtrak (CENTER), and Ch. Pepperhill's Travelin' Bear CDX (RIGHT).

the puppies from that litter will not be consistent. Some of the first-generation puppies might look similar, but the second and succeeding generations will not be consistent in looks or characteristics. The result may be a litter of "designer dogs," but for what purpose? The breeder cannot bank on the litter's containing only puppies that are non-shedding and hypoallergenic. The pups will not magically have an even blend of all of the strong points of the two parent breeds with none of the weak points. Further, the pups in the first generation might look similar, but each individual puppy will have a unique mixture of genes from the parents, and it is unlikely that any two will be genetically the same. As a result, the pups will not breed "true," meaning that the puppies may not look like the parents. It is, I suppose, technically possible that an individual puppy might possess all of the best features of both parents, but it is equally possible that he will pos-

sess all of their worst features! It is only through careful selective breeding practices over time, using pedigree knowledge and a thorough understand of the principles of genetics, that anyone can eventually create a new breed that features the best characteristics of the two original dogs. This will take many generations, replete with successes and failures, before it is achieved.

Now if my previously mentioned red dog and white dog are random-bred (or mixed-breed) dogs, there will be a much wider variation in the resulting

puppies. This is simply the result of the fact that each mixed-breed parent has a wider range of genes in his makeup. Purebred dogs are, by definition, dogs that, when bred to another dog of the same breed, will always produce puppies that look like that breed. This will simply not be the case with litters from mixed-breed parents.

There will be variation between dogs of the same breed, but all Golden Retrievers look like Golden Retrievers, even though they don't appear identical. Just what they will look like is controlled by their individual set of genes, which they received from their parents, who received theirs from their parents, and so on.

Pedigree knowledge means that breeders can select which characteristics they wish to emphasize in the puppies they produce. In order for pedigree knowledge to be useful, you must know your own dog's pedigree and be breeding to a bitch whose pedigree you know as well. This does not simply mean that you can recite the names of the dogs in the animals' pedigrees. That information, by itself, has little value. You must know what the dogs in the pedigree looked like, what their structure was, what their strengths were as producers, and what their weaknesses were. It is especially helpful if you have actually seen and touched the dogs in real life, not just seen a photograph on the Internet. You also need to know the health status of each dog and whether or not they have thrown particular health issues or other problems in their puppies. This sort of knowledge cannot be found in a book or online. It is gained from direct experience, advice from your mentor, and conversations with other breeders whose integrity you trust.

How is this knowledge useful? Let's say that you want to work toward improving the heads in your line of Goldens and want to breed your best bitch to a stud dog who will, hopefully, improve the heads on the puppies. How would you go about this? In addition to all of the research into health issues and clearances you would normally do on any stud dog, you need to find a dog who possess an excellent head type. But suppose he was the only dog in his litter with a good head and no one in his extended family had a good head? Would you still want to use this dog? Probably not. You want a dog who not only has a great head but also has parents, grandparents, and siblings who all had/have great heads; in other words, you want a dog who comes from a family with fabulous heads. This dog, when bred, is much more likely than the first dog—whose head was really an anomaly for his breeding—to be dominant in providing the good heads you seek. Only a depth of pedigree knowledge can give you that kind of information.

Good breeders always plan their litters well in advance. The serious, long-term breeder goes far above and beyond this, probably having several generations of breeding plans in mind. Sometimes a breeder will be waiting for the right dogs of the pedigree with which he wants to work to come along. For example, let's say I'm doing a mating today. I probably have already decided whether I want to keep a dog or a bitch from the litter (if one of the puppies meets my expectations). And I probably have already decided how I would like to breed that dog or bitch to a dog or bitch I've kept from another litter or one I've seen elsewhere, based on the pedigrees of both. What's more, it would not be at all unusual if I already have some plans about just how I would breed a pup I kept from that third-generation litter! That is exactly how I make use of my linebreeding plans.

Linebreeding, Inbreeding, and Outcrossing

I will not go into the theories of genetics here, for that is a topic that requires much more space than I have available in a book of this scope. Any serious breeder will find that he has to learn something about genetics and the modes of inheritance to be successful. At the very least, understanding that some characteristics are dominant and others are recessive is vital to understanding how to breed. I'd suggest an in-depth book on canine genetics for the detailed background that you eventually will need to be familiar with. For the purposes of discussion here, remember that all puppies are the result of the genes that they inherit from their parents, half from the mother and half from the father. It is how those genes mix together that determines the characteristics of the puppies.

It would be very nice if there was some way to ensure that only the positive characteristics of the parents were passed on to the puppies; however, science has not advanced to this point and probably never will. For example, when trying to overcome a long loin, breeding a dog with a short-coupled body to your bitch with a long loin will not result in all the puppies having the desired length of loin. In fact, the pups in the litter will more than likely reflect all possible aspects of the combination—some with short loins, others with long loins, and, if you are lucky, perhaps a few with the desired length of loin. However, it is also possible that the puppy with the desired length of loin also has a new problem that neither parent had, such as, perhaps, a straighter front assembly. This, of course, is what makes breeding such a challenge.

There are three basic methods that all breeders of purebred dogs use, either consciously or unconsciously; these are *outcrossing*, *inbreeding*, and *linebreeding*. All three of these methods rely on pedigree knowledge to be safe and successful. When deciding which method to use in a planned litter, it is vitally important to remember that both the desirable and the undesirable genes will be passed on to the puppies and that the laws of genetics will prevail.

Outcrossing is breeding a dog and a bitch that have no common ancestors for at least four generations behind them. This provides the widest possible gene pool to the puppies produced, and also tends to result in puppies who, as adults, will likely have a wider variation from each other in type, size, weight, and so on. Outcrossing is the safest method for those new to the breed and can be very successful.

The reverse of outcrossing is inbreeding. This is breeding sibling to sibling or parent to offspring. Inbreeding provides the smallest possible gene pool and thus the least amount of variation within the litter (although there will still be considerable differences from puppy to puppy). Inbreeding also provides the best chances for undesirable recessive traits and diseases to be present in the offspring. Therefore, inbreeding should be used only by experts who have in-depth knowledge of all of the potential pitfalls in the pedigrees.

In between the two extremes is linebreeding. This is breeding dogs within the same line or family that have at least one common ancestor in the first three generations. The relationship between the dogs will not be as close as in inbreeding. Linebreeding allows some concentration of desirable genes while still providing some diversity in the available gene

The sister-and-brother team of Ch. Libra Mala-gold Clover OD (LEFT) and Ch. Libra Malagold Coriander OS, SDHF (RIGHT) took the Veterans Classes at the 1988 GRCA national specialty. Breeder, Connie Miller.

pool to try to avoid problems produced by undesirable recessive genes. It offers some control over the available gene pool. This is the method most commonly used by many successful breeders today.

Most improvements that breeders seek cannot be established in a line in one generation. In the previously mentioned example of loin length, for example, if the breeder were lucky enough to get a good-quality puppy with the desired shorter loin, it would be necessary to breed that puppy to a dog who also

possessed the same desirable length of loin. Quite likely, this would have to be repeated again in at least the next generation to incorporate correct loin length in the line. The desired result could probably be reached sooner if linebreeding were employed, but it could also be accomplished by outcrossing unrelated dogs that possess the desired characteristic. The advantage of using linebreeding is that the desired results are realized more rapidly because of the smaller available gene pool. The drawback is the greater possibility of unwanted recessive genes coming into play because of the greater chance that both parents will carry the same recessives.

This is why consistently breeding quality dogs is so difficult. A dedicated breeder can spend a lifetime working to reliably produce the exact kind of Golden

he has visualized for many years and yet still not reach his goal. It also speaks to the great desirability for new breeders to start their breeding programs with the best possible quality dogs. This avoids wasting unnecessary effort trying to fix problems with the results of their breeding efforts that others have already learned to avoid in earlier breeding programs. The smart breeder will want to start with the best and then labor to further improve on the work of those who came before him, not try to improve lesser-quality breeding stock. This is yet another good reason to establish a good working relationship with a top breeder/mentor.

On the opposite page is an example of a pedigree that shows tight linebreeding. First, look at the unmarked pedigree and see if you can recognize why it is a linebreeding. In this five-generation pedigree, you will notice that several names appear multiple times. This makes this pedigree a linebreeding.

For the purposes of this illustration, we are going to make several assumptions—that the breeders were aware of the health statuses of many of the dogs in the pedigree, were aware of the health statuses of both the proposed sire and the dam, felt that these two dogs were worthy of breeding to each other, felt that these dogs were outstanding examples of Goldens, and wished to try to improve on their strong points.

Now, let's look at the marked pedigree and see how this works. Notice that the dog in the blue box, Ch. Sunset's Happy Duke, appears no less than eight times in this five-generation pedigree, starting in the third generation. Note also that Ch. Cummings Golden Princess (in green) appears seven times in the five generations. All of the dogs outlined in red are the products of breedings between "Duke" and "Princess." Therefore, this pedigree represents a litter that

is linebred on Duke and Princess. Both the strengths and the weaknesses of these two dogs will tend to dominate the puppies born of this breeding.

This pedigree represents an actual Pepperhill breeding done may years ago. In actual practice, this was a highly successful litter, producing a number of champions and top-quality breeding dogs, as well. Some of the puppies from this breeding went on to become foundation stock for other kennels active at that time. It was the root pedigree from which my own line of Goldens stemmed.

PROTECT YOUR BREED

The Golden Retriever was originated to perform specific functions and to have a certain look. The standard puts these requirements into words. Those who consider themselves serious breeders—no matter what purpose their dogs serve—must maintain the requirements of the standard in their bloodlines. They should never exaggerate or ignore aspects of the standard that could in any way result in changing the essence of the breed in the puppies they cause to be born.

Those who breed simply to make dogs do not consider any of the concerns expressed by ethical hobby breeders. The future of the Golden Retriever is wholly dependent on the decisions made by today's breeders.

Name _____ AKC No. _____
Breed Golden Retriever Color _____ Sex _____
Breeder Barbara & Jeffrey Pepper Whelped _____

Ch. Pepperhill Yankee O'Goldtrak (Sire, AKC No. _____)
- Am.Can.Ch.Pepperhill's Basically Bear
 - Ch. Gold-Rush's Great Teddy Bear
 - Ch. Cummings Gold-Rush Charlie
 - Ch. Sunset's Happy Duke
 - Ch. Cummings Golden Princess
 - Ch. Golden Pines Glorybe's Angel
 - Golden Pine's Tiny Tim
 - Ch. Golden Pine's Glorybe
 - Ch. Cummings Dame Pepperhill
 - Ch. Sunset's Happy Duke
 - Ch. Cragmount's Peter
 - Glen Willow's Happy Talk
 - Ch. Cummings Golden Princess
 - Ch. Cragmount's Double Eagle
 - Cragmount's Easy Lady
- Goldtrak Charlie's L'l Angél, CD
 - Ch. Cummings Gold-Rush Charlie
 - Ch. Sunset's Happy Duke
 - Ch. Cragmount's Peter
 - Glen Willow's Happy Talk
 - Ch. Cummings Golden Princess
 - Ch. Cragmount's Double Eagle
 - Cragmount's Easy Lady
 - High Farms Beau Teak-A, TD
 - Ch. High Farms Beau-Teak
 - High Farms Teakwood
 - Aureal Wood's Cream Cheese
 - High Farms Gay Katrina, WC
 - Ch. Major Gregory of High Farms
 - Tigathoe's Pandora

Pepperhill's Bear-Naise (Dam, AKC No. _____)
- Am.Can.Ch.Pepperhill's Basically Bear
 - Ch. Gold-Rush's Great Teddy Bear
 - Ch. Cummings Gold-Rush Charlie
 - Ch. Sunset's Happy Duke
 - Ch. Cummings Golden Princess
 - Ch.Golden Pines Glorybe's Angel
 - Golden Pine's Tiny Tim
 - Ch. Golden Pine's Glorybe
 - Ch. Cummings Dame Pepperhill
 - Ch. Sunset's Happy Duke
 - Ch. Cragmount's Peter
 - Glen Willow's Happy Talk
 - Ch. Cummings Golden Princess
 - Ch. Cragmount's Double Eagle
 - Cragmount's Easy Lady
- Am.Can.Ch.Russo's Pepperhill Poppy
 - Ch. Cummings Gold-Rush Charlie
 - Ch. Sunset's Happy Duke
 - Ch. Cragmount's Peter
 - Glen Willow's Happy Talk
 - Ch. Cummings Golden Princess
 - Ch. Cragmount's Double Eagle
 - Cragmount's Easy Lady
 - Russo's Wildwood Flower
 - Ch. Misty Morn's Sunset, CD TD WC
 - Ch. Sunset's Happy Duke
 - Amber Lady of Tercor Farm
 - Ch. Russo's Cummings Elsa
 - Ch. Sunset's Happy Duke
 - Ch. Cummings Golden Princess

Certificate of Pedigree

I Hereby Certify to my knowledge and belief, this Pedigree is true and correct.

Date _____ Signed _____

STONEHEDGE, POCASSET MA 02559

ABOVE: This five-generation pedigree represents an actual mating. Can you find the dogs who are being lined on? BELOW: The same pedigree, marked to show the linebreeding.

Hereditary Diseases in the Golden Retriever

The population of dogs in general, whether purebred or of mixed heritage, is affected by numerous diseases. Some of these are considered to be hereditary in nature, others may be considered familial, and some may be environmentally induced. As with humans, the causes of many of these diseases are unknown, though an increasing number are the subject of intensive

scientific study. Until fairly recently, funding for these necessary studies of canine health problems was not readily available. Fortunately, since the early 1980s, more and more money has become available for serious study of these issues.

The DNA profile of the dog was recently completed, and this has opened up many new and more accurate methods of studying the heritability of diseases and the search for cures. By determining which genes cause different types of cancers, for example, we hope that research will lead to the discovery of treatments that can destroy the cancer-causing cells. In addition, the differences between the human genome and the canine genome are relatively small, and so many of the same diseases affect both humans and dogs. Because the results of many studies can be applied to man and dog alike, more funding has become available for research into many very serious illnesses.

The creation of any true breed requires some degree of linebreeding and inbreeding. We will define *purebred* here to mean that when you breed a male and a female of the same breed to each other, all of the puppies in the resulting litter will look similar and have similar characteristics, which makes them identifiable as being of that same breed. In other words, when you breed a Golden Retriever to another Golden Retriever, you will always get Golden Retriever puppies who look similar to their parents. In random-bred (mixed-breed) dogs, this similarity

With each Golden puppy born is the breeder's hope of improving his beloved breed.

does not happen. To accomplish the goal of creating a breed, man plays a role by selecting which dogs will be bred to which bitches. Breeding like to like results in the production of offspring with similar characteristics. This is accomplished by reducing the size of the gene pool by breeding dogs that have very similar characteristics.

The same concentration of genes and the shrinkage of the gene pool that leads to the creation of a pure breed may also concentrate genes that may be linked to disease. Of course, mixed-breed dogs are just as subject to dictates of their inherited genes as

purebreds, so there is no guarantee that, for example, a random-bred dog will never develop cancer any more than it is possible to say that all Golden Retrievers will develop the disease.

One advantage that purebred dogs have over mixed-breed dogs is the dedication of breeders who do all in their power to eliminate serious inherited diseases from the gene pool of their breed. One way this is accomplished is through health testing of potential breeding stock to determine as accurately as possible whether or not the dogs are carrying specific diseases. Further, dedicated breeders—unlike those who allow any dog to breed to any other dog—are willing to donate money to studies that aim to identify the genes that cause specific diseases. Once they know the genetics behind a disease, it is much easier to eliminate dogs carrying faulty genes from the breeding pool. This potentially will also help in the development of preventative treatments (such as vaccinations) and medications to cure the disease in dogs that have already contracted it.

The community of dedicated Golden Retriever breeders has contributed millions of dollars to health research over the years, with some of those funds going toward cancer studies in the breed. There are promising results that may, in the future, allow breeders to determine which dogs are carrying the suspected genes and which are not. By choosing to breed only dogs that are not affected by an inherited disease, breeders can produce puppies that are much less likely to develop that disease. The ultimate goal, over time, is to eliminate such diseases from the breed's gene pool.

Further, increased knowledge of just what causes certain diseases creates the potential to develop vaccines that inhibit specific diseases so that they pose less of a threat or can even be eliminated

TOP: Genetically sound pups of consistent type are what breeders strive for in each litter. BOTTOM: Healthy Goldens live long lives, providing their families with many years of affection and companionship.

permanently. This has already happened with certain human diseases, such as smallpox, which has been wiped out worldwide.

Like all dogs, the Golden Retriever is subject to the potential of contracting many different illnesses, some that are quite serious or life-threatening and others that are less so. However, as with any breed, there are certain diseases that seem to affect the Golden much more frequently than other breeds. A survey of Golden owners and breeders conducted in

the last years of the twentieth century by the Golden Retriever Club of America Foundation identified six major areas of concern:

1. Several forms of cancer
2. Hip dysplasia
3. Subaortic stenosis (SAS)
4. Various allergies
5. Elbow dysplasia/osteochondrosis
6. Behavior and temperament issues

All of these issues are at least partially controlled by each dog's genetic inheritance. Cancer and SAS can lead to the early death of affected dogs, and the others have a direct effect on the quality of life of the individual dog. Behavior and temperament issues have a direct bearing on a dog's suitability as a companion—which is, of course, the primary reason that most people own dogs to begin with. Aggressive dogs, hyperactive dogs, extremely timid dogs, or dogs who fight with other dogs do not reflect correct Golden temperament and do not make good family pets. No one really wants to own a dog who is difficult to live with because of his temperament, even if he is beautiful or a good worker.

Not all of the listed issues are found as commonly in the breed today. The incidence of some of them has already decreased as a result of the efforts of conscientious breeders. For example, SAS was much more common twenty to twenty-five years ago. Around that time, screening for SAS became a more routine practice. Continued emphasis on health screenings, combined with improving diagnostic techniques, may well have led to a marked decrease in its incidence in Goldens today. In the survey, only 1.4 percent of respondents' dogs had been diagnosed with this disease. This low percentage shows the value of health screening, something that irresponsible breeders do not have done on their dogs.

Cancer

Without question, the most serious problem found in Golden Retrievers is the familial tendency to develop cancer. All purebreds and all mixed-breed dogs have the potential to be subject to the ravages of this dreadful disease. However, the Golden Retriever breed especially seems to suffer from various forms of cancer. In fact, Morris Animal Foundation has indicated that as many as 60 percent of all Golden Retrievers ultimately die from cancer. Far too many of these cancer cases strike relatively young dogs. As a result, the average lifespan of the Golden today is shorter than it was twenty-five years ago, having been reduced from twelve to thirteen years down to eight to ten years. Goldens are particularly susceptible to lymphoma (which affects the lymph nodes) and hemangiosarcoma (which affects the blood vessels and spleen). Several other kinds of cancer are also seen in Goldens, including osteosarcoma (bone cancer) and mast cell (skin) tumors.

Because of the Golden Retriever's hereditary susceptibility to cancer, the Golden Retriever Foundation (GRF) began a five-year campaign in 2007 to raise $500,000 toward a joint cancer research project with the Morris Animal Foundation (MAF) and the AKC Canine Health Foundation. The goal is to fund a $30 million effort to cure canine cancer within ten to twenty years—a dog's lifetime. The GRF continues to solicit donations toward meeting this pledge and funding future projects to eliminate cancer (see the GRF's Web site at www.Golden RetrieverFoundation.org for more on how you can help). You can also go directly to the sponsors' Web sites, www.CureCanineCancer.org, www.morrisanimalfoundation.org, and www.akcchf.org, to learn

more about canine cancer, get the latest updates, and make a contribution.

There are a number of exciting studies on canine cancer that are in progress at the time of this writing, with funding provided through the MAF and the AKC Canine Health Foundation. Substantial progress has been made in learning about how cancer is established in the body and treatment for the diseases. Every study, even those that do not meet their goals, contributes additional data toward the discovery first of a cure and later of methods of screening and prevention so that someday dogs will no longer be threatened by cancer. As an additional benefit, many of the funded studies involving our canines provide information that is also very useful for the understanding, treatment, and cure of cancer in humans—especially children.

The question of whether or not to breed dogs from canine families suspected of passing on cancer to the next generation is a difficult one. Presently, there is no foolproof method of determining whether or not a dog will pass on a predisposition to cancer to his progeny. Further, with a problem as widespread as cancer, removing from the gene pool all dogs thought to be from families with high incidences of cancer would further reduce the size of that gene pool and perhaps cause more problems than it solves. We all hope that new methods of determining cancer carriers will be developed as a result of the research currently being done.

Hip Dysplasia

Hip dysplasia, a malformation of the hip's ball-and-socket joint, was first recognized as a problem in the 1950s. While the problem is not fatal, it can have a marked negative effect on the quality of life

of severely affected dogs. As a result, following some groundbreaking studies, the Golden Retriever Club of America established an x-ray screening protocol for the disease and a registry to list of the names and general results of dogs that have been tested. The GRCA then created an alliance with the German Shepherd Dog Club of America, which also had a screening program. This alliance led to the eventual formation of the Orthopedic Foundation for Animals (OFA), whose screenings became the established standard for hip-dysplasia testing. Dogs need to be at least two years old to receive an OFA hip "clearance" because the disease often does not show up in hip x-rays of younger dogs but develops as dogs mature. The health survey found that about 11 percent of respondent's dogs were suffering from this potentially debilitating disease.

As best as can be determined presently, hip dysplasia and elbow dysplasia appear to be at least partially determined by environmental influences in addition to genetic coding. Overweight dogs and young dogs who are subject to stressful, excessive exercise can develop hip and/or elbow problems. Feeding practices have also been found to have an effect on the development of these diseases.

Unfortunately, screening alone has not led to the end of hip dysplasia, but it did reduce the numbers and, perhaps, the severity of the disease in affected dogs. Other forms of screening, such as PennHIP, developed by the School of Veterinary Medicine at the University of Pennsylvania, have shown promise in determining the presence of the disease in much younger dogs on an objective basis. This allows for dogs to get hip clearances and accordingly be used for breeding purposes at an earlier age.

Most Goldens have a fairly high threshold of pain, so those affected with hip or elbow dysplasia

Goldens love to romp on the beach.

often do not show symptoms until the problem has become severe. It is not unusual for a dog who is later diagnosed with hip dysplasia to move well, with no indication of limping or other manifestations of pain. The only way to determine with certainty that a dog is clear of or affected by hip dysplasia is through an x-ray screening evaluated by an expert, such as that of the OFA or PennHIP, that studies the actual hip socket and bones.

There are numerous studies on hip dysplasia, many of them ongoing at the time of this writing, and the interested reader is encouraged to seek out these resources. For example, a simple online search for "hip dysplasia in dogs" will lead the reader to hundreds and hundreds of entries, many providing links to breed-specific studies as well as general studies on the disease. The Web sites of the GRCA (www.grca. org), OFA (www.offa.org), GRF, AKC Canine Heath Foundation, and MAF are but a few of the available resources. These last three organizations will have information on all of the diseases that are known to affect our Goldens.

Subaortic Stenosis (SAS)

This heart valve condition first received considerable attention as a problem in the Golden Retriever in the early 1980s. It was "discovered" in several lines of Goldens. Testing for the problem is best done by a veterinary cardiologist, and affected dogs should not be used for breeding because the condition appears

to have a genetic component and can therefore be passed from parent to child. As more information became available, many breeders began to routinely have breeding stock checked—despite the expense of the examination. As mentioned, affected dogs are most often removed from the breeding programs of reputable breeders, another reason for choosing a puppy from such a breeder.

Allergies

As with people, Golden Retrievers are subject to allergies. While allergies are rarely life-threatening, they can certainly have a negative effect on the dog's quality of life and thus on the owners' quality of life. The most commonly seen are food allergies and allergic skin problems—the famous "hot spots" that so many Goldens develop. Some allergies are the result of inhaled pollens and allergens.

In dogs, most allergies show up on the skin. Itching can be caused by a food allergy or by flea bites. Many Goldens with sensitive skin might benefit from medicated shampoos. Dogs with fleas often develop allergic reactions to the flea saliva left on their skin when the fleas bite them. These dogs should have flea baths while their homes are treated to get rid of the fleas so that the dogs are not reinfested. Lasting repellents (applied once monthly to the dog's neck) can be used to avoid infestation, but usually the home needs to be treated, as well. Remember, fleas do not live on a dog—they just jump aboard for the blood meal that they need to reproduce. One flea can lay hundreds of eggs, so treatment of the environment is important. In warmer climates, fleas in the outside environment are not killed off in winter, so treatment of the grounds might be necessary.

Food allergies can often be solved by a simple change of diet once you have determined the food ingredient to which your dog is allergic. While most allergies can be treated, this can sometimes be an expensive and even lifelong process. Canine sires and dams who are not affected by allergies tend to have puppies that do not experience allergic problems. This is yet another reason for selective breeding and for buying your Golden Retriever rom a reputable hobby breeder.

Elbow Dysplasia

Elbow dysplasia can be a confusing topic, so an overview is presented here. Like hip dysplasia, elbow dysplasia is a bone deformity diagnosed by x-rays, which are read primarily by the OFA. The condition appears most commonly in fast-growing, larger breeds of dog, and can affect Golden Retrievers. Diagnosis is not simple because there are several conditions that may be indicators of the problem, such as osteochondrosis, an abnormality of the cartilage and the bone beneath it. Causes include genetic factors, nutritional factors, and trauma. Several other medical conditions may also lead to elbow dysplasia. Surgery can sometimes help more severely affected dogs.

Lameness in a front leg, especially during the rapid growth that takes place during the second six months of a dog's life, is a major symptom. Breeders began to realize that elbow dysplasia could be a cause of lameness in their Goldens in the 1980s. Testing for this disease is now considered routine for all breeding stock to check for its presence before breeding a dog or bitch.

Dogs can be affected by pollens, grasses, and other allergens found outdoors.

Temperament

Some readers might be surprised to find behavioral and temperament issues listed along with the more traditional health issues of great concern to dedicated Golden breeders. Temperament problems in the Golden are, unfortunately, not as rare as they should be. According to a veterinary survey in the 1990s, the Golden Retriever makes the list of the top ten breeds that bite. Some of us have seen a Golden attack another dog without any provocation. Many more of us have seen a Golden shaking with fright for no discernable reason. And seeing a Golden who behaves like a hyperactive child, almost unable to

control himself, is certainly not uncommon at shows, field trials, or obedience or agility events. The kind of "wired" temperament that seems to have no "off" switch is not the type of temperament that this breed should exhibit.

Make no mistake, temperament (both good and not so good) is passed from parent to child. There is, in fact, at least one identifiable line of Goldens with bad temperaments that can be traced by pedigree back to at least the 1950s in the United States, and to the United Kingdom before that. In that particular case, which I have researched myself, we are talking about dogs that attack other dogs, or occasionally people, without provocation. I have witnessed males attacking other males, or even bitches, in the show ring for no apparent reason. Certainly, not every dog from these lines had bad temperaments, but one

or more often showed up from litters of these lines. Occasionally, dogs from these pedigrees who did not have any temperament issues still produced puppies that developed bad temperaments.

A stable, eager-to-please temperament is expected of a Golden. A hyperactive dog might do well in fast-paced competition but does not possess correct Golden temperament; such dogs should not be rewarded for behavior that is contrary to the requirements of the breed standard.

The question of whether or not to breed dogs with this type of atypical temperament is a good one. The competitive spirit has led some breeders to choose to breed dogs that are always "up." Is this the right way to go? Each breeder must decide for himself. However, whether a Golden is a field-trial dog, an agility competitor, a show dog, or a dog working in obedience—or simply a companion dog—I believe that the requirements of the breed standard should always be kept in mind. Changing something as fundamental as temperament can

Healthy Goldens in mind and body are lively, active, and happy dogs with a zest for life.

have a far-reaching, and perhaps unintended, negative effect on the breed.

The reality is that the vast majority of Goldens, even those produced by serious, ethical breeders involved in competitive venues, are destined to be companion dogs, living with families that are often ill-equipped to deal with dogs that are constantly on the go, unable to settle down and fit into normal household routines. Unfortunately, Goldens with wired temperaments, though no fault of their own, are often the ones who wind up in shelters or with rescue organizations because pet owners cannot handle them. Breeders must keep this in mind when planning future matings.

Even more importantly, any Golden that shows continual signs of aggression toward other dogs and/or people in normal situations should not be forgiven for this unacceptable conduct, nor should excuses be

made for this type of behavior. It is simply unacceptable. Dogs exhibiting unprovoked aggressive behavior should certainly not be bred, lest this atypical, highly undesirable, and unacceptable temperament be passed on to future generations. Temperament is, without question, passed genetically from parent to puppy. Breeders must consider the temperaments of breeding animals at least as carefully as they consider the physical characteristics of these dogs when making the decision of whether or not to breed. If we lose the correct biddable Golden temperament, we will have lost a critical hallmark of the breed.

Other Health Issues

There are a number of other diseases thought to be inherited or to be problems within certain related families of Goldens. These include eye diseases such as juvenile cataracts; other types of cataracts (some that affect vision and others that do not); entropion, ectropion, and distichiasis (eyelash problems); and, more rarely, central progressive retinal atrophy.

Among the other diseases that affect Goldens to varying degrees are epilepsy, swallowing disorders, and thyroid problems. As better reporting becomes available, additional problems may come to light. The wise breeder will make a point of staying current on all health issues that relate to our Goldens in the continuing effort to produce the healthiest and longest-lived dogs possible. The future health of the breed depends on determining the health status of breeding pairs before breedings take place. The decisions that all breeders make today will have an effect on the future generations of the breed.

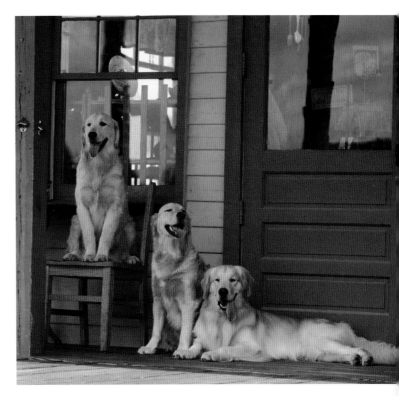

All Goldens should have the amiable, stable disposition for which the breed is known.

GOLDEN RETRIEVER FOUNDATION

Everyone who loves the Golden Retriever is urged to make a contribution to an organization that works to protect our breed from the ravages of disease. For example, the Golden Retriever Foundation has funded many studies on serious health issues that affect the breed. The GRF also provides money to other health studies funded by the American Kennel Club Canine Health Foundation and the Morris Animal Foundation. More information can be found on their Web site, www.goldenretrieverfoundation.org.

Choosing Your Second Golden

For most of us, our first Golden was not chosen with much in the way of careful forethought and planning. Perhaps you purchased him as a family pet from a casual breeder or from an ad in the newspaper. Quite possibly, not much thought was given to who the parents of the pup were and what their health status might

Three generations (LEFT TO RIGHT): Ch. Dewmist Silky Rainbow, Dewmist Rainbows Quest, and Ch. Styal Silksilla.

have been. You had little concern for the quality of the dog or the health issues that might affect him in the future. He was a cute puppy, and that was all that mattered.

Your new dog settled in and became part of your family, and you quickly grew to love him. The typical Golden's unquestioning devotion to his owner captured your heart, and you were a willing recipient of his affection. As part of learning how to best live with your Golden and tame some of his exuberance, you may have attended obedience classes. There you discovered one of the Golden's greatest assets—a driving desire to be with people and to please them.

Your Golden, given the opportunity to learn properly, and being eager to please you, quickly learned to do as you asked. Perhaps this led to more training and, as it does for many, your first experience in a competitive activity with a dog. As you attended group training lessons for your dog, you mentally competed with the other dogs and handlers in your class to see who learned the fastest and which dog was best at following directions, wanting to be the best in your class. Your dog did well, so perhaps you moved on to more advanced classes and, possibly, to the obedience ring at a show. There you were introduced to the world of show dogs, obedience competitors, and maybe even agility contenders.

In the competitive ring, you learned that there were many Goldens who had performance skills similar to those of your dog. At the same time, you may have noticed variations of style in that not all the Goldens you were seeing looked the same, and you wondered why this was so. If you started showing your dog in conformation classes, you quickly realized the differences in type among the dogs you saw in the ring, though the differences probably were not as pronounced as the contrast between the conformation dogs and the obedience dogs. If you were among the few doing field work, you may have noticed the physical differences between the dogs winning at field trials and the dogs winning in the conformation ring.

By the time your dog was two or three years of age, with any luck, you were learning more about the breed and comparing the divergence of type that you saw in the dogs in various areas of specialization. Hopefully you did some serious reading and discussed your observations and questions with others interested in the breed as you searched for some answers. If you were really lucky, you found a knowledgeable breed mentor to guide you on your way.

This is the path of learning taken by most who become serious about their activities with their dogs. In the very beginning, most people realize that they know little about the history behind the breed in general or their dogs in particular and not much about correct type. Those who become serious about competing in one venue, and who have had some success, often think that, having reached that plateau of success, they now know just about everything they need to know to compete successfully, as well as how

When your older Golden prefers the comforts of the couch to the feel of grass under his feet, you may decide to get a new dog with whom to pursue a competitive sport.

to breed dogs that win. So, they decide to become breeders. Although this is perhaps the most important time to consult those with extensive experience in the breed, this is rarely done. But not talking to someone with experience can lead to some serious problems in their breeding program.

You love your first dog, and he will always hold a special place in your heart. You learned many things about Goldens from him, but too often you also learned his limitations. This did not diminish your love for him in any way. You will always owe him a debt, for he will have started your love affair with the Golden Retriever. However, because he was purchased before you ever thought about serious

The Golden tends to wait for direction rather than act independently.

COPING WITH THE LOSS OF YOUR DOG

Despite our wishes to the contrary, all good things come to an end, even our time with our treasured dogs. At some point, all of us will lose one or more of our beloved canine friends. The pleasures and benefits of owning a dog are obvious to those of us that own one. We don't need a reason to love the furry beast that thinks we are the greatest thing in the world and is always happy to do whatever we ask of him.

Historically, the ability of our dogs to carry out their primary function, whether as a helper in gathering food for the table, a guardian of our flock or possessions, or a protector of our children, was perhaps the most important aspect of dog ownership. Keeping a dog for companionship alone was something only the richest could afford. Today, companionship and the never-ending, nonjudgmental love offered by dogs to their owners is reason enough to own a dog, though their abilities to perform the functions for which they are bred may still play a significant role in our decision to own a particular breed. We are lucky that our dog doesn't care how rich we are or how big our home is. As long as we love him, he is content.

Unfortunately, an inevitable drawback of dog ownership is that our dogs' life spans are considerably shorter than our own. This means that the death of a beloved companion dog is an experience we all have in common, many of us multiple times in our lives. The pain and sense of loss this brings can be a shock. Often, we don't realize just how much we've come to depend on our canine friend and companion. The dog was, after all, a member of the family.

For each of us, this loss is an intensely personal experience. A dog is not simply a possession, an inanimate object to be admired occasionally and ignored most of the time. Our dogs demand a relationship with us. They make their presence known, and a strong bond is built between us even if this bond was not our intention. In what often seems like a short time, our companions become old and somewhat feeble. Illness and loss of some function comes naturally with age. The time comes when we as caretakers must decide whether to prolong a life that has lost most of its joy and dignity or to let our friend and companion go. Sometimes that difficult decision is made for us, but more often we have to make it for ourselves.

In late September 2001, I had to make that decision for my last home-bred Golden Retriever. Lucy was a few weeks shy of her thirteenth birthday and had lived a full and happy life. In the space of about two weeks, she suddenly became weak and developed more and more difficulty getting up by herself. She was very unhappy. An extensive checkup by her veterinarian revealed the strong probability of a brain tumor. I reluctantly made the very painful decision that prolonging her life would only serve my needs and not hers. As I held her in my arms, she was painlessly allowed to go to her final rest.

Lucy's death ended an era of over thirty-two years of my having at least one Golden at my feet. As prepared as I thought I was for this event, I remain shocked at the depth of my reaction to her death. Some of my friends pointed out that I had lost dogs before and that I must be accustomed to dealing with loss after so many years. Somehow, they thought that each succeeding death would become easier. It's not. It's actually more difficult.

The loss of a dear friend, your companion dog, has a profound effect. For each of us, the mourning process is different. There is no "right way" to handle the loss. All of us find ways to cope, often with the support of friends and loved ones. Time softens the impact, but each of our dogs has a lasting consequence on our lives. The impact of a new loss for those involved in the sport for many years is, I believe, cumulative. Each loss evokes memories of dogs that have gone before. For me, my ownership of dogs of other breeds has provided solace. But even as I write this now, so many years later, there is an empty place in my heart where my Goldens will always live.

So, don't feel that it's wrong to be upset by the death of your dog. The depth of your loss is testimony to the strength of your bond. There is no reason to feel ashamed by your response. You have lost an important part of your life.

involvement in the breed, he may not have been of a quality that allowed you to reach your new goals of competition or perhaps breeding. A second dog, obtained with these goals in mind, may be the answer. A second dog will not diminish your love for the dog who came first.

Before purchasing a second dog, as a budding exhibitor or breeder who plans to get seriously involved in Goldens, you need to sit back and assess what you have learned from the experience of owning your first Golden. Buying your second dog gives you the opportunity to correct the misconceptions and mistakes you encountered the first time around. When you reach the decision to purchase your second dog, stop and think things through. While your first purchase may have been based as much on impulse as on forethought, now is the time to think your plan through before taking the leap.

Planning should begin by first considering just why you want another dog and what you expect to

The kind of puppy you seek will of course be cute, with the playful and sweet nature of the Golden, and the potential to succeed at your chosen endeavor.

gain from the purchase. Are you looking for a dog who will be more competitive in your area of interest, or are you looking for a dog who can achieve the more easily obtainable titles? In other words, what are your goals for your second dog? Determining as precisely as possible what these goals are will help you select the right dog to meet them.

Are you interested in acquiring a dog to show to his championship, or is your goal a Group winner or even a Best in Show winner? If the performance world is where your interest lies, are you looking for a dog who can earn a title (if so, what titles?), or is a top winner what you are seeking? If field trials are your area of interest, to what level of work do you want to bring your dog? Is a Hunting Retriever title your goal, or are you looking for a potential field-trial champion? Are you looking for a versatile dog who can work in several venues or a dog more suited to just one area of competition?

Once you've decided on your goals, you have a serious question to consider. Is the Golden Retriever the right breed for you to reach your goals, or is it possible that another breed might be more suitable? For example, if you are looking for a dog who has the instinctual concentration and speed of a Border Collie for the agility ring, the Golden Retriever might not be the right breed for you. If your heart's desire is to own a retriever with a Field Champion title, perhaps a Chesapeake Bay Retriever or a field-bred Labrador would be your ideal dog. If you are looking for a dual champion, the Golden is most probably not the breed for you—the last dual-champion Golden, Dual Ch. Tigathoe's Funky Farquar, qualified for his title in 1978. You'll have much more potential for success with a Brittany or German Shorthaired Pointer.

Breeders have a strong ethical responsibility to protect and preserve the breed they love for future generations. This means maintaining the essential

characteristics of the breed, not breeding to change the fundamental elements of the Golden Retriever to meet the individual goal of a more competitive dog. Breeders need to realize that breeding for Border Collie characteristics in their Goldens is damaging to the breed as a whole. If we start to breed these "foreign" characteristics from one breed into another, we are contradicting the reasons that purebred dogs exist.

Setting Goals

Once you have determined which competitive aspect of the dog sport you wish to pursue, just how far you want to travel down that competitive road, and that the Golden is the right breed for you, you will have yet another important decision to make. Are you also planning to breed your new dog? If breeding is not your interest and you are not planning to show in the conformation ring, you can, and probably should, spay or neuter your new charge and not worry about any health issues he may carry being passed on to future generations. This is certainly not to say that health issues should not be important to you when you purchase your new dog. Health should be high on your list of concerns whether or not you plan to spay or neuter. Of course, if you are looking for a conformation dog, you must remember that AKC rules prohibit the showing of dogs that have been surgically altered, and this includes spaying or neutering. Naturally, if the possibility of breeding your dog is part of your plans, then you will have to pay very close attention to the health status of the parents and the prior generations of dogs in your new puppy's pedigree.

So, having decided just what your goals are, the next step is to search for a breeder. Figuring out how to best go about this is often one of the most difficult parts of the process. With some breeds that are not as numerically popular as the Golden, there are few choices, but with a breed as admired as the Golden Retriever, there are a multitude of breeders all over the country. You are going to want to ask the breeder many questions about the puppy's parents and their successes in your chosen field of interest and will probably want to study pedigrees, as well, to determine how your potential puppy's ancestors did in competition. Still, care must be taken in the selection process so that you can get a healthy puppy that carries the potential to achieve your goals. Be prepared to spend a good deal of time and energy in selecting a breeder if you truly want to achieve success. Do not rush! This is not a quick process. And a good dose of luck is always handy, too!

Finding the Right Breeder for You

Your area of interest will be the first criterion in narrowing down the field of breeders to contact. You will be looking for an ethical hobby breeder with a documented history of long-term success in your chosen venue. The track record of this breeder over time should be your focus. A breeder who has found success, as demonstrated by generations of winning dogs, has learned which combinations of bloodlines work for them and, just as importantly, which lines don't blend well with their own lines.

Breeding is not a sure thing. Nature will always step in and decide just what will happen, even with the best-laid plans. The smart breeder learns just as much from mistakes as from success. Really good breeding is more an art than a science, though a thorough foundation in science is a necessary component of all successful breeders' education. It is

from a breeder of this school that you want, if at all possible, to purchase your dog.

You should not put a lot of focus on the current winner. You are interested in the pedigrees of dogs winning over time. If at all possible, you will want to purchase a dog whose ancestors have also been successful in your area of specialization. A dog from a family of dogs that have been winning for generations is much more likely to be a winner himself. A pup from a successful dog whose family does not have similar successes is much less likely to produce what you are looking for in future generations. You are looking for a pedigree that consistently produces good dogs.

At the same time, generally speaking, you will have more success with a linebred pup than with a puppy from an outcross litter, as there will tend to be less variation of quality within the litter. Spend some time reading the breeding chapter in this book to help you understand these concepts. Please keep in mind that breeding to the current big-winning dog might be exactly the wrong thing to do with a prized bitch. You want a stud dog who has the attributes you wish to improve in the brood bitch as well as those you want to hold on to in her pups. The big-winning dog might not have what you need.

Health concerns in Goldens, or at least our growing knowledge about health issues in the breed, seem to be on the rise. If you are planning on breeding your new pup, you will need to pay particular attention to genetically based diseases that might be carried not only by the parents of your puppy but also, just as importantly, by your puppy's ancestors and their siblings, going back at least three or four generations in the pedigree. If you are aware that a particular dog carries a health-related issue, you will want to make certain that the litter you are looking at is not linebred on that dog, as this could lead to the puppy's being affected by the disease or being a genetic carrier even if not affected himself. It is for reasons such as this that breeders need to study both genetics and pedigrees. If you intend to become a breeder yourself, you will need to learn a good deal of specific information about the ancestors of your own dogs.

Scientific advances have given us a much wider insight into the potential for health-related problems in the breed. New advances permit breeders to check for potential problems in a litter even before the litter is actually bred. In time, DNA testing will give us an even better method of avoiding some of the more serious problems. Conscientious breeders will soon have better and better ways to plan their litters. However, because the randomness of nature will always have a strong influence and because there are still many areas in which we have little or no knowledge of how health problems develop and are passed from parent to puppy, it is unlikely that we will ever reach the point of being able to totally eliminate all of the issues.

A Good Mentor

It is especially important for the budding breeder to develop a mentor-mentee relationship with someone who has been involved with the breed for many years. The sharing of important information about dogs should never be a witch hunt of any kind; it needs to result from an honest, trusting relationship built up over time. Breeding top-quality dogs is an art that relies on the application of scientific principles and the kind of knowledge that can only be developed through years of work with dogs and bloodlines. The knowledge of how one line will "nick" with another (how well the lines will blend together in positive ways) can only be learned in two ways: either through direct experience or from someone else who has the necessary background and

A top-winning conformation dog Ch. Happy HR Highmark Bad News Bear, JH competes in the field at the GRCA national specialty, showing his ability to do what the breed was bred to do.

experience. Your second dog provides you with the opportunity to avoid the mistakes you made the first time around; to improve, to plan, to set goals, and to meet others who share your passion for the breed.

As you become seriously involved in your area of the dog sport, you will discover that the "old-timers" tend to spend a good deal of time chatting about individual dogs they have bred or have known over the years, either as competitors or from some other kind of direct experience. The knowledge gained through this type of forthright discussion is invaluable when planning a breeding program. In reality, it is the only way of learning some of the important information about individual dogs. A good mentor can save you years of experimentation in trying to find the right pedigree combinations to produce the kind of dogs you can be proud of, and will help you develop, over time, an identifiable line (or strain) of your own.

Honest Information

There is an unfortunate tendency in today's world of the Internet to circulate unproven, usually negative, accusations about others' dogs, perhaps in a misguided attempt to make one's own dogs look better. As a result, much of the information found about individual dogs on message boards, blogs, and the like, has little basis in fact—or is so exaggerated as

A well-bred Golden will be an active companion well into his senior years.

to have little relationship to the actual truth. Beware of relying on this undocumented type of information in making your decisions about where to purchase a dog or which stud dog to consider for your bitch. Trust your mentor for this kind of information. And don't add to the problem by making statements on the Internet that you don't know to be factual.

There are several honest sources of information about health-related issues. The OFA (the Orthopedic Foundation for Animals, www.offa.org) and CERF (the Canine Eye Registration Foundation, www.vmdb.org/cerf.html) provide information, for example, that has been verified as accurate for the individual dogs registered with those organizations. Some types of information can be obtained from other organizations approved by the Golden

Retriever Club of America. Serious, conscientious breeders usually have health examinations performed by board-certified veterinarians on dogs they are considering for use in their breeding programs. Breeders should be willing to share that information with anyone interested in purchasing their puppies. Ask to see the actual veterinary reports.

For information about the grandparents and the dogs further back in the pedigree you are considering, you will have to rely either on documented facts from reliable sources such as the OFA or on the knowledge you might be able to obtain from your mentor. There are really no other practical ways to

Look for a breeder whose love of her dogs is evident. Connie Gerstner Miller of Malagold relaxes at a show with "Ronnie."

gain this information, but it is very important, as it can have a significant impact on the puppies descended from these dogs.

If your experience with the breeder of your first dog was not what you wanted or expected, think about what you would like to be different the second time around. With your first dog, most likely you were primarily interested in a pet when you made the purchase. But now you have goals in mind that need to be considered as you choose the source of your second dog. A knowledgeable breeder with whom you can establish a good personal relationship and who is willing to serve as your mentor should be what you look for when you are ready for your second dog. If you were lucky enough to have established this type of relationship with your first breeder, value it. Consult that person about your pending purchase if he doesn't have what you are looking for.

Making Your Choice

First and foremost, you will want to purchase from a breeder with a known reputation for honesty and integrity who specializes in your area of interest. This time around, you want not only a healthy dog but also a dog who will be competitive with other Goldens in your sport of choice.

Second, you should have learned about the many health-related issues that can affect your dog and use this knowledge in making a more informed purchase this time. You should have learned what questions to ask; now is the time to ask them.

Third, you should have done some studying about canine anatomy and what makes a dog with superior structure; you will now apply this knowledge, as well. If breeding is a consideration for you,

keep in mind that it is much harder to improve your breeding stock when you don't start with superior-quality dogs. If you want to breed your first dog and find that he is lacking in many physical characteristics that you now know are correct, keep in mind that it will be quite difficult to "breed up" the desired qualities so that you begin to produce the type of dogs you desire. The process of improving a poorer quality dog easily takes a number of generations. Instead, consider spaying or neutering your beloved first dog and then seeking a second dog or bitch that has the potential to become a worthy foundation for your breeding program. I promise that, in the long run, you will be far better off.

Finally, as you begin the process of finding your second dog, decide whether you want to purchase a dog or a bitch. If your plan is to establish a breeding program, without question your best bet is to purchase the best possible bitch from a bloodline known to produce quality Goldens. You will be looking for an experienced breeder who has produced not just one good dog in a litter, but several over a number of litters for a number of years. You are seeking a record of consistency from generation to generation. Producing one good dog out of many litters can be as much the result of pure chance as it is the result of planning. You need a dedicated, longtime breeder with a record of success from whom to purchase your dog.

The goal, then, is not to rush into a purchase of a dog but instead to invest the time and energy necessary to do the research required to find the best possible candidate. If you don't do your homework, you are much less likely to reach your goals. Learning from your mistakes (and understanding that we all make them) will help you succeed. Use all you have learned from ownership of your first dog to make the best possible choices for your second dog.

The well-bred Golden will be ready to participate in whatever endeavor you choose.

BIBLIOGRAPHY

American Kennel Club, The. ***The Complete Dog Book***, twentieth edition. New York: Ballantine Books, 2006.

Battaglia, Carmen. ***Dog Genetics: How to Breed Better Dogs***. Neptune, NJ: TFH Publications, 1978.

Bauer, Nona Kilgore. ***Dog Heroes of September 11th: A Tribute to America's Search and Rescue Dogs***. Allenhurst, NJ: Kennel Club Books, 2006.

Beauchamp, Richard. ***Solving the Mysteries of Breed Type***, second edition. Allenhurst, NJ: Kennel Club Books, 2007.

Charlesworth, Mrs. W. M. ***The Book of the Golden Retriever***. London: The Field, 1933.

Elliott, Rachel Page. ***Dogsteps—A New Look***. Wilsonville, OR: Doral Publishing, 2001.

Foss, Valerie. ***The Ultimate Golden Retriever***, second edition. New York: Howell Book House, 2003.

Gilbert, Jr., Edward M. and Thelma R. Brown. ***K9 Structure and Terminology***. New York: Howell Book House, 1995.

Hastings, Pat. ***Tricks of the Trade***. Aloha, OR: Dogfolk Enterprises, 2005.

Padgett, George. ***Control of Canine Genetic Diseases***. New York: Howell Book House, 1998.

Sawtell, Lucille. ***All About the Golden Retriever***. London: Pelham Books, 1980.

Schlehr, Marcia. ***The New Golden Retriever***. New York: Howell Book House, 1996.

——————————. ***A Study of the Golden Retriever***, third edition. Flat Rock, MI: Travis House, 1994.

Secord, William. ***Dog Painting: A History of the Dog in Art***, second edition. Woodbridge, Suffolk, England: Antique Collectors' Club, Ltd., 2009.

Spencer, James. ***Training Retrievers for the Marshes and Meadows***. Loveland, CO: Alpine Publications, 1998.

Spira, Harold R. ***Canine Terminology***. Wenatchee, WA: Dogwise Publishing, 1982.

Trotter, Patricia Craige. ***Born to Win: Breed to Succeed***, second edition. Freehold, NJ: Kennel Club Books, 2009.

Tudor, Joan. ***The Golden Retriever***. New York, Howell Book House, 1968.

INDEX